Royal Weddings

Königliche Hochzeiten

Second Revised Edition

Friederike Haedecke

Julia Melchior

teNeues

Inhalt · Content

Faszination Königshochzeiten
Ein „Ja" zu Liebe, Thron und Untertanen

Ein solches Ereignis bekommt die Welt nur alle paar Jahrzehnte zu sehen: Als Prinz William von Wales, der Erbe der bedeutendsten Monarchie der Welt, seine Kate Middleton zur Frau nahm, waren mehr als zwei Milliarden Menschen per Fernsehen und Internet dabei. Die Hochzeit in Westminster Abbey war die aufwändigste Eheschließung, seit Williams Eltern 1981 „Ja" zueinander gesagt hatten. Die Faszination, die königliche Hochzeiten auf das bürgerliche Publikum ausüben, ist seit Jahrzehnten ungebrochen. Abertausende säumen den Weg vom Palast zur Kathedrale, verfolgen die Zeremonie auf Großleinwänden oder fiebern im heimischen Wohnzimmer mit, wenn ein Königsspross vor den Altar tritt.

Vielleicht ist es das Märchenhafte, das so bezaubert. Ein atemberaubendes Kleid, eine Rundfahrt im offenen Rolls Royce oder gar in einer goldenen Kutsche. Und manchmal auch das Happy End einer Romanze, bei der die Liebe über die Staatsräson gesiegt hat. Plötzlich öffnen sich die Türen zu einer Welt, zu der wir sonst keinen Zutritt haben. Und das an einem Tag, der vor allem für die beiden Hauptpersonen der aufregendste in ihrem Leben sein dürfte. Denn vor dem Altar sind Braut und Bräutigam plötzlich ganz allein. Der Gang in die Kirche, das Ja-Wort, die komplizierten Gelöbnisse – das alles muss eingeübt sein. Kein Hofstaat kann nun mehr helfend zur Seite springen. Trotz der generalstabsmäßigen Organisation läuft nicht immer alles nach Plan. Kronprinzessin Victoria küsst ihren Daniel schon mehrfach spontan, noch bevor der „offizielle" Hochzeitskuss auf dem Palastbalkon bejubelt werden kann. Und manchmal gibt's auch die ein oder andere Panne. Der Ring will partout nicht an Máximas Finger passen, obwohl er x-mal anprobiert wurde. Oder das sündhaft teure Kleid von Diana wirft plötzlich dort Falten, wo sie ganz bestimmt nicht hingehören. Kleine Versprecher, kullernde Tränen oder ein in der Aufregung missachtetes Protokoll – bei all der Pracht sind es manchmal gerade diese Momente, die den Charme einer königlichen Hochzeit ausmachen.

„Royal Weddings" porträtiert die unvergessenen Hochzeiten von Regenten und Thronfolgern mit all den großen und kleinen Besonderheiten, die jeder königlichen Hochzeit ihren einzigartigen Charakter verleihen.

The Fascination of Royal Weddings
"Yes" to Love, Throne and People

Only once in several decades is there an event like this. When Prince William of Wales, heir to the proudest throne in the world, married his Kate, more than two billion viewers were watching on television and on the Internet. The wedding in Westminster Abbey was the grandest since his parents had married in 1981. The fascination that royal weddings exercise on the public has persisted over the years. When an heir to the throne steps up to the altar many thousands line the route from the palace to the cathedral, follow the ceremony on big screens or watch breathlessly in their own living rooms.

Perhaps it is the fairy tale character of the event that bewitches – a breathtaking dress, a drive in an open Rolls Royce or even a golden coach. And sometimes the happy ending in a romance in which love has triumphed over reasons of state. Suddenly the doors open on a world from which we are usually shut out, and that on a day which for the main actors is probably the most stirring of their lives. At the altar the bride and bridegroom are suddenly on their own. Everything must be practised beforehand: the drive to the church, the exchange of vows, the complicated responses. In church no courtiers are there to help them, and in spite of organisation down to the last detail, things don't always go according to plan. Crown Princess Victoria spontaneously kissed her Daniel several times before the "official" kiss on the balcony of the palace. Sometimes there is a hitch: Máxima's ring refuses to slip onto her finger although the process has been practised many times, or creases suddenly appear on Diana's wickedly expensive gown where they are definitely not supposed to be. Small slips of the tongue, uncontrollable tears or the demands of protocol ignored in the excitement – it is often just these moments, among all the pomp and circumstance, that constitute the charm of a royal wedding.

"Royal Weddings" portrays the unforgettable marriage celebrations of monarchs and heirs to the throne with all the individual touches which give their unique character to every royal wedding.

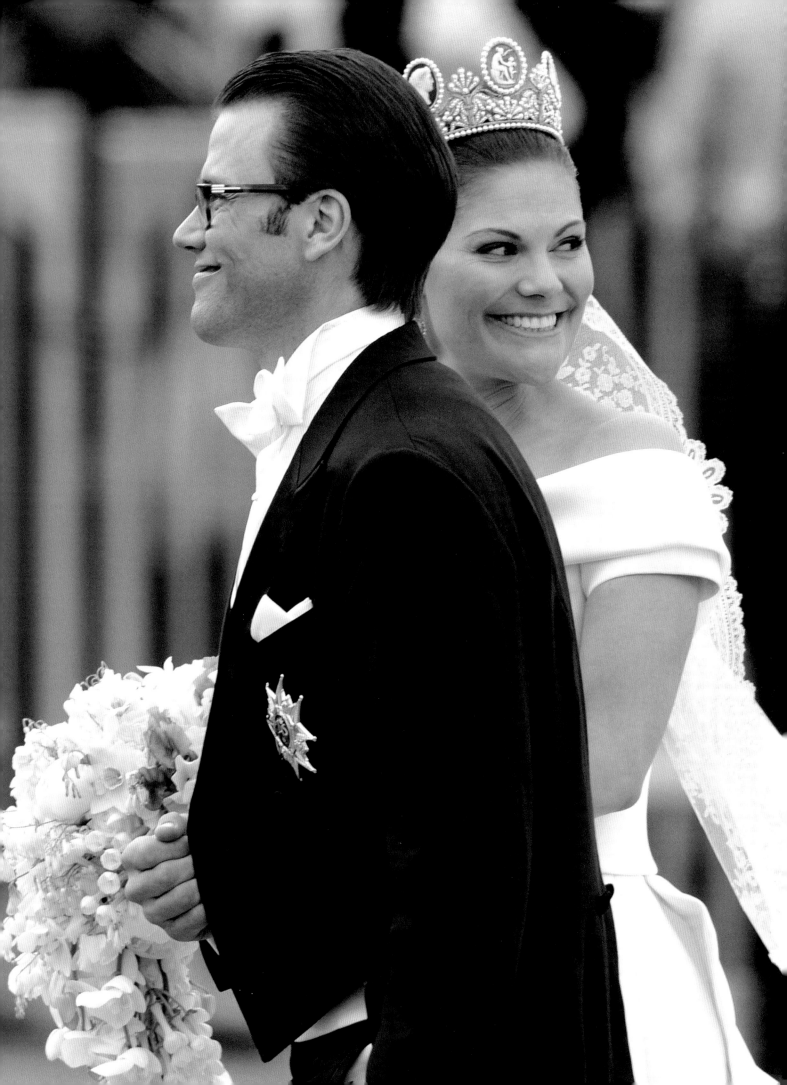

Victoria & Daniel

Das Mittsommermärchen
Schweden, 19. Juni 2010

The Midsummer Fairy Tale
Sweden, 19 June 2010

Hunderttausende hatten sich in der Abendsonne am Fuß des Palastes eingefunden, um noch einmal das frischvermählte Brautpaar zu sehen. Unter Fanfarenklängen traten Kronprinzessin Victoria und Prinz Daniel auf den Balkon vor ein blaugelbes Fahnenmeer. Unzählige Liebesbekundungen des Brautpaars hatten die Herzen der Schweden an diesem Tag schon höher schlagen lassen. Doch jetzt bot sich ihnen eine Weltpremiere. Zum ersten Mal in der Geschichte königlicher Hochzeiten wandte sich die Braut an das Volk. „Liebe Freunde. Danke, dass Ihr mir meinen Prinzen geschenkt habt", sprach Victoria mit kräftiger Stimme und entfachte einen Sturm der Begeisterung bei der jubelnden Menge. Royalisten und Republikaner freuten sich mit ihrer Thronfolgerin.

An diesem Tag hatte sie gesiegt – über die Konvention und über ihren Vater, der lange gegen die Heirat mit ihrem einstigen Fitnesstrainer war. Victoria hatte Daniel 2002 in Stockholms exklusivstem Sportklub „Master Training" kennengelernt, den er mit einem Freund betrieb. Mit Argusaugen beobachtete die Öffentlichkeit die heranwachsende Liebe: Ein Mann aus dem Volk brächte die Monarchie in Gefahr, warnten die konservativen Kreise den König. Daniel wäre der Rolle des Prinzgemahls nicht gewachsen, wurde geunkt. Doch mit den Jahren ließ sich König Carl Gustaf vom

Hundreds of thousands had gathered in front of the palace in the evening sunshine to catch a further glimpse of the newly married couple. To a fanfare of trumpets Crown Princess Victoria and Prince Daniel stepped out onto the balcony to look down across a sea of yellow and blue. Countless loving gestures between them had already caused Swedish hearts to beat faster that day but now they were to experience a world premiere: for the first time in the history of royal weddings the bride spoke directly to the people. "Dear friends, thank you for giving me my prince," said Victoria with a determined voice, to be met with a storm of delighted applause from the crowd. Royalists and republicans alike rejoiced with their future queen.

This was her day of triumph, over convention and over her father, who had stubbornly opposed her marriage to her former personal trainer. Victoria had met Daniel in 2002 in Stockholm's most exclusive sports club "Master Training", which he ran with a friend. The public watched their blossoming romance with eagle eyes. Conservative circles warned the king that a man of the people would endanger the monarchy and in any case Daniel would not be up to the role of prince consort. Over the years however King Carl Gustaf became convinced of the contrary. With Daniel at her side, his elder daughter had matured from a fragile

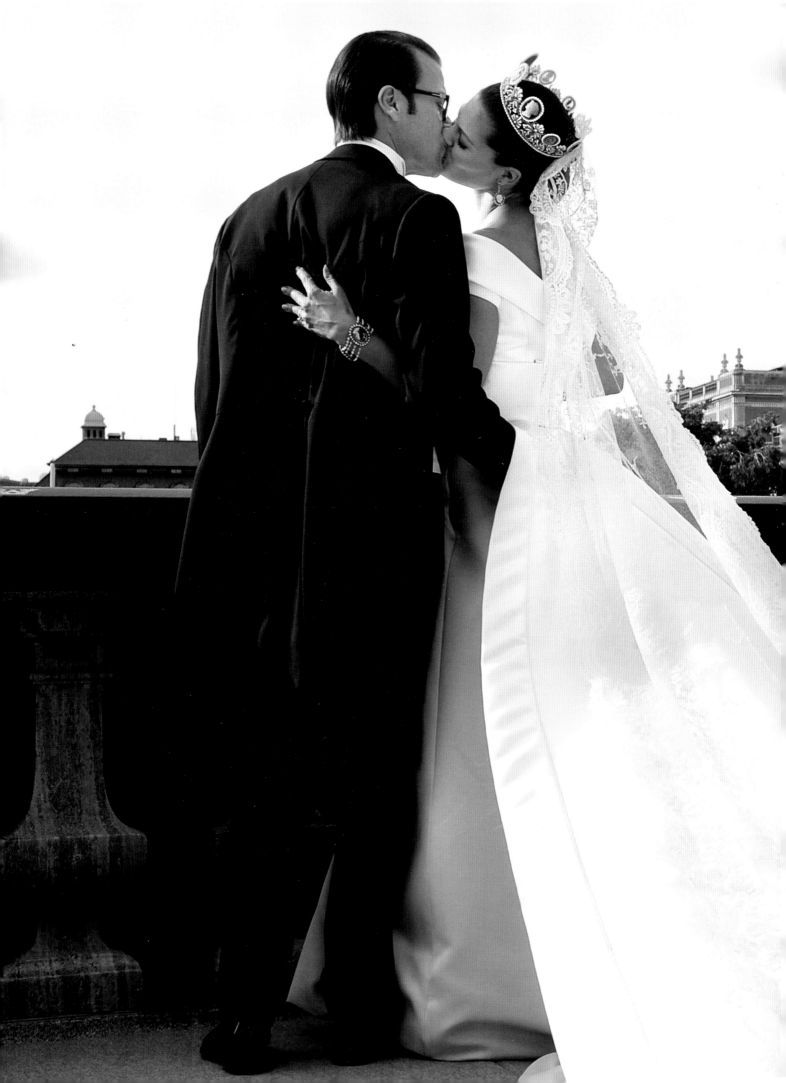

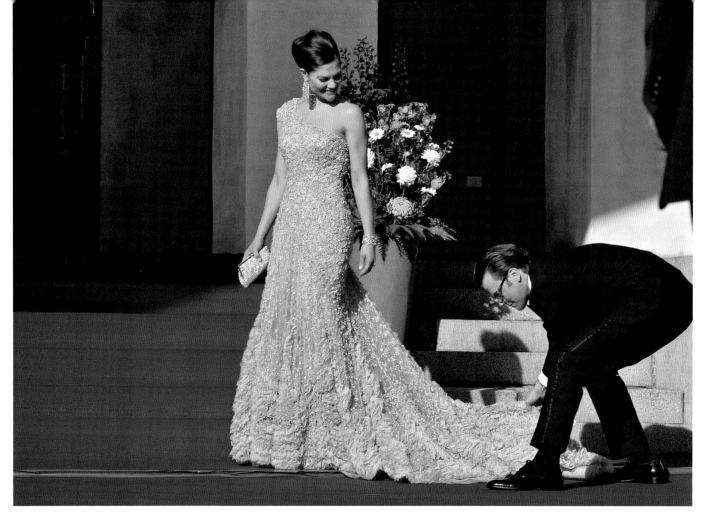

Zum Niederknien. Daniel richtete seiner Victoria die Robe für den perfekten Auftritt am Vorabend der Hochzeit. Das Brautpaar war Ehrengast bei einem Festkonzert, zu dem die schwedische Regierung eingeladen hatte. Als Königin wird Victoria eines Tages das Amt des Staatsoberhaupts innehaben.

On bended knee. Daniel makes a last-minute adjustment to Victoria's dress before a perfect appearance on the eve of the wedding. The bridal couple were guests of honour at a concert hosted by the Swedish government. One day Victoria will be queen and head of state.

Gegenteil überzeugen. An der Seite von Daniel reifte seine älteste Tochter von einer zerbrechlichen jungen Frau zur selbstbewussten glücklichen Repräsentantin des Landes.

Am 19. Juni 2010 konnte sich die ganze Welt davon überzeugen. Als sich um 15:30 Uhr die Pforten des Stockholmer Doms öffneten, geleitete ein sichtlich stolzer Vater die strahlend schöne Victoria durch das Kirchenschiff. Doch nicht bis zum Altar, wie es Tradition gewesen wäre. Auf halbem Weg übergab der König seine Tochter dem Bräutigam. Gemeinsam schritten Victoria und Daniel durch ein Spalier aus gekrönten Häuptern, die am Altar Platz genommen hatten. Vier Geistliche trauten das Traumpaar in einer Zeremonie der großen Gefühle. Mit jeder Geste demonstrierten Victoria und Daniel, dass dieser Bund aus Liebe geschlossen wurde. Stets suchten sie ihre Blicke und hielten sich fest an den Händen. Den Handkuss für den Herrn machte Victoria vor dem Altar hoffähig, als sie vor lauter Glück ihre Lippen zärtlich auf den Handrücken

young woman to a happy and confident representative of her country.

On 19 June 2010 Victoria proved this before the whole world. When at 3.30 p.m. the doors of the Stockholm Cathedral opened, a visibly proud father led a radiantly beautiful Victoria up the aisle – not however all the way, as tradition would have required. Halfway along the king gave away his daughter to the bridegroom and together Victoria and Daniel walked between the assembled crowned heads to the altar. Four clerics conducted a ceremony laden with emotion: with every gesture Victoria and Daniel showed that theirs was a marriage for love. Every few minutes they gazed at each other and firmly held hands throughout the service. Victoria even made it acceptable for a man's hand to be kissed, when out of pure happiness she gently pressed her lips against the hand of her newly married husband. Unmistakably she illustrated what pop singer Björn Skifs and casting show winner Agnes Carlsson sang at the end of the service, "When You Tell

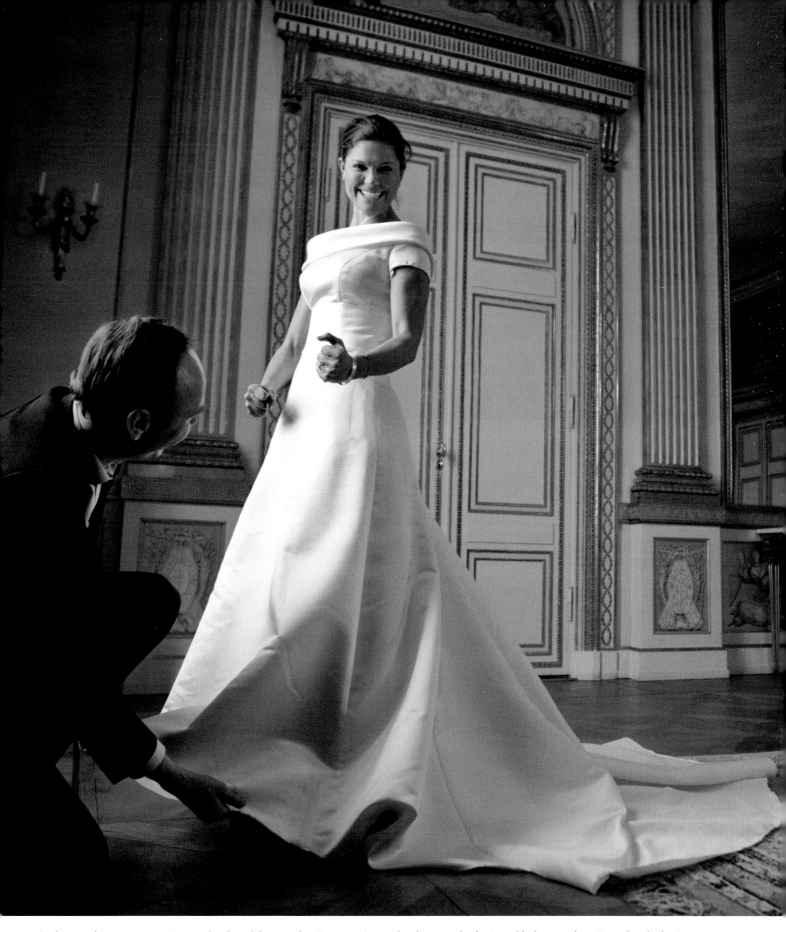

Sie kann es kaum erwarten. Die Vorfreude auf ihren großen Tag war Victoria bei der Anprobe des Brautkleids anzusehen. Der schwedische Couturier Pär Engsheden hatte der Kronprinzessin ein zeitloses Kleid aus cremefarbener Duchesse-Seide mit V-förmigem Rückenausschnitt geschneidert.

She can hardly wait. Victoria's excitement about her big day was evident as she tried on her wedding dress. Swedish couturier Pär Engsheden had designed for her a timeless gown of cream-coloured duchesse satin with a V-neck at the back.

ihres frisch angetrauten Ehemanns drückte. Unmissverständlich zeigte sie, was Popmusiker Björn Skifs und Castingshow-Gewinnerin Agnes Carlsson zum Ausklang des Gottesdiensts besangen. „When You Tell the World You're Mine", heißt es in dem eigens für diese historische Hochzeit komponierten Schmusesong. Aus Liebe wurde an diesem Tag zum ersten Mal in der Geschichte Schwedens ein Untertan zum Prinzgemahl.

Seine schwerste Prüfung als frischgebackener Prinz von Schweden stand Daniel beim Festbankett bevor. Über 500 internationale Gäste aus Aristokratie, Politik und Gesellschaft waren in den Reichssaal des Palastes geladen, in dem seit Hunderten von Jahren Schwedens Könige gekrönt werden. Jetzt musste Daniel hier seine Feuertaufe bestehen. Doch von Anspannung zeigte der Bräutigam keine Spur, als er sich von seinem Platz erhob, um vor der hochkarätigen Hochzeitsge-

the World You're Mine", a sentimental song specially composed for this historic wedding. On this day, for the first time in Swedish history love had made a subject into a prince consort.

His hardest test as a freshly created prince of Sweden was to be at the festive banquet. Over 500 international guests from the nobility, politics and society were gathered in the hall of state of the palace, the Rikssalen, where for hundreds of years the kings of Sweden had been crowned. Now Daniel had to go through his baptism of fire. Yet when he rose from his seat to make his first speech before the distinguished guests the bridegroom showed not a trace of nerves. "Once upon a time the young man was, perhaps not a frog, in the beginning of the fairy tale. But he was certainly not a prince. The first kiss did not change that." Daniel's joking introduction earned him wild applause

Ausgezeichnet. Königin Silvia richtete ihrem Schwiegersohn Frack und Orden. Da sie selbst bürgerlich geboren ist, konnte sie Daniels Aufregung am besten nachvollziehen. An diesem Tag wurde aus dem schwedischen Untertan Seine Königliche Hoheit Prinz Daniel von Schweden, Herzog von Västergötland.

In excellent order. Queen Silvia adjusts the tailcoat and decorations of her son-in-law. Born a commoner herself, she can best understand Daniel's nervousness. On this day the subject of the Swedish crown will become His Royal Highness Prince Daniel of Sweden, Duke of Västergötland.

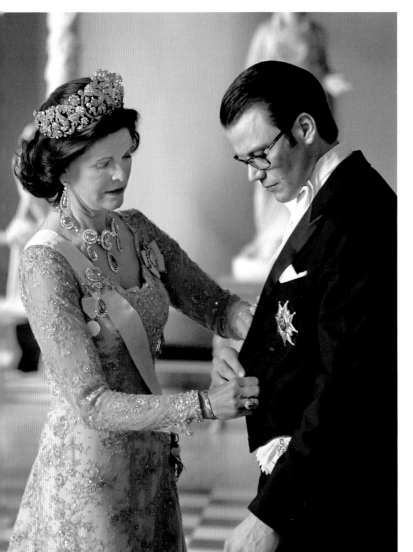

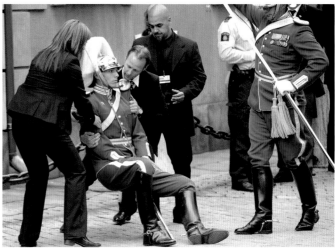

Weiche Knie. Einem Soldaten der Ehrengarde gingen die Kräfte aus. Ärgerlich, denn um seinen Platz in der ersten Reihe dürften ihn viele beneidet haben. Entlang der Strecke der Hochzeitskutsche hatten sich Hunderte Freiwillige postiert, um den Royalfans den Weg zu weisen.

Weak at the knees. A soldier in the guard of honour collapses. Annoying: many people will have envied him his place in the front row. Hundreds of volunteers had stationed themselves along the route of the wedding coach to direct the crowds.

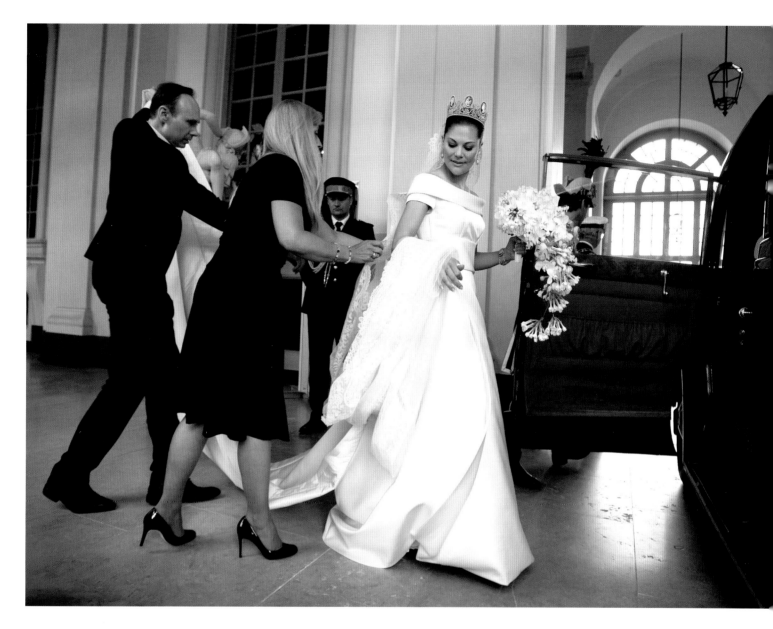

Jetzt gilt's. Nach monatelangen Vorbereitungen machte sich Victoria um 15:25 Uhr auf zur Trauung. Für den schwedischen Hof war diese Hochzeit eine gigantische logistische Herausforderung. Allein 25 Frisöre sorgten für die diademtauglichen Frisuren der gekrönten Häupter.

Now! After months of preparation Victoria finally set off for the wedding at 3.25 p.m. The occasion was a gigantic logistical challenge for the Swedish court. No fewer than 25 hairdressers were needed to prepare the crowned heads for their tiaras.

sellschaft seine erste Rede zu halten. „Am Anfang des Märchens steht ein junger Mann. Wenn er auch kein Frosch war, aber ein Prinz war er definitiv nicht. Daran hat auch der erste Kuss nichts geändert", spaßte Daniel über seine Biografie und erntete tosenden Applaus. Selbst die stets auf Contenance bedachte Königin Beatrix der Niederlande griff zum Taschentuch, als Daniel seiner Victoria seine Liebe erklärte. Minutenlang klatschten ihm die Gäste Beifall und hießen Prinz Daniel im europäischen Hochadel willkommen.

from his listeners. Even Queen Beatrix of the Netherlands, usually known for her composure, reached for her handkerchief when Daniel declared his love for Victoria. The guests applauded for several long minutes, welcoming the newly titled Prince Daniel into the higher ranks of the European nobility.

Krönung einer Liebe. Jahrelang galt die Beziehung zwischen der Kronprinzessin und ihrem einstigen Fitnesstrainer als nicht hoffähig. Stets musste Victoria ihre Pflichten allein wahrnehmen. Dabei war sie oft wochenlang auf Reisen. Als Victoria einmal für einen Monat nach China aufgebrochen war, fand Daniel ein Kästchen mit 30 Briefen vor – einen für jeden Tag, an dem sie nicht bei ihm sein konnte. Von nun an wird sie Daniel immer an ihrer Seite haben.

Den Triumph ihrer Liebe brachte Victoria auch mit der Wahl des Kameendiadems zum Ausdruck: Die mittlere Kamee des Diadems zieren Amor und Psyche aus der griechischen Sage, in der die schöne Königstochter über sich hinauswächst, um ihre Liebe zu Gott Amor zu retten. Auch Victorias Mutter trug das zweihundert Jahre alte Diadem bei ihrer Hochzeit.

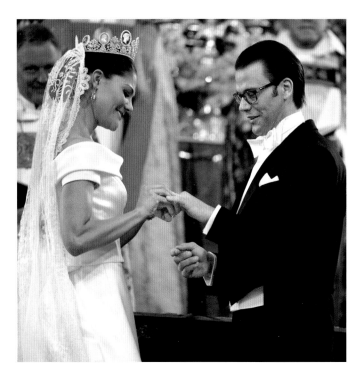

A love crowned. For years the relationship of the crown princess with her former personal trainer was considered inappropriate and unacceptable at court. Victoria had to undertake her duties alone and was often away for weeks at a time. When on one occasion she had left for a month's visit to China Daniel found a box with 30 letters from her – one for every day she could not be with him. From this day on Daniel would always be at her side.

The triumph of their love was also symbolised in Victoria's tiara: the central cameo showed Cupid and Psyche from the Greek myth, in which the beautiful king's daughter prevailed over all her trials to prove her love for the god Cupid. The same 200-year-old tiara had been worn by her mother at her own wedding.

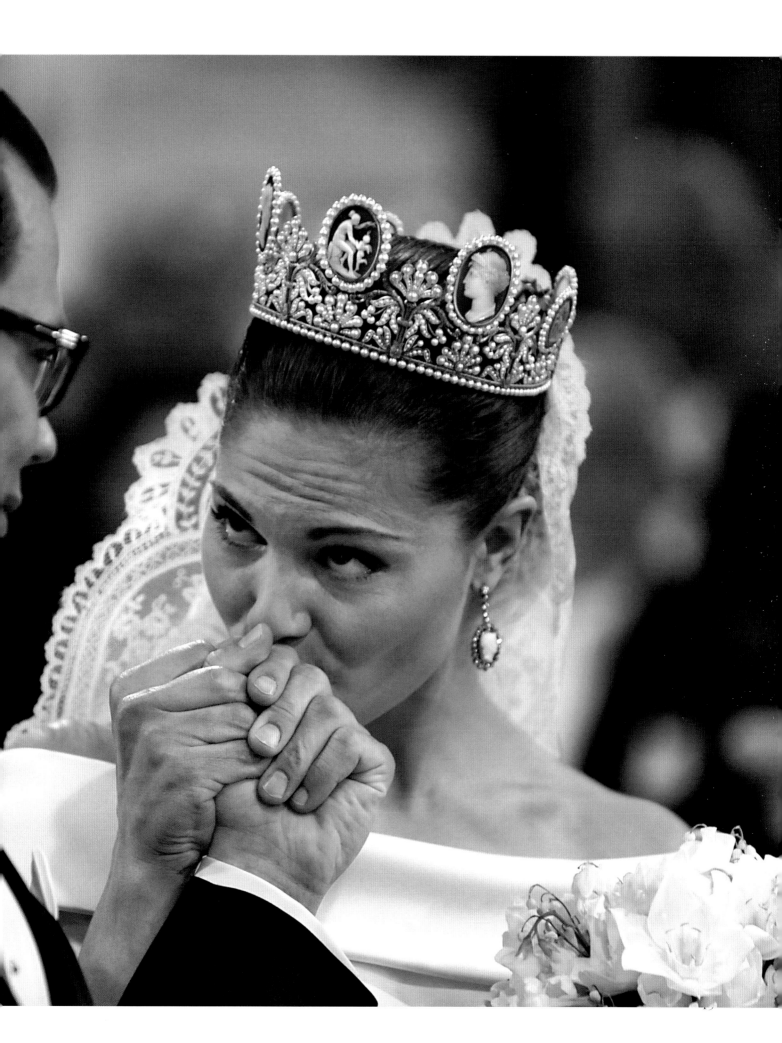

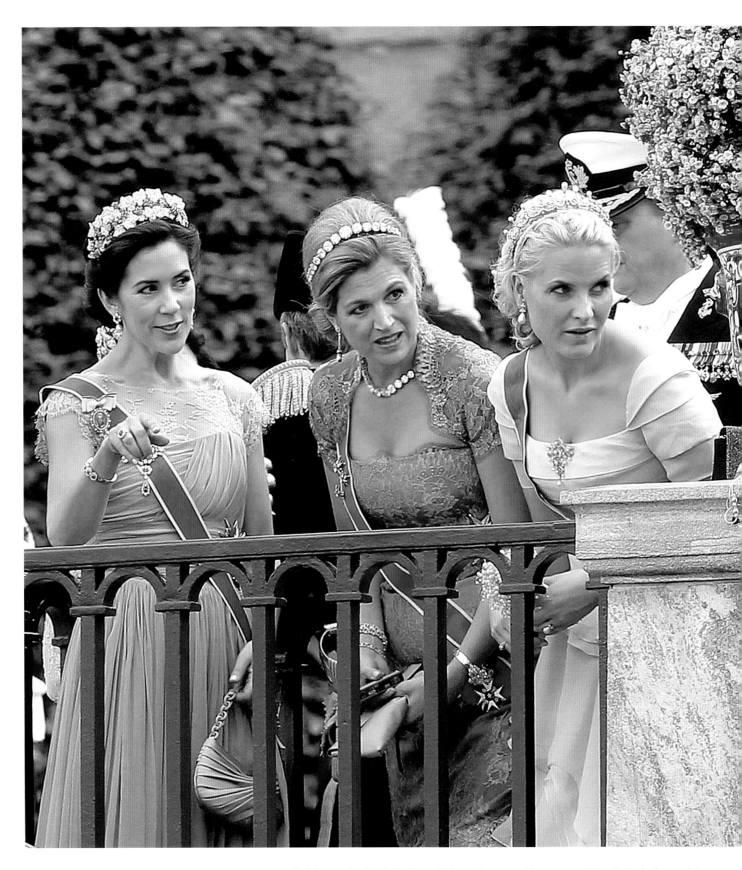

Royal Countdown. Gespannt warteten Mary von Dänemark, Máxima der Niederlande und Mette-Marit von Norwegen auf dem Palastbalkon auf die Ankunft des Brautpaars. Beim privaten Polterabend auf Schloss Drottningholm zwei Tage zuvor hatten die drei selbst einen großen Auftritt. In wochen-langer Emailkorrespondenz hatten sie den 80er Jahre-Hit „The Final Countdown" der schwedischen Gruppe Europe auf das Brautpaar umgetextet. Mit „The Royal Countdown" unter der musikalischen Leitung von Haakon und Mette-Marit von Norwegen stimmten sie die Gäste auf rauschende Festtage ein.

Hochadelsheiratsmarkt. Seit der Trennung von ihrem Verlobten darf mit Prinzessin Madeleine Europas schönste Königstochter wieder umworben werden. Der begehrteste Junggeselle indes ist vergeben. Fürst Albert von Monaco, der sein Singledasein lange Zeit zu genießen wusste, ließ sich von den Feierlichkeiten in Stockholm inspirieren. Drei Tage später hielt er um die Hand seiner Freundin Charlene Wittstock an.

Marriage market for the higher nobility. Since her engagement was broken off Princess Madeleine, Europe's prettiest princess, is on the market again. But the most eligible match, Prince Albert of Monaco, long happy as a bachelor, is no longer available. Three days later, inspired by the festivities in Stockholm, he proposed to his partner Charlene Wittstock.

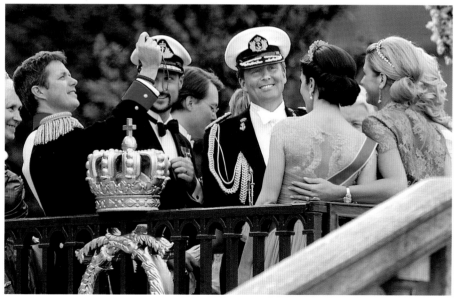

Royal countdown. On the palace balcony Mary of Denmark, Máxima of the Netherlands and Mette-Marit of Norway eagerly await the arrival of the bridal couple. At the private pre-wedding party at Drottningholm Palace two days earlier they themselves had taken the stage. By means of a lengthy e-mail correspondence they had adapted the eighties hit "The Final Countdown" by the Swedish group Europe so as to apply to Victoria and Daniel. With "The Royal Countdown", conducted by Haakon and Mette-Marit of Norway, they set the tone for a few days of light-hearted festivities.

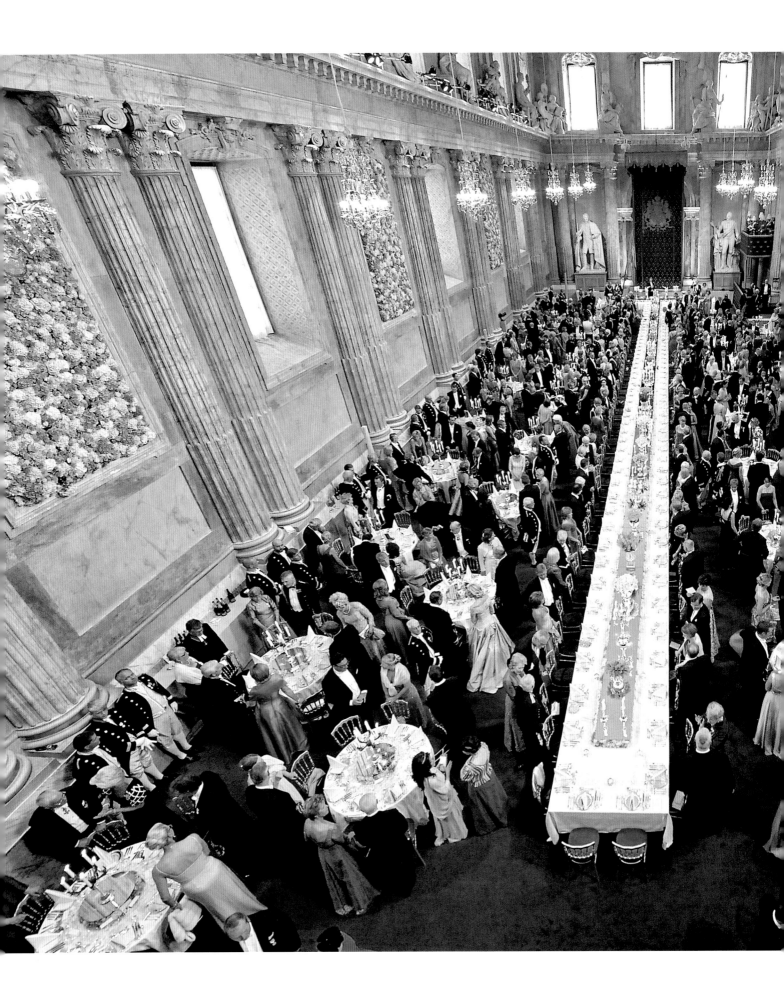

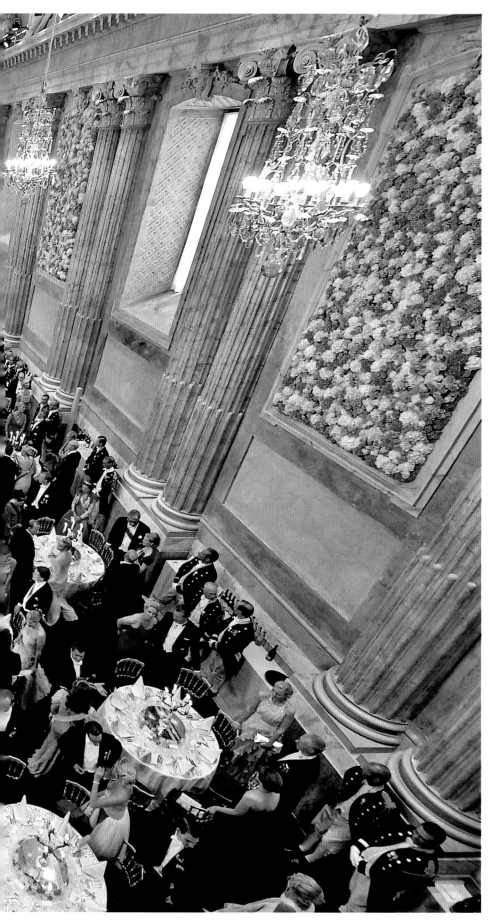

Handarbeit. Die Tafel im Reichssaal des Palastes war vom König höchstpersönlich noch kurz vor dem Bankett kontrolliert worden. Die mehr als einhundert Jahre alte Tischwäsche musste im Anschluss an das Fest in 18 Schritten gewaschen und gemangelt werden und drei Monate kühl lagern, um sie für den nächsten Einsatz wieder in Form zu bringen.

All by hand. Shortly before the banquet the festively decked table was inspected by the king himself. Afterwards the table linen, a hundred years old, had to be washed and mangled in 18 stages and then stored in a cool place for three months to be fit for the next time it would be needed.

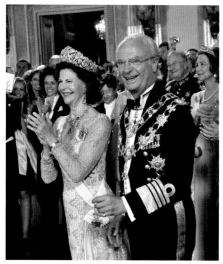

Königlich amüsiert. So ausgelassen wie bei der Hochzeit ihrer ältesten Tochter hat man das Königspaar selten erlebt. Carl Gustaf und Silvia feierten an diesem Tag auch ihren eigenen Hochzeitstag. Sie hatten auf den Tag genau vor 34 Jahren geheiratet. Die Ehe von Victoria und Daniel ist die vierte am schwedischen Königshof, die an einem 19. Juni geschlossen wurde. Doch es ist die erste, bei der ein Mann aus dem Volk in das Königshaus eingeheiratet hat.

Royally amused. The king and queen had rarely been seen so relaxed as at the wedding of their elder daughter. In fact it was Carl Gustaf and Silvia's own wedding anniversary: they had married on that day exactly 34 years earlier. The wedding of Victoria and Daniel was the fourth to be celebrated at the Swedish royal court on a 19 June. But the first on which a man of the people married into the royal house.

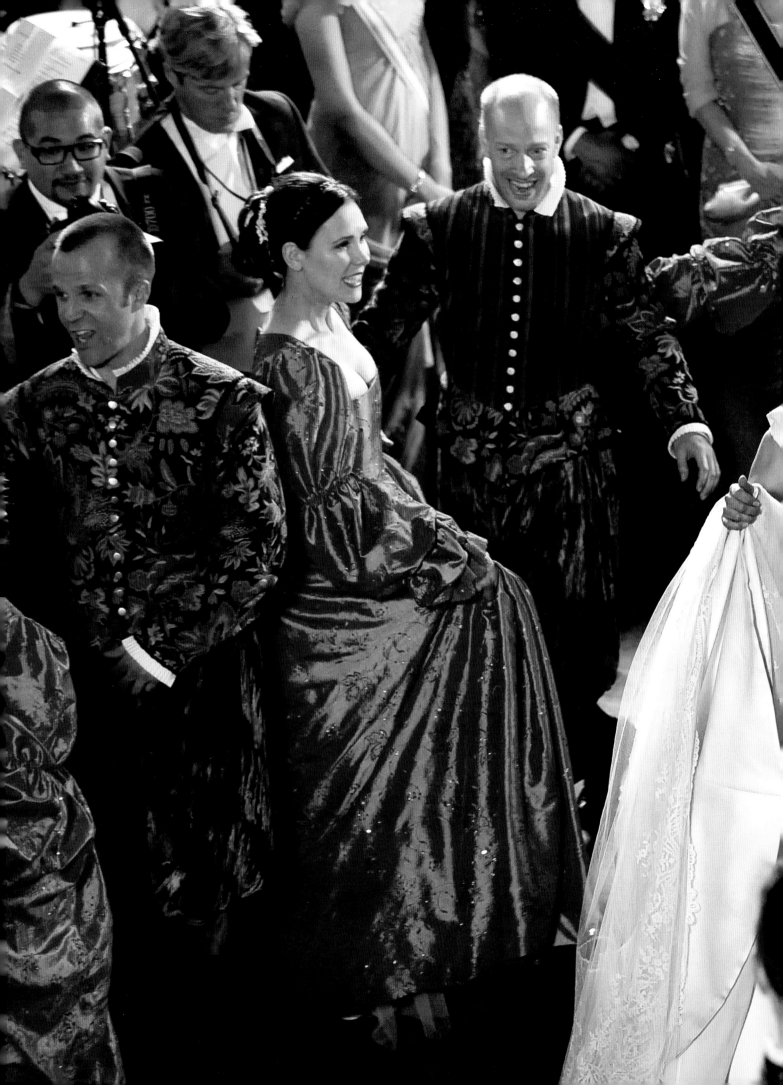

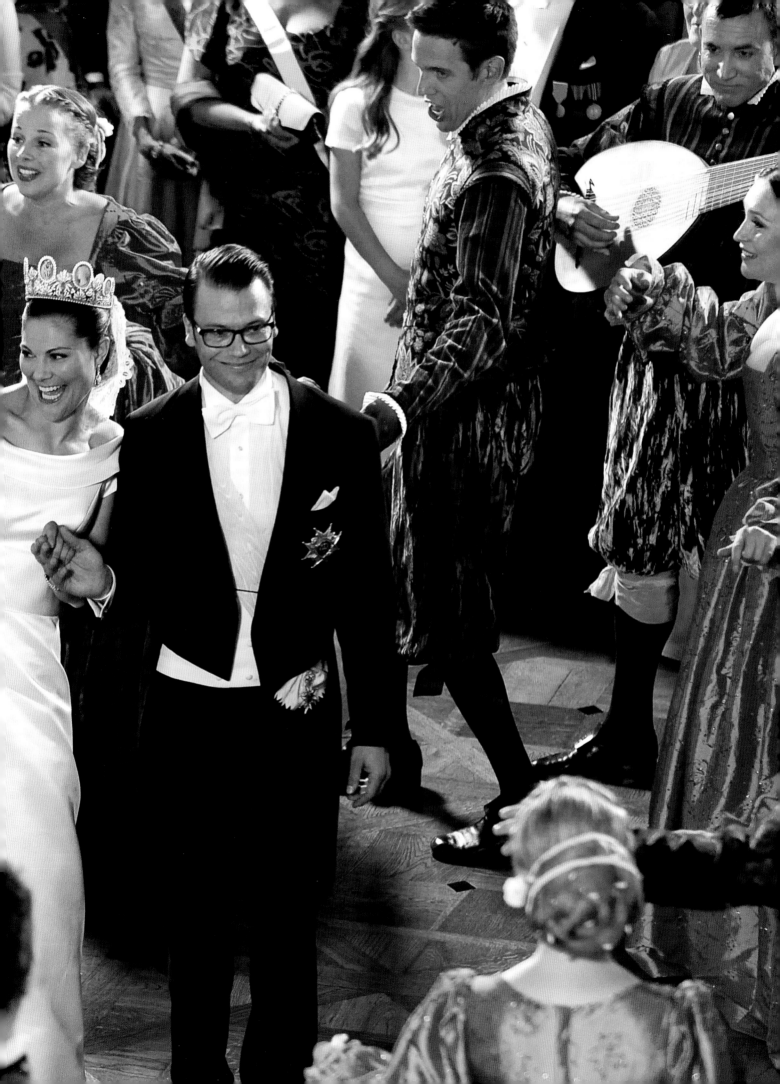

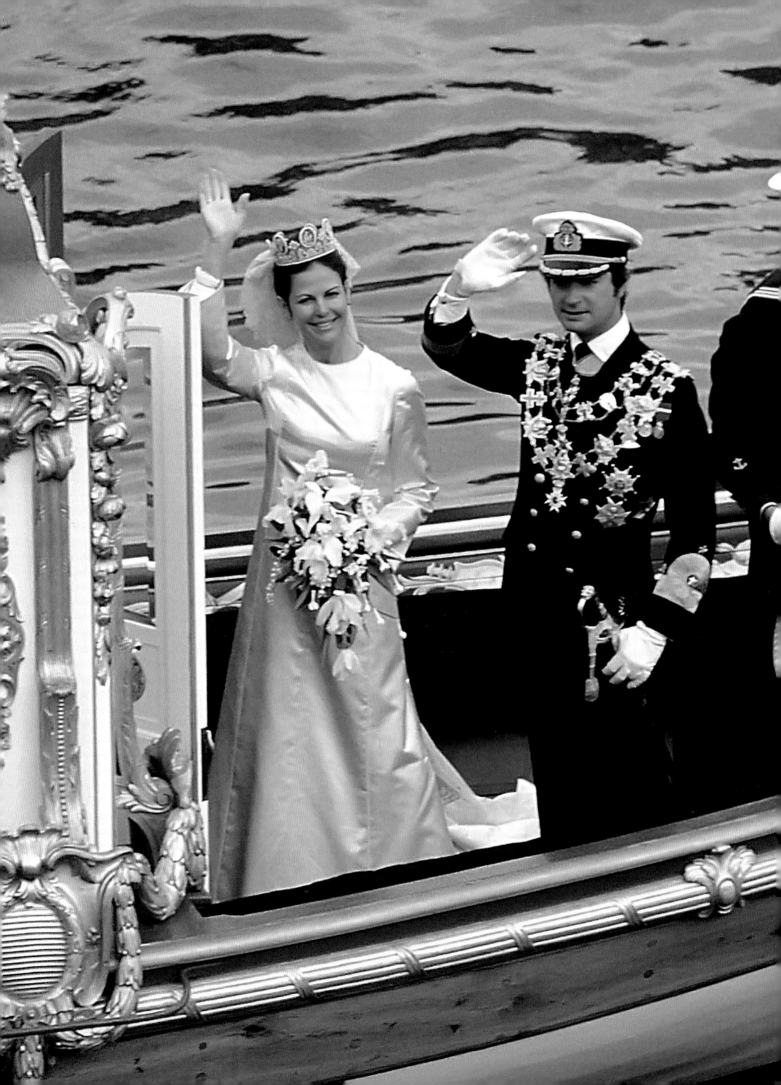

Carl Gustaf & Silvia

Die Hochzeit der Dancing Queen
Schweden, 19. Juni 1976

The Wedding of the Dancing Queen
Sweden, 19 June 1976

Die Überraschung durch Anni-Frid, Benny, Björn und Agnetha war ein voller Erfolg. In historischen Kostümen – die Herren in Strumpfhosen, die Damen im Reifrock – erschienen die Mitglieder der Popgruppe ABBA auf der Bühne der Oper von Stockholm, um dem Brautpaar ihr Geschenk zu machen. Der Auftritt war Teil einer Gala am Vorabend der Hochzeit des schwedischen Königs, bei dem sich die bekanntesten nationalen Künstler ein spezielles Programm überlegt hatten. ABBA widmete der künftigen Königin einen Song, den noch keiner kannte: „Dancing Queen" – das Lied wurde zu einem ihrer größten Hits und eroberte weltweit die Nr. 1 der Charts. König Carl XVI. Gustaf und seine Braut Silvia schütteten sich in ihrer Loge fast aus vor Lachen. Dass die künftige Queen nicht „seventeen" war, wie es in dem Lied heißt, störte niemanden. Bereits der Auftakt zum königlichen Polterabend, der mit einer deutlichen Verzögerung begann, sorgte für Heiterkeit. Bei der sonst so generalstabsmäßigen Planung hatte das Protokoll schlicht übersehen, die Braut abholen zu lassen, die mutterseelenallein im Schloss wartete.

Überhaupt ging alles sehr gelassen zu bei dieser Hochzeit. Dabei war sie für die 1970er Jahre durchaus ungewöhnlich, denn die Auserwählte des Königs war eine Bürgerliche. Bei den Olympischen Sommerspielen 1972 in München war der Blick des damaligen

The surprise sprung by Anni-Frid, Benny, Björn and Agnetha was an unqualified success. In period costumes, the men in tights and women in crinolines, the members of the pop group ABBA appeared on the stage of the Stockholm Opera to present their gift to the bridal couple. Their performance was part of a special gala, on the eve of the king's wedding devised by leading Swedish artists. In honour of the future queen ABBA presented a new song, "Dancing Queen", which became one of their greatest hits and went on to conquer the world at the top of the charts. In their royal box King Carl XVI Gustaf and his bride shook with laughter; nobody minded that the future queen was not "seventeen" as in the song. There had already been some amusement because of the considerable delay in starting the programme. It turned out that the protocol officials, who had planned everything else with military precision, had forgotten to arrange for the bride to be fetched, so she was waiting all on her own at the palace.

In any case this was altogether a very relaxed wedding. For one thing it was highly unusual in the 1970s for the king to have chosen a commoner as his bride. At the Munich Summer Olympics in 1972 the pretty German chief hostess Silvia Sommerlath had attracted the attention of the crown prince of Sweden and it "just clicked", as he ever afterwards explained.

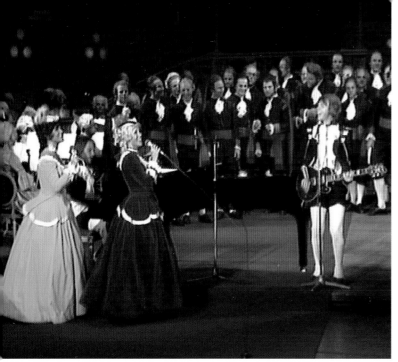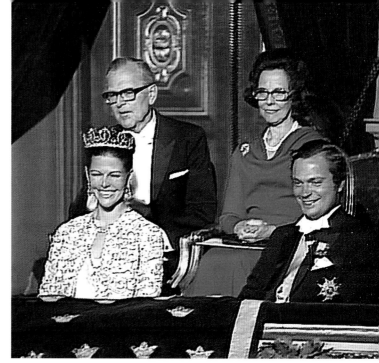

Unbezahlbares Geschenk. An die Uraufführung von „Dancing Queen" zu Ehren des Brautpaars erinnern nur TV-Mitschnitte. „Dancing Queen" ist bis heute ein Discodauerbrenner und mit den Mitgliedern von ABBA verbindet das Königspaar seit diesem Tag eine gute Freundschaft.

Priceless present. Television clips are the only record of the first performance of "Dancing Queen" in honour of the bridal couple. To this day the song is a top favourite at discos and the king and queen have maintained a warm friendship with ABBA ever since.

schwedischen Kronprinzen auf die schöne deutsche Chef-Hostess Silvia Sommerlath gefallen. „Es hat Klick gemacht", hat er diesen Moment später immer wieder beschrieben. Ein hundertfaches „Klick" der Fotokameras begrüßte die beiden vier Jahre später, als sie am 19. Juni kurz vor 12 Uhr vor der Storkyrkan, dem Dom von Stockholm, eintrafen. Silvia trug ein schlichtes, elfenbeinfarbenes Kleid von Designer Marc Bohan aus dem Hause Dior mit einer vier Meter langen Schleppe. Der Brautschleier aus Brüsseler Spitze war bereits seit 120 Jahren im Besitz der Königsfamilie Bernadotte. Der Bräutigam präsentierte sich in Admiralsuniform mit Ordenskette und Säbel und hatte als Hommage an die Heimat seiner Braut das Großkreuz des Verdienstordens der Bundesrepublik Deutschland angelegt.

Langsam schritten die Brautleute den Gang hinunter bis zum Altar. Sogar noch etwas langsamer als gewollt, denn die Blumenkinder zwangen das Brautpaar mit ihren Schrittchen fast zum Gänsemarsch. Erst als der König einen kleinen Blumenträger mit sanftem Nachdruck anschob, ging es etwas schneller voran. Die Gäste in der Kirche, die diese kleine Episode mitbekamen, amüsierten sich königlich. Vor dem Altar ging

Four years later the "click" of hundreds of media cameras greeted them as they arrived shortly before noon on 19 June at the Storkyrkan, Stockholm's cathedral. Silvia wore a simple ivory-coloured dress and train designed by Marc Bohan at Dior. Her veil of Brussels lace had been in the possession of the Bernadotte royal family for 120 years. The bridegroom wore an admiral's uniform with sword and decorations, including, as a tribute to his bride's home country, the Grand Cross of the Order of Merit of the Federal Republic of Germany.

The bridal couple moved at a majestic pace along the aisle to the altar, more majestic than they wanted in fact; the young bridesmaids and pages took their duties seriously and walked so slowly that they almost brought them to a halt. Only when the king gave one of them a gentle push did the pace quicken a little, to the amusement of the congregation. Once at the altar everything went smoothly. Silvia went through the wedding service in fluent Swedish without showing the slightest sign of nerves. At the end of the ceremony the king and new queen of Sweden rode through Stockholm in an open carriage and then on a golden barge to the applause of the crowds. From the very first day Silvia

Majestätisch. Ein Kleid aus dem Hause Dior, ein Strauß mit Orchideen, Jasmin und Maiglöckchen und die mit Kameen besetzte Krone, die seit 1844 Schwedens Königinnen tragen, machten Silvia am Tag ihrer Hochzeit nicht nur per Gesetz zu einer echten Königin.

Majestic. A dress by Dior, a bouquet of orchids, jasmine and lily-of-the-valley and the cameo-adorned crown worn by Sweden's queens since 1844 made Silvia a queen as a person as well as by law.

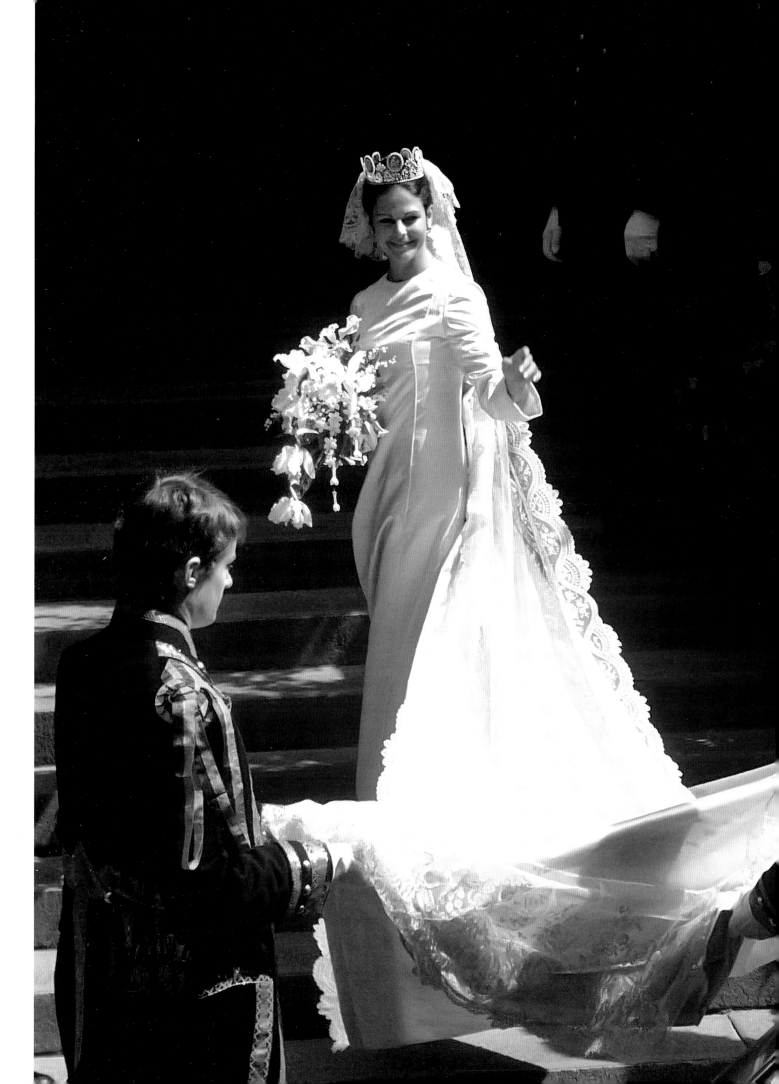

dann alles glatt. Silvia bestand die Trauung in fließendem Schwedisch und zeigte bei alledem keine Anzeichen von Nervosität. Fröhlich ließen sich der König und die neue Königin anschließend in einer offenen Kutsche und auf einer goldenen Barkasse vom Volk bejubeln. Silvia fügte sich vom ersten Tag an perfekt in ihre neue Rolle. Als habe sie nie etwas anderes getan, winkte sie elegant den Untertanen zu und nahm Geschenke und Komplimente mit einem strahlenden Lächeln entgegen.

Der einzige, der den Tag nicht so befreit genießen konnte, war Walther Sommerlath. Traditionsgemäß fiel ihm als Brautvater die Rolle zu, beim anschließenden Bankett eine Rede zu halten, bei der niemand Geringeres als Könige und Staatspräsidenten zu seinem Publikum zählten. Seine nun königliche Tochter tat ihr Bestes, die Nerven des Vaters zu beruhigen. Kurz bevor sich Walther Sommerlath erhob, hatte sie ihm noch ein Zettelchen zugesteckt. „Ich liebe Dich, Papa, Dein Kätzchen", soll da zu lesen gewesen sein.

slipped perfectly into her new role: as if she had never done anything else she waved gracefully to her husband's subjects and accepted presents and compliments with a radiant smile.

The only person who couldn't relax and enjoy the day was Walther Sommerlath. Traditionally it fell on him as the bride's father to make a speech at the banquet, where kings and presidents, no less, would be among his audience. His now royal daughter did her best to calm his nerves. Shortly before he rose to speak she slipped him a note which apparently read: "I love you, Papa. Your little kitten."

Im Mittelpunkt des Interesses. 1 400 geladene Gäste verfolgten die Zeremonie im Dom von Stockholm. Nur 200 Journalisten waren in der Kirche zugelassen worden, obwohl mehr als 1 000 eine Akkreditierung beantragt hatten. Die Trauung nahm Erzbischof Olof Sundby vor, das Oberhaupt der schwedischen Kirche. An seiner Seite assistierte der Leipziger Theologe Ernst Sommerlath, der damals 87-jährige Onkel der Braut.

The centre of interest. 1,400 invited guests attended the ceremony in Stockholm's cathedral. Although over 1,000 journalists had applied for accreditation, only 200 were allowed into the church. The service was conducted by Archbishop Olof Sundby, the head of the Swedish church, assisted by the 87-year-old Leipzig theologian Ernst Sommerlath, uncle of the bride.

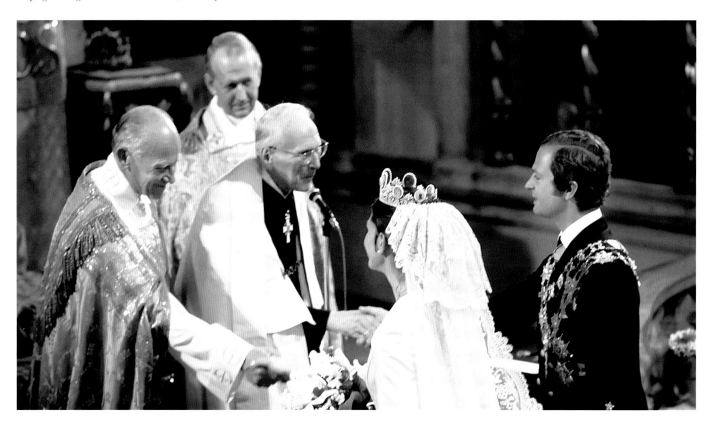

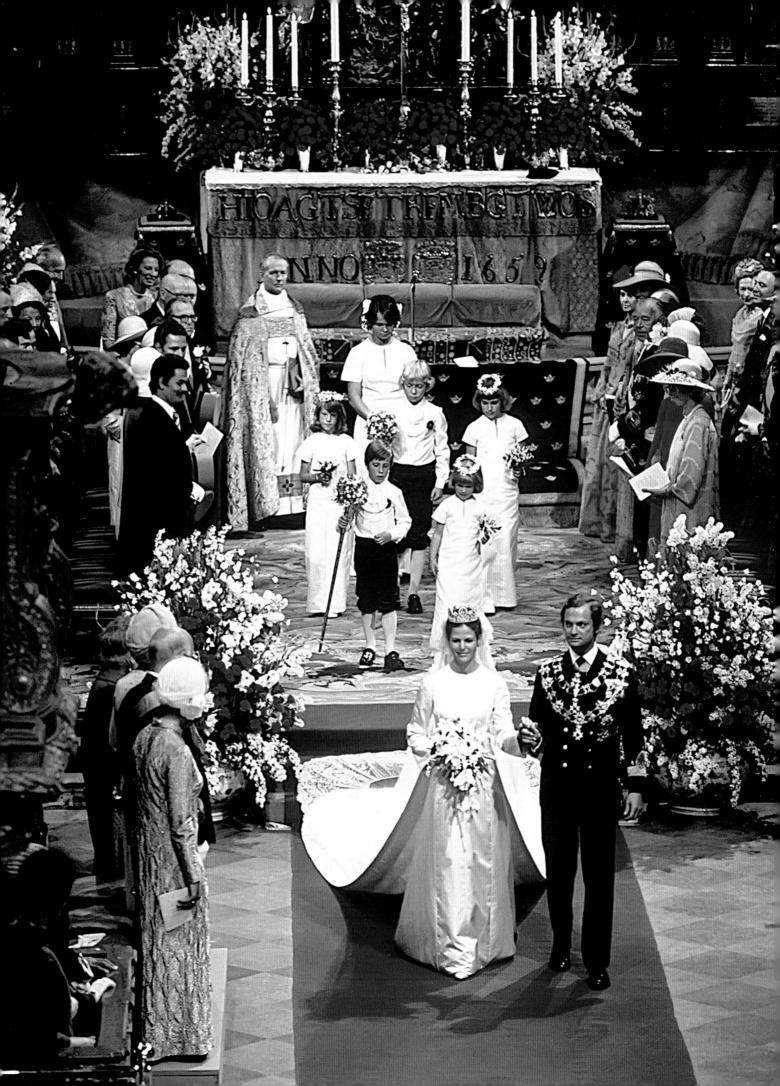

Ungeduldig. Da der offizielle Ritus keinen Kuss vor dem Altar vorsah, der Bräutigam aber auch nicht warten wollte, bis er mit seiner Braut auf dem Schlossbalkon stand, küsste er sie heimlich und beinahe unentdeckt am Kirchenausgang.

Impatient. The order of service didn't provide for a kiss at the altar but the bridegroom didn't want to wait until he stood with his bride on the balcony, so he kissed her privately and almost unobserved as they left the church.

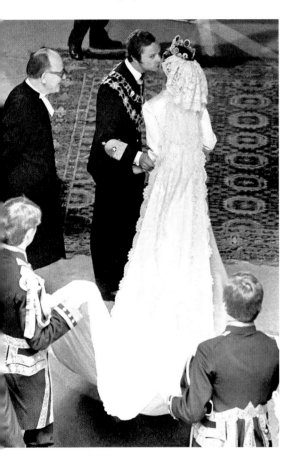

Wertvoller Import. Mit Königin Silvia schnellten die Beliebtheitswerte der bis dahin in Schweden durchaus umstrittenen Monarchie in die Höhe und sind bis heute sehr hoch geblieben. Geschätzte 1,5 Millionen Euro kostete das Hochzeitsfest, das dem Königshaus soliden Rückhalt im Volk verschaffte.

A valuable import. With Silvia the popularity of the Swedish monarchy, then at a low ebb, soared, and has remained at a high level ever since. An estimated one and a half million euros was spent on the wedding celebrations, which have provided the royal house with solid backing among the population.

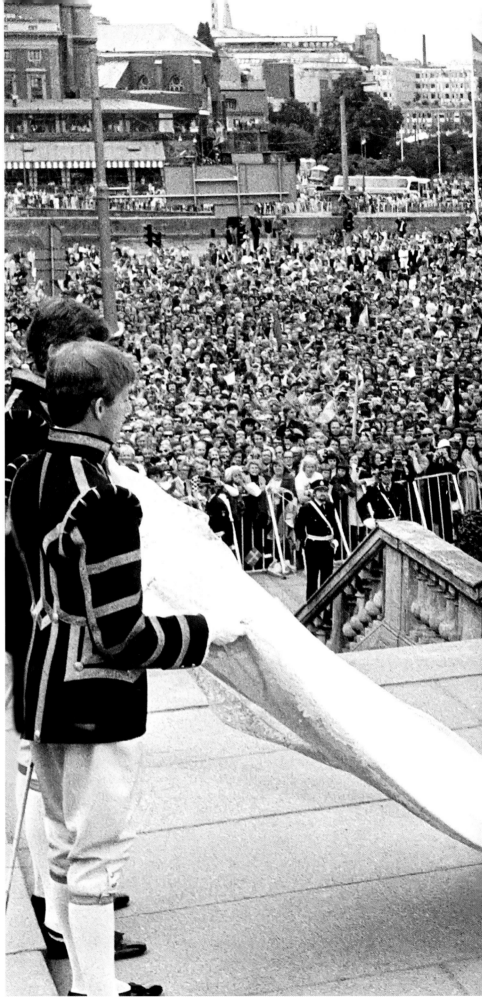

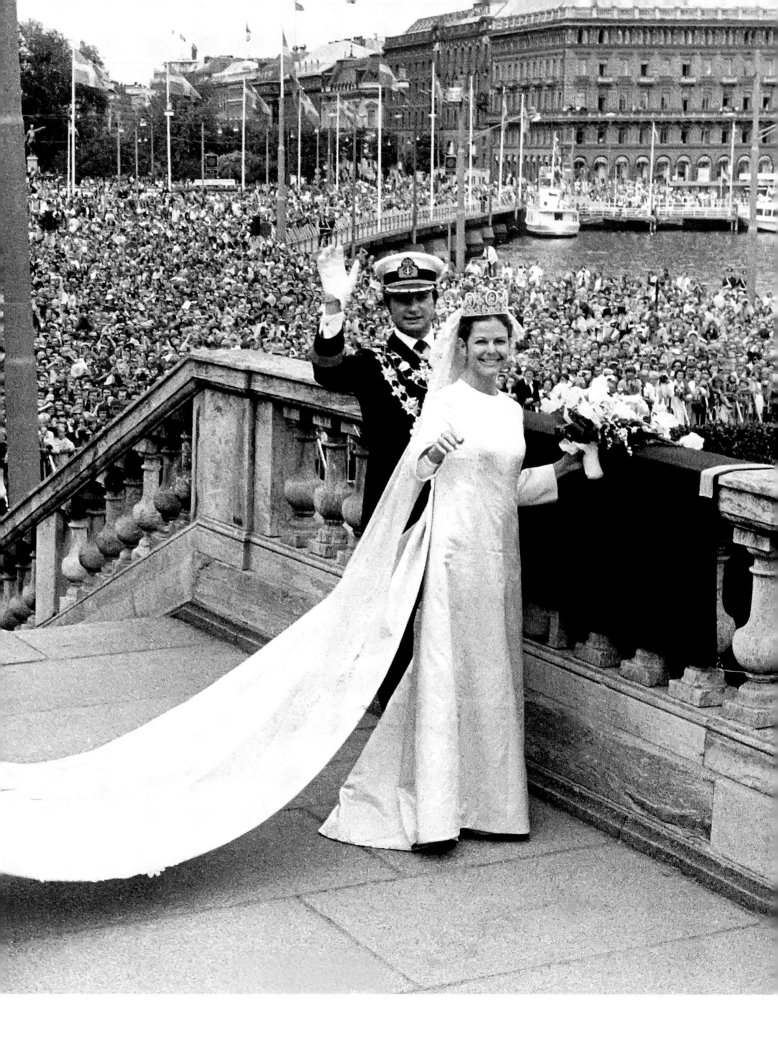

Praktisch. Auf Anraten ihrer Mutter hatte Silvia unter ihrem rechten Ärmel mit einem Gummiband ein Taschentuch befestigt, falls sie bei der Zeremonie doch die Rührung überkommen sollte. In der Aufregung vergaß sie das kleine Provisorium, das nun auf allen Fotos der winkenden Braut zu sehen ist.

Practical. On the advice of her mother, Silvia had used a rubber band to secure a handkerchief under her right sleeve, in case she was overcome by emotion during the ceremony. In the excitement she forgot that it was there so that it was clearly visible on the photographs that showed the bride waving.

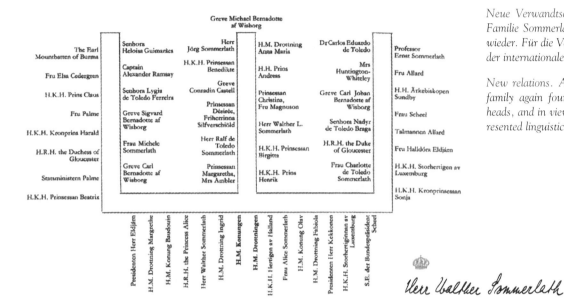

Neue Verwandtschaft. Beim Bankett fand sich Familie Sommerlath inmitten gekrönter Häupter wieder. Für die Verständigung war in Anbetracht der internationalen Gäste Sprachtalent gefragt.

New relations. At the banquet the Sommerlath family again found themselves among crowned heads, and in view of the many nationalities represented linguistic talent was much in demand.

Herr Walther Sommerlath

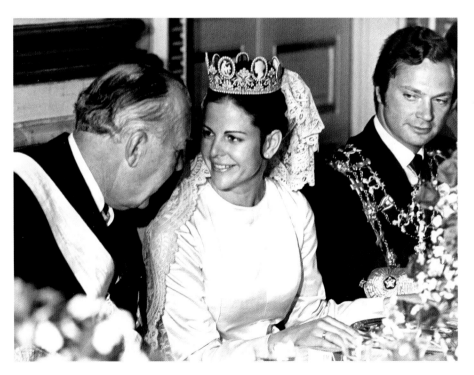

Väterlicher Freund. Prinz Bertil, der Onkel des Königs, hatte Carl Gustaf bei der Wahl seiner Braut den Rücken gestärkt. Die Verfassung hatte ihm selbst die Ehe mit seiner bürgerlichen Liebe Lilian jahrzehntelang verwehrt. Noch im gleichen Jahr konnte er sie endlich heiraten.

Fatherly friend. Prince Bertil, the king's uncle, had supported Carl Gustaf's choice of bride. Under the constitution he had been prevented for decades from marrying his commoner fiancée Lilian and now at last he was allowed to do so.

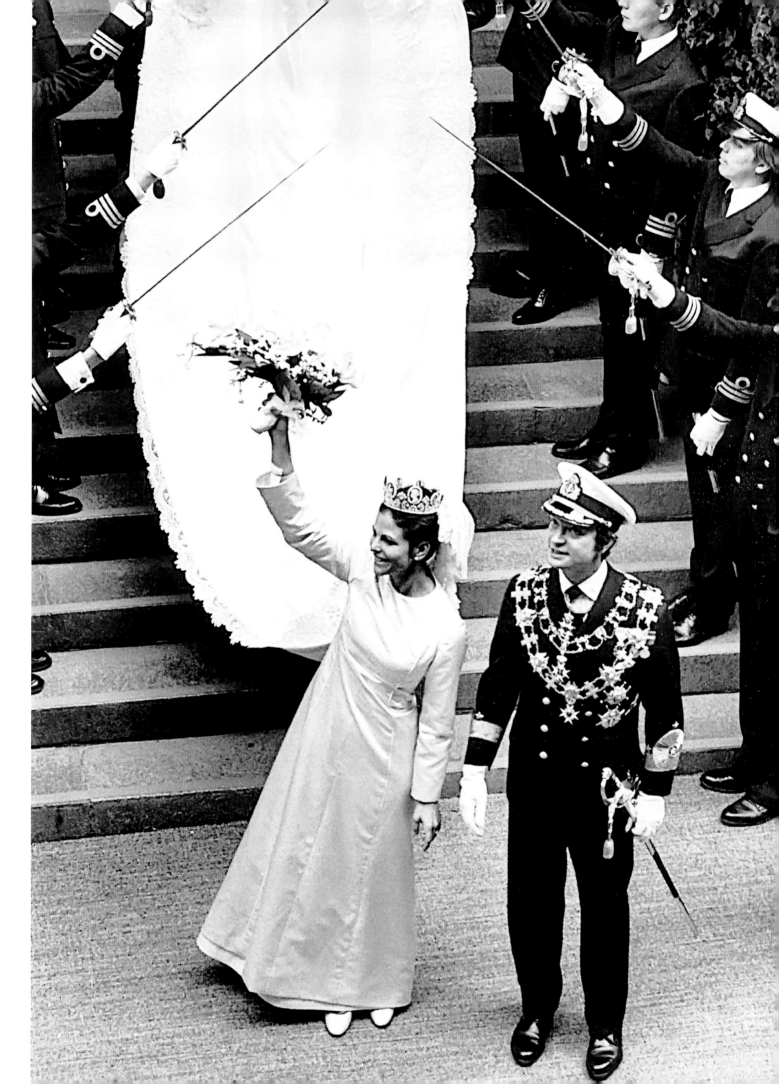

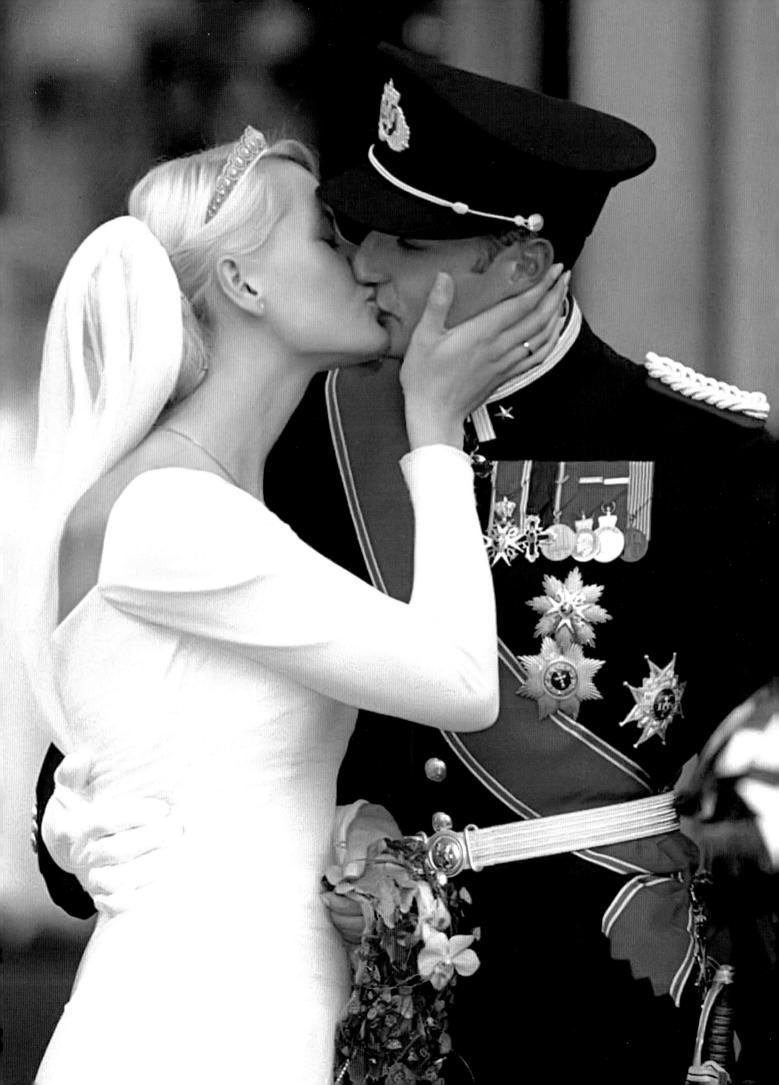

Haakon & Mette-Marit

Der Sieg der Liebe
Norwegen, 25. August 2001

Triumph of Love
Norway, 25 August 2001

Sie boten ein ungewöhnliches Bild: Der norwegische Thronfolger, Kronprinz Haakon, seine frisch angetraute Frau, Kronprinzessin Mette-Marit, und auf deren Arm der kleine blonde Junge, ihr Sohn Marius. Vier Jets der norwegischen Luftwaffe hatten mit donnerndem Überflug den Auftritt des Brautpaars auf dem Balkon des Königsschlosses von Oslo angekündigt. Um 18:55 Uhr brandete frenetischer Jubel auf, als das Paar den Kleinen hochnahm. Haakon hatte sich für eine bürgerliche, alleinerziehende Mutter entschieden und die ganze Nation stand hinter ihm!

Was diese Hochzeit ausmachte, war nicht der Pomp. Es war einfach die Liebe dieses Paares, die bezauberte. Ihr Balkonkuss zählt sicherlich zu den schönsten in der Geschichte der royalen Hochzeiten. Als wären sie ganz allein, legte Mette-Marit ihrem Mann vor Millionen Fernsehzuschauern zärtlich die Hand an die Wange und küsste ihn lang und innig. Hinter den Brautleuten lag der Großteil eines Tages, den die beiden ganz nach ihren Wünschen gestaltet hatten. Mette-Marit und Haakon hatten sich ein modernes Fest gewünscht, das nicht im Ballast der Traditionen ersticken sollte. Sie suchten persönlich die Musik für die kirchliche Trauung aus, zogen entgegen den Gepflogenheiten gemeinsam in den Dom ein und luden zum abendlichen Ball auch 50 Norweger aus dem Volk,

It was certainly a most unusual sight: Crown Prince Haakon of Norway and his newly married bride, Crown Princess Mette-Marit, and on her arm a small blonde-haired boy, her son Marius. Their appearance on the balcony of the royal palace in Oslo had been heralded by four jet planes from the Norwegian Air Force thundering overhead, and at 6.55 p.m. a roar of approval burst out as the couple held up the little boy. Haakon had chosen a commoner and single mother as his bride and the whole country stood behind him.

What made this wedding so special was not the pomp but simply the obvious love of the young couple: their kiss on the balcony was certainly one of the most romantic in the history of royal weddings. As if they were quite alone, before millions of television viewers Mette-Marit laid a hand tenderly on her husband's cheek and gave him a long and intimate kiss. So far the day had proceeded just as they had wished. Mette-Marit and Haakon had wanted a modern ceremony not weighed down by the burden of tradition. So they themselves chose the music for the church wedding, broke with tradition by entering the cathedral together and invited 50 ordinary Norwegians to the evening ball at the palace, including some on welfare benefits and former drug addicts. Their unconventional approach was also a gesture of gratitude to a nation which

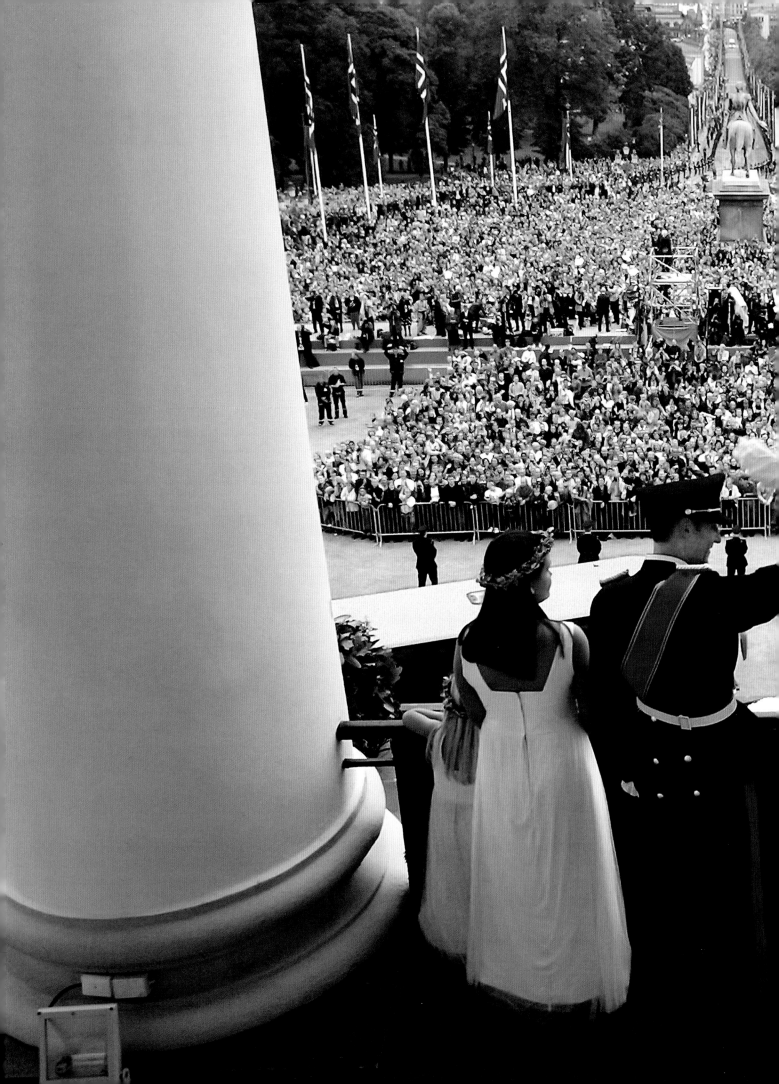

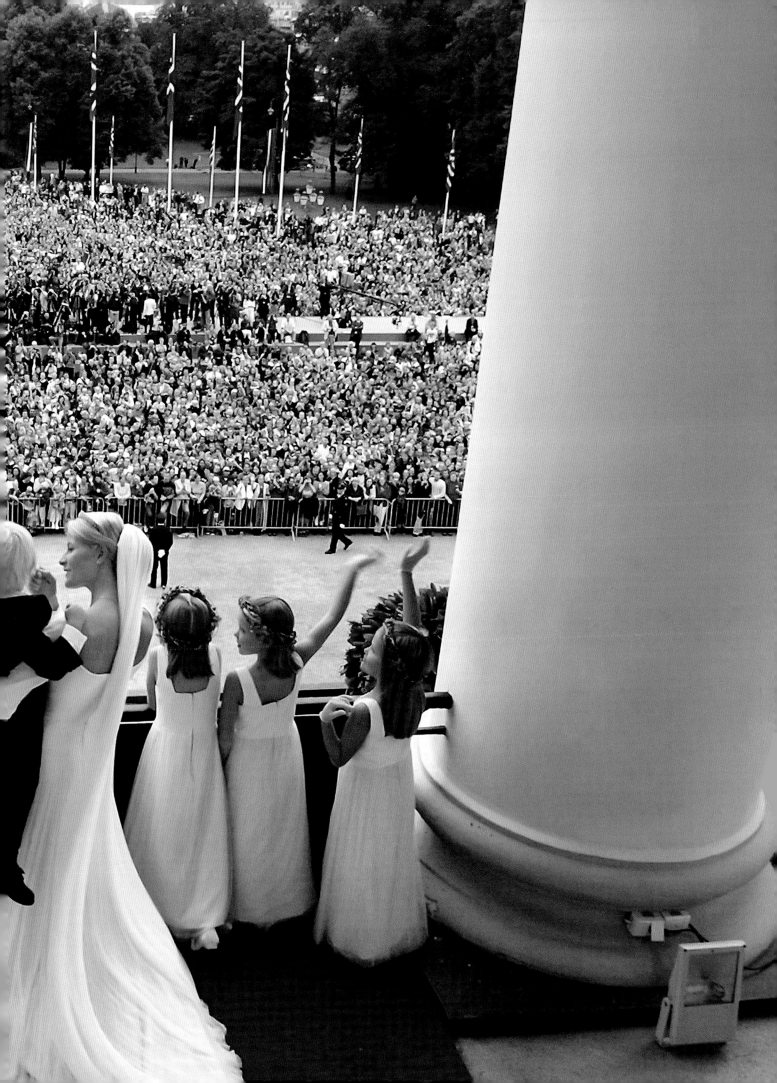

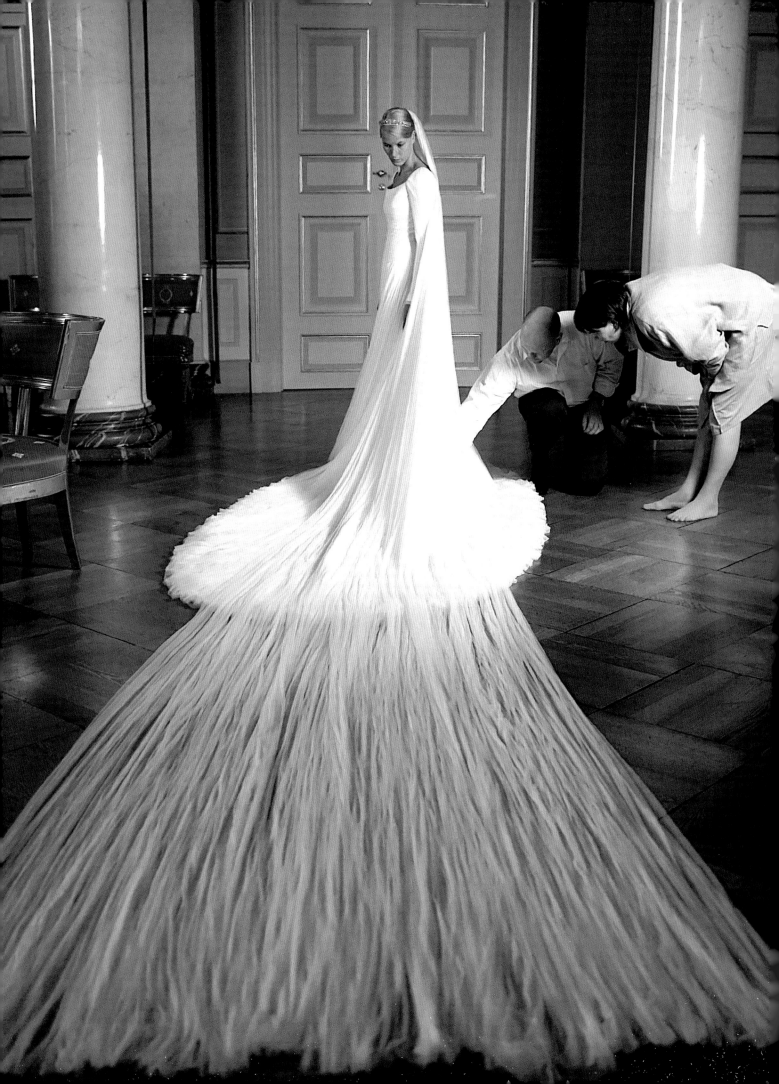

Moderne Prinzessin. Das Brautkleid von Mette-Marit bestach durch die schlichte Eleganz, mit der die Designer 110 Meter Seide verarbeitet hatten. Trotz des langen Schleiers würde sich die Braut problemlos durch den langen Festtag bewegen können. Als die künftige Kronprinzessin am Morgen angekleidet wurde, gelang Schwiegermutter Königin Sonja dieser fröhliche Schnappschuss.

A modern princess. Mette-Marit's wedding dress was all the more striking for the elegant simplicity of the design, created from over 350 feet of white silk. In spite of its generous veil the bride was able to move in it effortlessly throughout the long day of festivities. This informal snapshot was taken by her future mother-in-law, Queen Sonja, while the bride was being dressed in the morning.

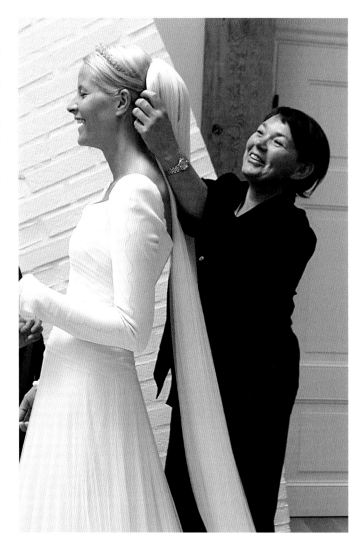

darunter Sozialhilfeempfänger und ehemalige Drogen abhängige. Die Art und Weise, in der das Paar feierte, war auch eine Verneigung vor einem Volk, das „Ja" gesagt hatte zu einer selbst für ein so liberales Land wie Norwegen außergewöhnlichen Brautwahl seines künftigen Königs.

„Ihr habt nicht den Weg des geringsten Widerstands gewählt, aber die Liebe hat gesiegt", sagte Bischof Gunnar Stålsett in seiner Predigt. Tatsächlich war die Liebe von Haakon und Mette-Marit lange Zeit auf die Probe gestellt worden. Zu groß erschien der gesellschaftliche Unterschied zwischen dem Königsspross und der modernen jungen Frau. Auch ihr unehelicher Sohn wollte nicht so recht in die Welt des europäischen Hochadels passen. Rückhalt fand Haakon bei seinen Eltern, die Mette-Marit ins Herz geschlossen und seine Entscheidung zu keiner Zeit in Frage gestellt hatten. Am 1. Dezember 2000 verkündete der Hof die Verlobung des Paares – doch die norwegische Öffentlichkeit

in the end had accepted its future king's choice of a bride which was unusual even in a country as liberal as Norway.

"You didn't take the easy way out," said Bishop Gunnar Stålsett in his sermon, "but love has triumphed." Haakon and Mette-Marit's love had in fact been put to the test for a considerable time. The gap in social status between the royal prince and the modern young woman seemed too wide, and her illegitimate son was likely to be unacceptable to the higher rank of the European aristocracy. But Haakon was supported by his parents, who had grown fond of Mette-Marit and at no time questioned his decision. On 1 December 2000 the court finally announced the couple's engagement, but the Norwegian public were not happy, particularly as further rumours, photos and videos of Mette-Marit's past life began to emerge.

Three days before the wedding she gave a press conference to face her critics, admitting her "extravagant

blieb skeptisch, zumal immer wieder neue Gerüchte, Fotos oder Videos aus Mette-Marits Vorleben auftauchten.

Drei Tage vor der Hochzeit stellte sich Haakons Braut in einer Pressekonferenz den Vorwürfen. Sie bekannte sich zu ihrer „ausschweifenden Vergangenheit" und stellte tapfer fest, dass sie ihre Biografie nicht ändern könne, aber durch ihre Erfahrungen stärker und gefestigter sei. Es fiel ihr sichtlich schwer, die Fassung zu wahren, doch ihre Offenheit wurde belohnt. Eine Welle der Sympathie ging durch Norwegen und in Oslo

past" and confessing bravely that although she could not unmake it, her experience had made her stronger and more stable. She was clearly close to tears but her frankness was rewarded: a wave of sympathy surged through Norway and in Oslo joyful preparations began for the biggest celebration for years.

Hundreds of thousands of spectators watched the ceremony on big screens in the streets of Oslo, many of them wearing the Norwegian national costume and improvised crowns. At the market in front of the town

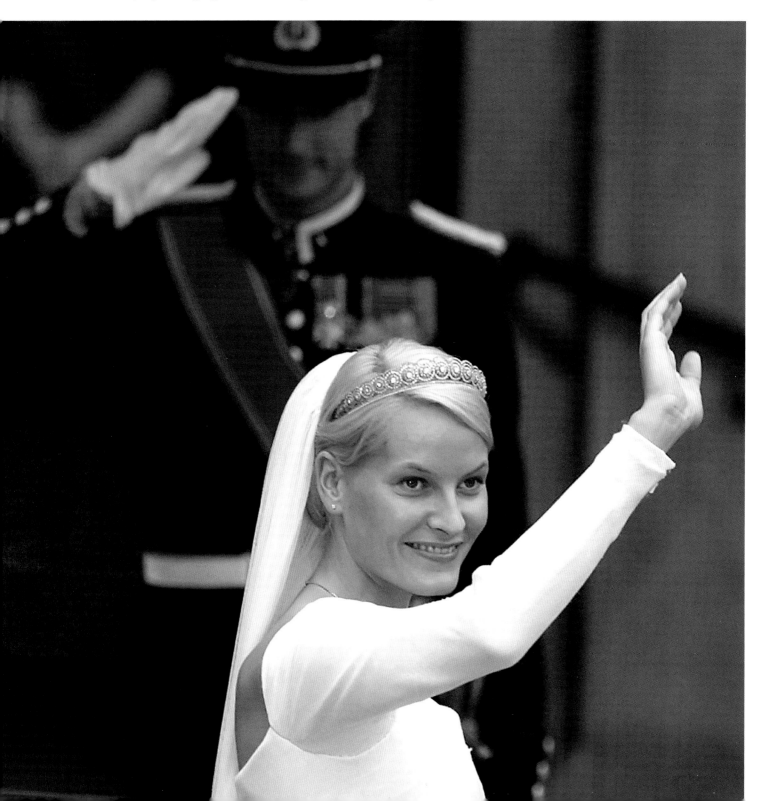

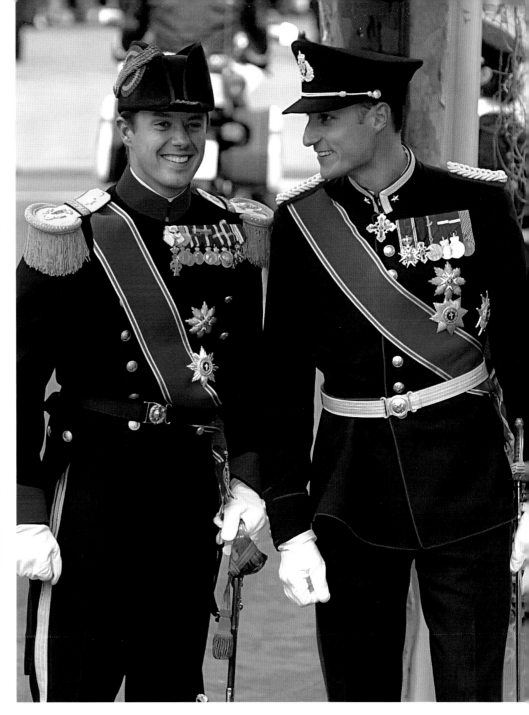

Außerordentlich. Um 16·50 Uhr traf der Bräutigam gemeinsam mit Kronprinz Frederik von Dänemark unter dem Applaus der Zuschauer an der Kirche ein. Haakon trug die Traditionsuniform des norwegischen Heeres, sein Trauzeuge Frederik eine Admiralsuniform. An Orden fehlte es beiden Thronfolgern nicht.

Princely splendour. To the cheers of the spectators, the bridegroom arrived at the church at 4.50 p.m. accompanied by his best man, Crown Prince Frederik of Denmark. Both princes wore impressive rows of medals.

Souverän. Als die Braut die Kirche erreichte, steigerte sich der Jubel vor der Kirche zu hysterischem Kreischen. Mette-Marit winkte entspannt, ihr Bräutigam salutierte respektvoll vor seiner künftigen Frau.

Perfectly composed. As the bride arrived, the cheers outside the church rose to hysterical heights. Mette-Marit, serene and smiling, waved to the crowd while the bridegroom saluted.

bereitete man sich nun uneingeschränkt begeistert auf das größte Fest seit Jahrzehnten vor.

Hunderttausende verfolgten in den Straßen Oslos auf Großleinwänden den Traugottesdienst. Viele waren in norwegischer Tracht gekommen und trugen selbst gebastelte Kronen auf dem Kopf. Auf dem Rathausmarkt gab es für umgerechnete zehn Euro sogar das Hochzeitsmenü für das Volk zum Probieren: Jakobsmuscheln, Steinbutt und Lammfilet. Allerdings wurde hier nicht ganz stilecht auf einem Plastikteller serviert. Vornehmer ging es da schon beim abendlichen Galadiner im Schloss zu. 400 geladene Gäste wurden Zeugen einer der ergreifendsten öffentlichen Liebeserklärungen, die je ein Prinz an seine Braut gerichtet hat.

hall, for the equivalent of ten euros, people could even sample food from the wedding dinner menu – scallops, turbot and fillet of lamb – though on plastic plates instead of porcelain. The gala dinner at the palace in the evening was a grander occasion, where 400 invited guests heard one of the most moving declarations of love a prince has ever made to his bride.

Wie der Vater, so der Sohn. Erst nach neun Jahren hatte König Harald seine Sonja heiraten dürfen, da sein Vater gegen die Ehe mit einer Bürgerlichen sein Veto eingelegt hatte. Seinem Sohn wollte das Königspaar keine Steine in den Weg legen. Auch bei Tochter Märtha Louise, die am Hochzeitstag ihres Bruders die Lesung vortrug, gab das Königspaar seine Zustimmung zur Heirat mit dem bürgerlichen Schriftsteller Ari Behn.

Like father, like son. King Harald too had had to wait nine long years for his beloved Sonja before his father agreed to his marriage with a commoner, so they were certainly not going to stand in their son's way. Their daughter Märtha Louise, who read the lesson at her brother's wedding, had also been allowed to marry a commoner, the writer Ari Behn.

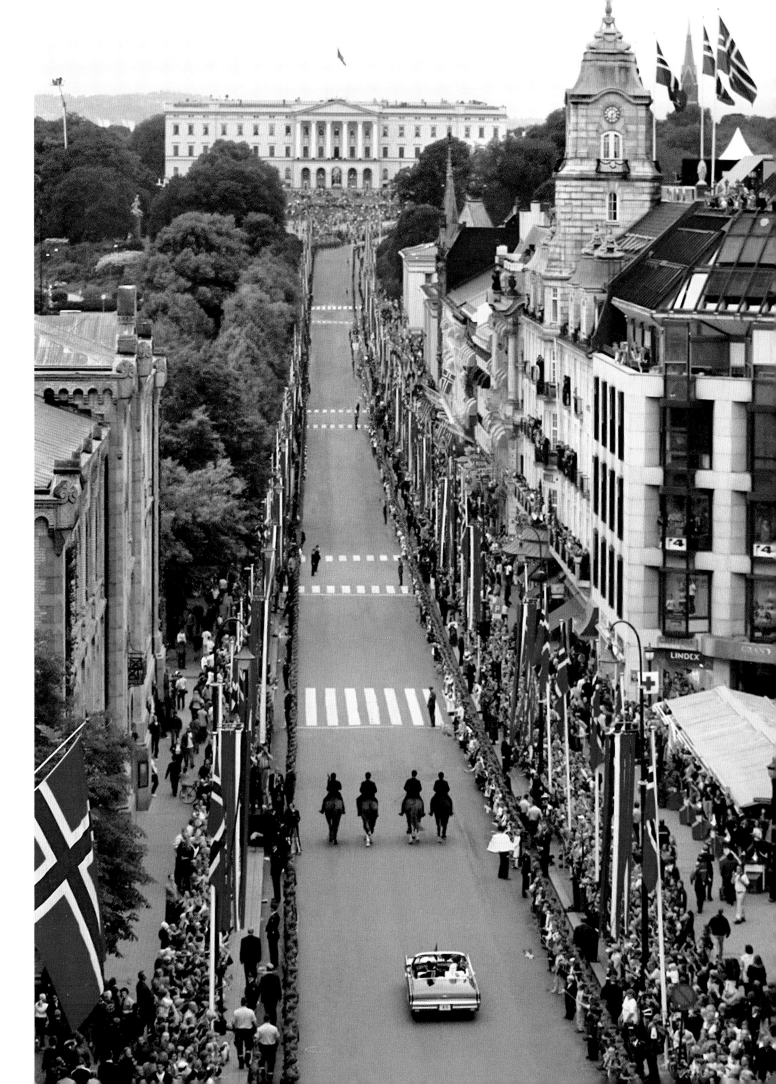

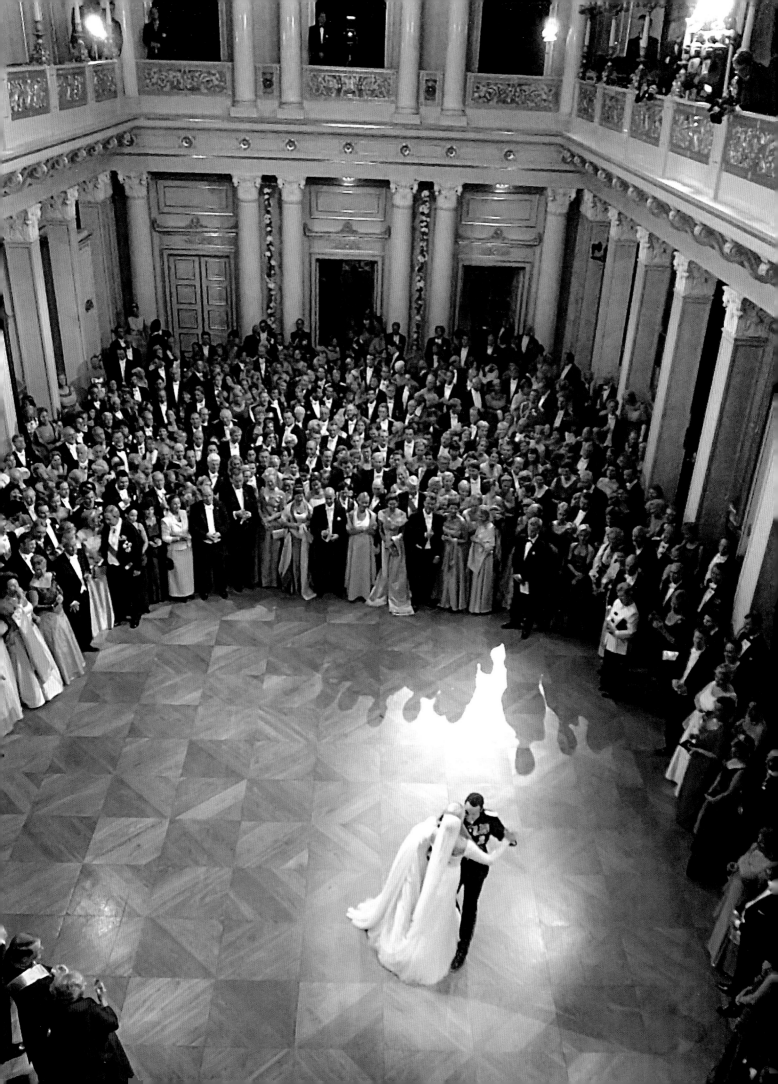

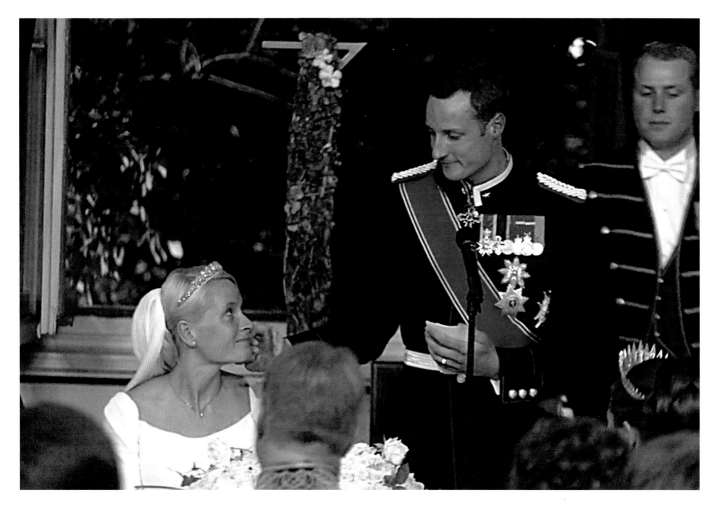

Leichtfüßig. Der innige Brautwalzer von Haakon und Mette-Marit krönte einen gelungenen Festtag. Erst um 1:30 Uhr verabschiedete sich das Paar und entschwand mit der königlichen Yacht „Norge" in die Flitterwochen Richtung Dänemark. Dort allerdings legte das Schiff ohne die frisch Vermählten an. Unbemerkt von der Presse waren Mette-Marit und Haakon entwischt und nach New York geflogen. Als ganz normales Liebespaar, ohne jeglichen Pomp und royale Verpflichtungen.

Graceful. The last act of a long and happy day of festivities came with Haakon and Mette-Marit's loving bridal waltz. Not until 1.30 a.m. did they leave the ball, to begin their honeymoon on the royal yacht "Norge" bound for Denmark. But on arrival there the ship docked without them: unknown to the press they had slipped away to New York like any ordinary couple, free of all royal ceremony and restraints.

Kronprinz Haakon von Norwegen, Auszug aus der Tischrede:

Liebe Mette-Marit,

in Deiner Seele lodert es. Du bist sensibel, leicht zu begeistern, detailorientiert, manchmal teilnahmslos, brennend engagiert, temperamentvoll, couragiert, unergründlich. Du kannst abwehrend sein oder resolut. Du hast eine gehörige Portion Humor und ein großes und warmes Herz. Ich glaube nicht, jemals auf jemanden so wütend gewesen zu sein wie auf Dich. Ich glaube nicht, jemals so schwach oder jemals so stark gewesen zu sein wie mit Dir zusammen. Ich glaube nicht, jemals mit so viel Liebe erfüllt gewesen zu sein wie an Deiner Seite. Danke für Deine Liebe und für alles, was Du getan hast. Ich bin stolz, mich Dein Ehemann nennen zu dürfen.
Mette-Marit, ich liebe Dich!

Extract from Crown Prince Haakon's speech at the wedding dinner:

Dear Mette-Marit,

You have an effervescent soul. You are sensitive, easily delighted, interested in detail, sometimes indifferent, sometimes passionately engaged, vivacious, brave and inscrutable. You can be defensive or determined. You have a notable sense of humour and a warm and generous heart. I don't think I have ever been so furious with anyone as with you. I don't think I have ever been so weak or so strong as with you. I don't think I have ever felt so full of love as at your side. Thank you for your love and for all that you have done. I am proud to call myself your husband.
Mette-Marit, I love you!

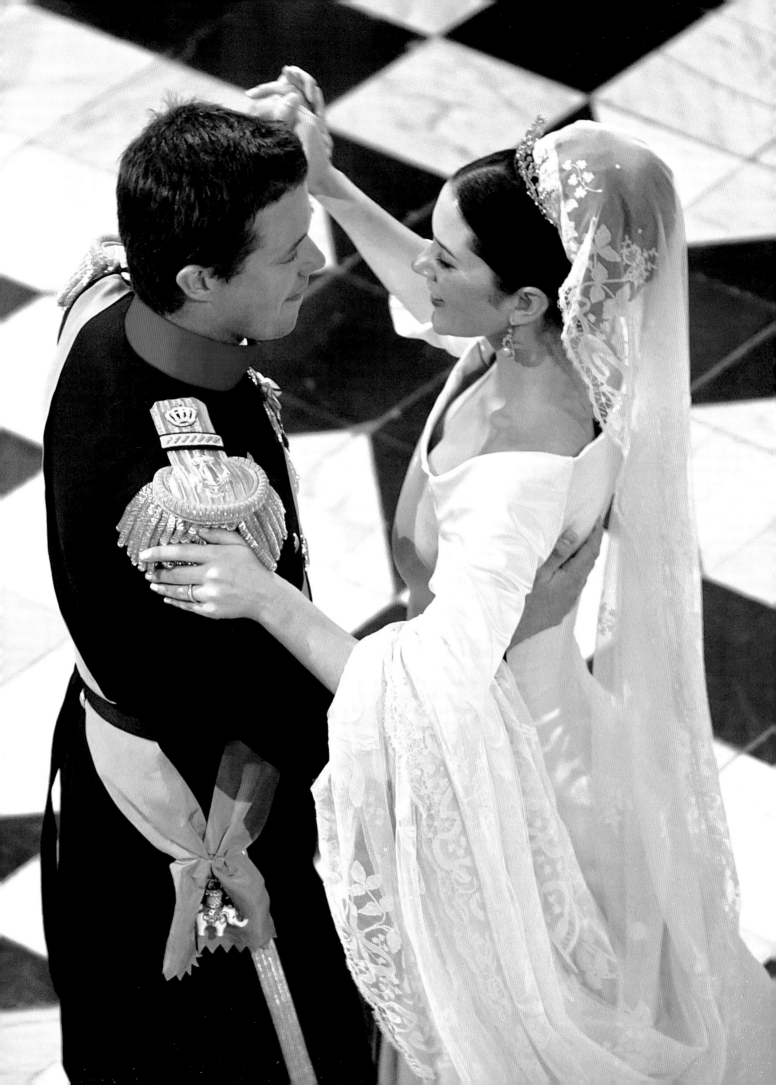

Frederik & Mary

Die romantische Hochzeit
Dänemark, 14. Mai 2004

The Romantic Wedding
Denmark, 14 May 2004

Nur ganz selten darf die Öffentlichkeit wirklich in das Herz eines Prinzen schauen. Frederik von Dänemark ließ es an seinem Hochzeitstag zu: Als sich um 16:15 Uhr das Portal der Kopenhagener Frauenkirche öffnete und Mary Donaldson am Arm ihres Vaters hereintrat, hielt der Thronfolger seine Freudentränen nicht zurück. Tatsächlich bot die Braut einen atemberaubenden Anblick. Sie trug ein betont schlichtes Seidenkleid, für das sie sich die Farbe Perlmuttweiß ausgesucht hatte. Sechs Meter erstreckte sich die Schleppe hinter ihr, in ihren Händen hielt sie einen Brautstrauß mit eingewobenem Eukalyptus, eine Hommage an ihre Heimat Australien. Denn die Liebe dieses Paares hatte bereits Kontinente überwunden. Der Thronfolger hatte Mary vier Jahre zuvor bei den Olympischen Sommerspielen in Sydney kennengelernt. Dass „Fred aus Dänemark", wie sich der Kronprinz schnörkellos vorgestellt hatte, noch ein bisschen mehr war, erfuhr die damals 28-jährige erst später.

Pünktlich um 15:30 Uhr war Frederik mit seinem Bruder Joachim vor der Kirche aus dem Wagen gestiegen und vom frenetischen Jubel der Untertanen begrüßt worden. Er trug eine Galauniform der dänischen Marine mit hellblauer Schärpe, die Brust mit zahlreichen Orden geschmückt. Stolze 45 Minuten musste er dann vor dem Altar ausharren. Und dennoch strahlte Frederik,

It is not often that the public is allowed to look deep into the heart of a prince, but on his wedding day Frederik of Denmark gave them the opportunity. As at 4.15 p.m. the door of the Copenhagen Church of Our Lady swung open to admit Mary Donaldson on the arm of her father, the crown prince made no attempt to hold back his tears of joy. The bride did indeed present a breathtaking picture. She had chosen a deliberately simple dress in mother-of-pearl silk and an embroidered veil. A 20-foot train spread out behind her and she carried a bouquet which included eucalyptus in honour of her native Australia. For the love of these two had already spanned continents: the heir to the throne had met Mary four years before at the Sydney Summer Olympics. That "Fred from Denmark", as he had then introduced himself, was rather more than that, she only learnt later.

Punctually at 3.30 p.m. Frederik and his brother Joachim stepped out of the car before the church and were greeted by wild applause from his future subjects. He wore a dark blue gala uniform of the Danish navy with a light blue sash and decorations. Then for all of 45 minutes he had to wait at the altar for his bride. Yet he beamed, chatting and joking with his brother while the church gradually filled with the crowned heads of Europe. Even Crown Prince Felipe of Spain and his

Familienbande. Marys Nichten vor ihrem Einsatz als Blumenkinder. Auch Frederiks Neffe und der Sohn von Freunden beugten sich dem Protokoll.

Family ties. Mary's nieces before stepping out as bridesmaids. Frederik's nephew and the son of friends bowed to the demands of protocol.

schwatzte und scherzte mit seinem Bruder, während sich die Kirche nach und nach mit den gekrönten Häuptern Europas füllte. Sogar Kronprinz Felipe von Spanien und seine Verlobte Letizia hatten sich die Zeit genommen, obwohl ihre eigene Hochzeit eine Woche später bevorstand. Als letzte erschienen Königin Margrethe und ihr Mann, Prinz Henrik. Währenddessen schwoll der Jubel vor der Kirche zu hysterischem Kreischen an: Der Rolls Royce mit der Braut näherte sich. Frederik atmete tief durch und dann schmolz er dahin – der Mann, der in den drei Gattungen der dänischen Armee ausgebildet ist und am Knöchel das Tattoo der Kampf-

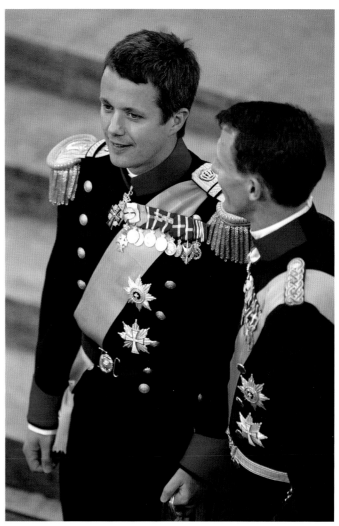

Geschwisterliebe. Während Marys Schwestern die Rolle der Brautjungfern übernahmen, stand Prinz Joachim seinem Bruder als Trauzeuge zur Seite. Die Kleiderfarben für die Brautjungfern hatten Mary und Königin Margrethe ausgesucht. Joachim erschien in der Galauniform der Infanterie.

Brothers and sisters. Mary's sisters were the older bridesmaids, Prince Joachim his brother's best man. Mary and Queen Margrethe had chosen the colour of the bridesmaids' dresses and Joachim wore the gala uniform of the Danish Infantry.

fiancée Letizia Ortiz had found time to come, although their own wedding was to take place only a week later. Last of all appeared Queen Margrethe and her husband, Prince Henrik. Meanwhile the cheers in front of the church had risen to hysterical heights; the bride's Rolls Royce was approaching. Frederik took a deep breath and then gave way to his emotions – and this was the man who had been drilled in all three arms of the Danish forces and bore on his ankle the tattoo of the Danish Frogman Corps. Gracefully Mary walked the last few steps to the altar. Apparently she had practised for days in advance, stealing into the church at seven in the

47

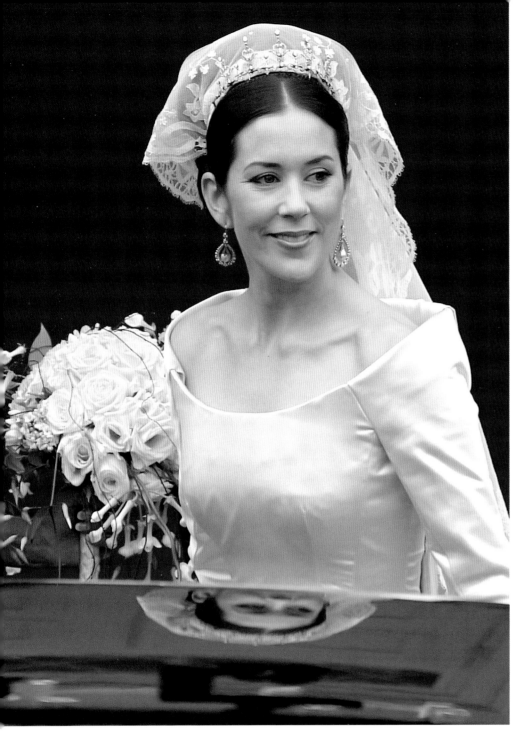

schwimmer trägt. Graziös schritt Mary die letzten Meter bis zum Altar. Tag für Tag, so heißt es, habe sie diesen Gang geübt. Sie sei stets um 7 Uhr morgens in die Kirche gehuscht, am Saum eines Kleides habe sie lange Lederriemen befestigt, um sich an das Gewicht der Schleppe zu gewöhnen.

Auch als sich das Brautpaar schon gesetzt hatte, kämpfte Prinz Frederik noch mit den Tränen. Erst im Verlauf der Zeremonie fand er langsam seine Fassung wieder. Als um 16:46 Uhr der entscheidende Moment da war, kam sein „Ja" laut und bestimmt. Ihres ein wenig zarter, aber nicht weniger überzeugt. Mit dem Hochzeitskuss wartete das verliebte Paar nicht einmal, bis es

morning with long leather strips attached to the hem of her dress to accustom her to the weight of her bridal train.

Even after the couple had taken their seats in the church, Prince Frederik was still battling with tears and only in the course of the service did he gradually regain his composure. When at 4.46 p.m. the decisive moment came his "Yes" was loud and determined, hers a little softer but equally determined. They didn't even wait to leave the church before exchanging the usual kiss – when on the way out a short stop was made to adjust the bride's train, Frederik kissed her on the lips. An open carriage escorted by a guard of hussars brought

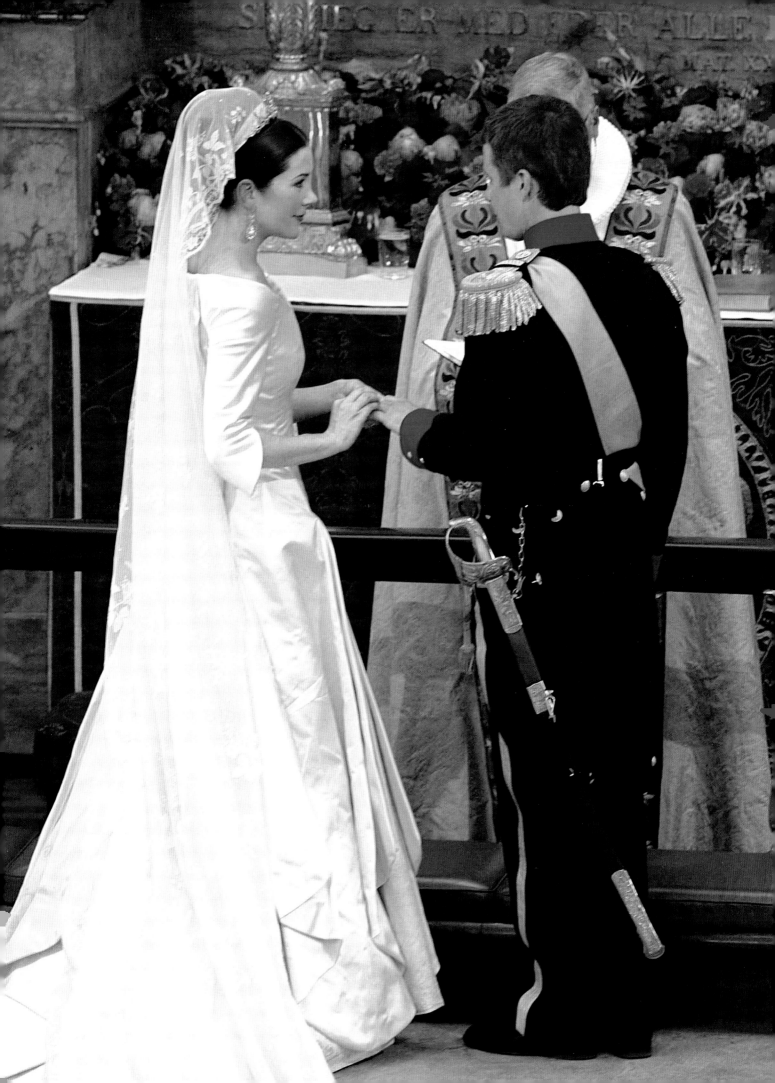

Rejoicing. Frederik's marriage was the first of a Danish crown prince to be celebrated in Copenhagen since 1743. So the interest of the Danes and their efforts to give the couple original presents were correspondingly enthusiastic. A special gift came from the just under 60,000 subjects of the Danish crown in Greenland; a few weeks earlier a first small quantity of gold had been discovered there and was then used to make the wedding rings. Mary was also presented with a pair of sealskin trousers. Danish farmers, too, made their contribution, on the day of the wedding they refrained from fertilising their fields so that no unpleasant smell should assail the noses of the bridal couple and their guests.

die Kirche verlassen hatte. Als beim Auszug ein kleiner Stopp gemacht wurde, um die Schleppe des Brautkleids zu richten, küsste Frederik seine Mary einfach beherzt auf den Mund. Eine von Gardehusaren eskortierte, offene Kutsche brachte die frisch Vermählten quer durch die Stadt zu Schloss Amalienborg. Etwa eine Million Menschen winkten ihnen bei ihrer Fahrt durch die Stadt zu und bejubelten den offiziellen Hochzeitskuss auf dem Schlossbalkon mit einem dreifachen „Hurra!".

the newly married couple through the town to the Amalienborg Palace. Perhaps a million people applauded them on their way through the town and greeted the official wedding kiss on the balcony with three cheers.

432 guests, nobility, friends and celebrities like Roger Moore had been invited to the wedding dinner at Fredensborg Palace. For the kitchen staff the evening presented an enormous challenge: 4,000 glasses were used, and 1,600 solid silver plates in the posses-

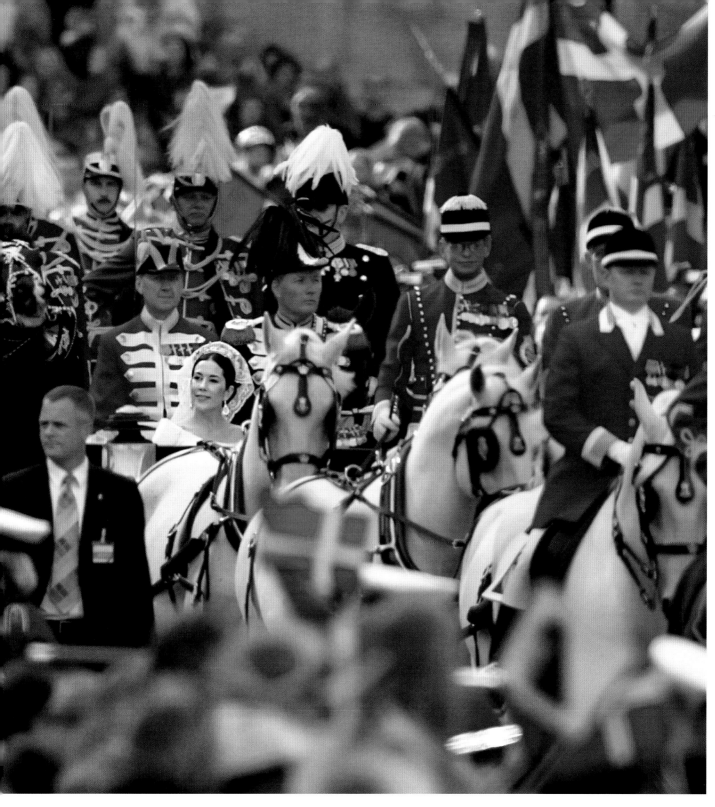

432 Aristokraten, Freunde und Prominente wie Roger Moore waren zum Hochzeitsfest in Schloss Fredensborg geladen. Auch für das Küchenpersonal war der Abend eine gigantische Herausforderung. 4 000 Gläser wurden benutzt und 1600 Teller aus massivem Silber, die seit Jahrhunderten zum königlichen Haushalt Dänemarks gehören. Am Tisch des Brautpaars wurde sogar von purem Gold gegessen. Eine geschlagene Woche, so die Hofsprecherin später, habe es gedauert, allein das Besteck von Hand zu spülen und zu polieren.

sion of the Danish royal household for hundreds of years. Plates at the bridal couple's table were of solid gold. The court spokeswoman later said that it had taken a whole week to wash and polish the cutlery by hand.

Ereignisreiche Tage: Für Mary und Frederik begannen die Hochzeitsfeierlichkeiten bereits zehn Tage vor der eigentlichen Trauung

Mittwoch, 5. Mai 2004: Eröffnung der Festwoche am Tag der Nationalen Verteidigung. Ehrung des Kronprinzen und der zukünftigen Kronprinzessin durch die dänischen Streitkräfte zu Lande, zu Wasser und in der Luft.

Wednesday, 5 May 2004: opening of the festive week on National Defence Day. The Danish land, sea and air forces salute the crown prince and future crown princess.

Freitag, 7. Mai 2004: „Rock 'n' Royal". Wohltätigkeitskonzert vor 40 000 Fans im Nationalstadion Parken zu Ehren des Brautpaars. Die beliebtesten dänischen Musiker traten auf, aus Australien war die Band Powderfinger eingeflogen worden. Als Höhepunkt der Veranstaltung sangen die Besucher für das Brautpaar „Den jeg elsker, elsker jeg" – „Wen ich lieb', den liebe ich".

Friday, 7 May 2004: "Rock 'n' Royal". Charity concert for 40,000 fans in honour of the bridal couple at the Parken National Stadium. Popular Danish musicians performed and the band Powderfinger was flown in from Australia. The climax of the concert was the song sung by the audience for the bridal couple: "Den jeg elsker, elsker jeg" – "The one I love, I love".

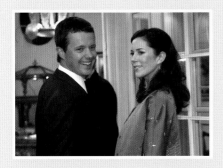

Samstag, 8. Mai 2004: Einladung des Generalgouverneurs von Australien zum Abendessen im Hotel Fredensborg Store Kro. Als Geschenk erhielt das Brautpaar 18 Bäume aus Marys Heimat – sechs von jeder Sorte: Huon-Pinie, Schnee-Eukalyptus und Mostgummi-Eukalyptus.

Saturday, 8 May 2004: dinner given by the Governor-General of Australia at the Fredensborg Store Kro Hotel. As a wedding present the couple were given 18 trees from Mary's homeland, six each of Huon pine, snow gum and cider gum.

Sonntag, 9. Mai 2004: Segelregatta im Hafen von Kopenhagen. Tausende Zuschauer verfolgten das Rennen zweier Boote, die von jeweils einer dänischen und einer australischen Crew unter Führung von Braut und Bräutigam gesegelt wurden. Marys Sieg nahm Frederik gelassen.

Sunday, 9 May 2004: regatta in Copenhagen Harbour. Thousands of spectators watched a race between two boats, one captained by Frederik with a Danish crew and the other by Mary with an Australian one. That Mary won didn't seem to worry Frederik.

Eventful days: for Frederik and Mary festivities began ten days before the actual wedding

Dienstag, 11. Mai 2004: Offizielles Dinner für 350 Staatsgäste im Schloss Christiansborg. Traditionell wird Gästen des dänischen Königshauses Wein von Prinz Henriks Familiengut Château de Caïx im französischen Cahors ausgeschenkt. Für diesen Abend gab es gar die Sonderabfüllung „Cuvée Speciale du Mariage Cahors".

Tuesday, 11 May 2004: official dinner for 350 guests at Christiansborg Palace. By tradition guests of the Danish royal family are served wine from Prince Henrik's family vineyard, Château de Caïx in Cahors in France. For this evening there was a special vintage, "Cuvée Speciale du Mariage Cahors".

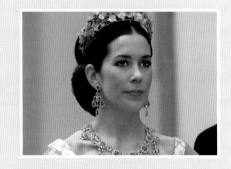

Mittwoch, 12. Mai 2004: Empfang des Brautpaars im Rathaus von Kopenhagen. Am Abend lud das Brautpaar Freunde und die junge Generation der Royals zu einer Warm-up-Party in den Lille Vega Club von Kopenhagen ein.

Wednesday, 12 May 2004: the bridal couple are received in Copenhagen Town Hall. In the evening Frederik and Mary give a warming-up-party for friends and the younger royals at the Lille Vega Club in Copenhagen.

Donnerstag, 13. Mai 2004: Empfang des Brautpaars im dänischen Parlament und Gala im Königlichen Theater. Es traten unter anderem ABBA-Pianist Benny Anderson und das John-Neumeier-Ballett auf. Den „Brautwalzer" aus dem Stück „Et Folkesagn" von Niels W. Gade tanzten zwei Solisten des Königlichen Balletts in Kostümen, die Königin Margrethe selbst entworfen hatte.

Thursday, 13 May 2004: the bridal couple are received in the Danish Parliament; Gala at the Royal Theatre. The programme included the John Neumeier Ballet and pianist Benny Anderson of ABBA. Two soloists of the Royal Ballet danced the "Bridal Waltz" from the play "Et Folkesagn" by Niels W. Gade in costumes designed by Queen Margrethe.

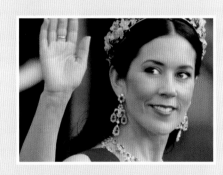

Freitag, 14. Mai 2004: Hochzeit von Kronprinz Frederik von Dänemark und Mary Donaldson. 16:00 Uhr: Trauungszeremonie in der Kathedrale von Kopenhagen 17:00 Uhr: Kutschfahrt durch die Stadt zu Schloss Amalienborg 17:40 Uhr: Das königliche Brautpaar zeigt sich auf dem Balkon des Palastes 20:00 Uhr: Hochzeitsbankett auf Schloss Fredensborg

Friday, 14 May 2004: wedding of Crown Prince Frederik of Denmark and Mary Donaldson. 4 p.m.: wedding ceremony at Copenhagen Cathedral 5 p.m.: drive in royal carriage through the town to Amalienborg Palace 5.40 p.m.: the bridal couple appear on the balcony of the palace 8 p.m.: wedding banquet at Fredensborg Palace

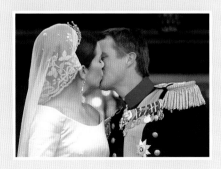

Großer Tag für ein kleines Königreich. Die Untertanen hatten aus Anlass der Festlichkeiten an diesem Freitag frei und somit die Gelegenheit, ihrem Kronprinzenpaar beim Balkonauftritt zuzujubeln. Und wer mochte, konnte den Tag noch beim „Hochzeitsbier" der Carlsberg-Brauerei ausklingen lassen, die eine spezielle Mixtur aus tasmanischem Hopfen und Malz vom königlichen Gut Schackenborg anbot.

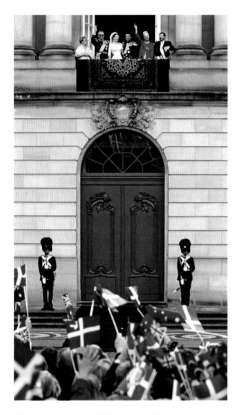

Big day for a small kingdom. To mark the celebrations the populace had been given a public holiday, so they were able to cheer their crown prince and princess when they appeared on the balcony. Anyone who so wished could wind up the day with a glass of "wedding beer" at the Carlsberg Brewery, which had brewed a special mixture of Tasmanian hops with malt from the royal farm at Schackenborg.

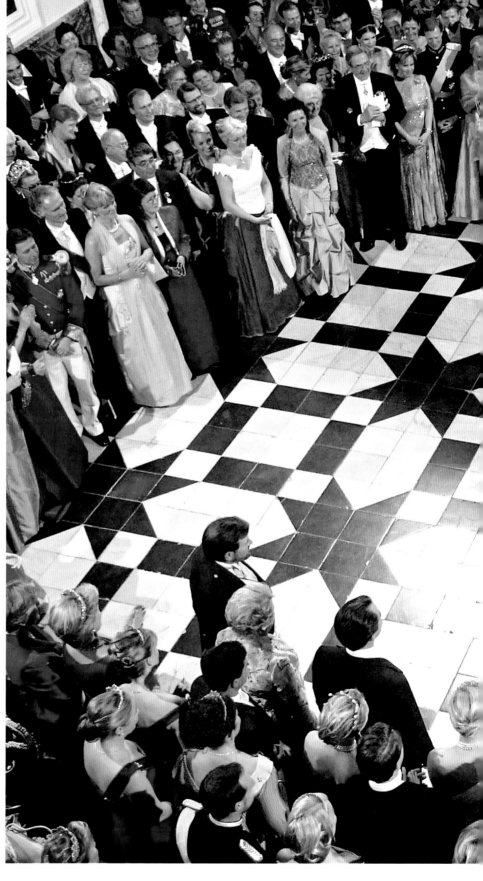

Herz im Dreivierteltakt. Die Gäste im Kuppelsaal von Schloss Fredensborg erfreuten sich am Brautwalzer, den das Paar auf die in Dänemark bei diesem Anlass traditionelle Melodie „Eine Volkssage" tanzte. Frederik war das Glück anzumerken, das er an diesem Abend inmitten seiner Familie und der übrigen Gäste empfand. Nicht immer war sein Verhältnis zu den Eltern ungetrübt gewesen. Öffentlich hatte sich der Kronprinz über die emotionale Kälte am Königshof während seiner Kindheit beklagt. Doch heute war alles vergessen. „Wir wissen, wie Du Dein wahres Ich gefunden hast: Es geschah, als Du Deine Mary getroffen hast. Es wurde Frühling in Deinem Herzen", sagte Königin Margrethe in ihrer Tischrede. Nach einem Feuerwerk war für das Kronprinzenpaar ein Feiermarathon beendet, bei dem es geschätzte 5 000 Hände geschüttelt und mehr als 1 000 Wangenküsse erwidert hatte.

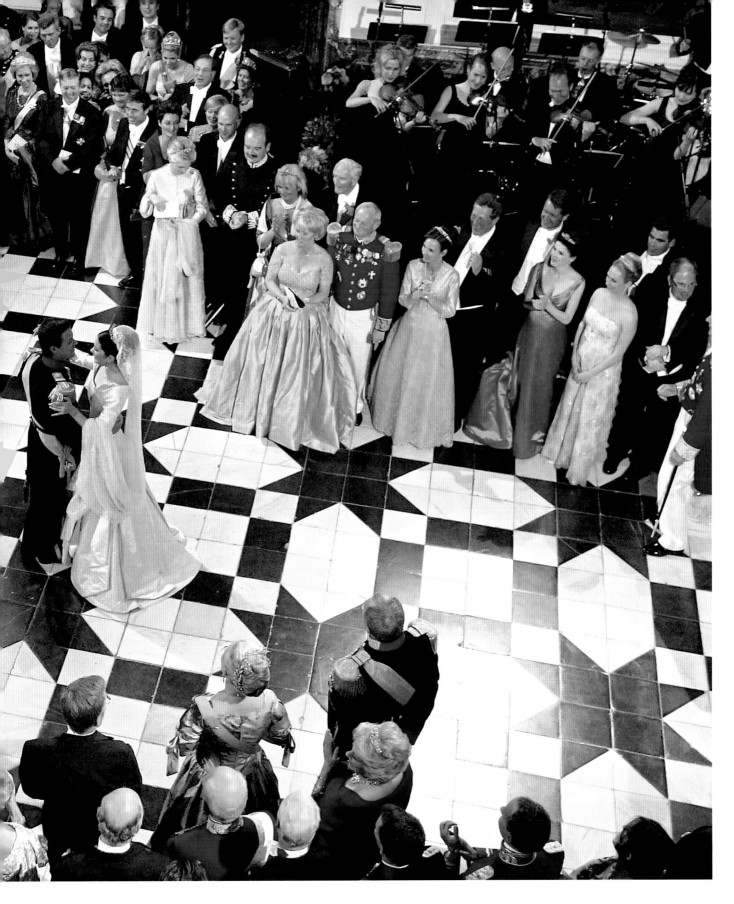

Hearts in rhythm. Guests in the ballroom of Fredensborg Palace look on while the couple, following tradition, dance the wedding waltz to the tune of "A Folk Tale". Frederik's relationship with his parents had not always been untroubled, he had publicly complained of the emotional coldness of his childhood at the court, but on that evening he was obviously happy among his family and friends. All was forgotten. "We know very well how you have found your true self," said Queen Margrethe in her speech at the banquet, "that happened when you met Mary. It brought springtime into your heart." A fireworks display marked the end of ten long days, over which the couple had shaken some 5,000 hands and kissed over 1,000 cheeks.

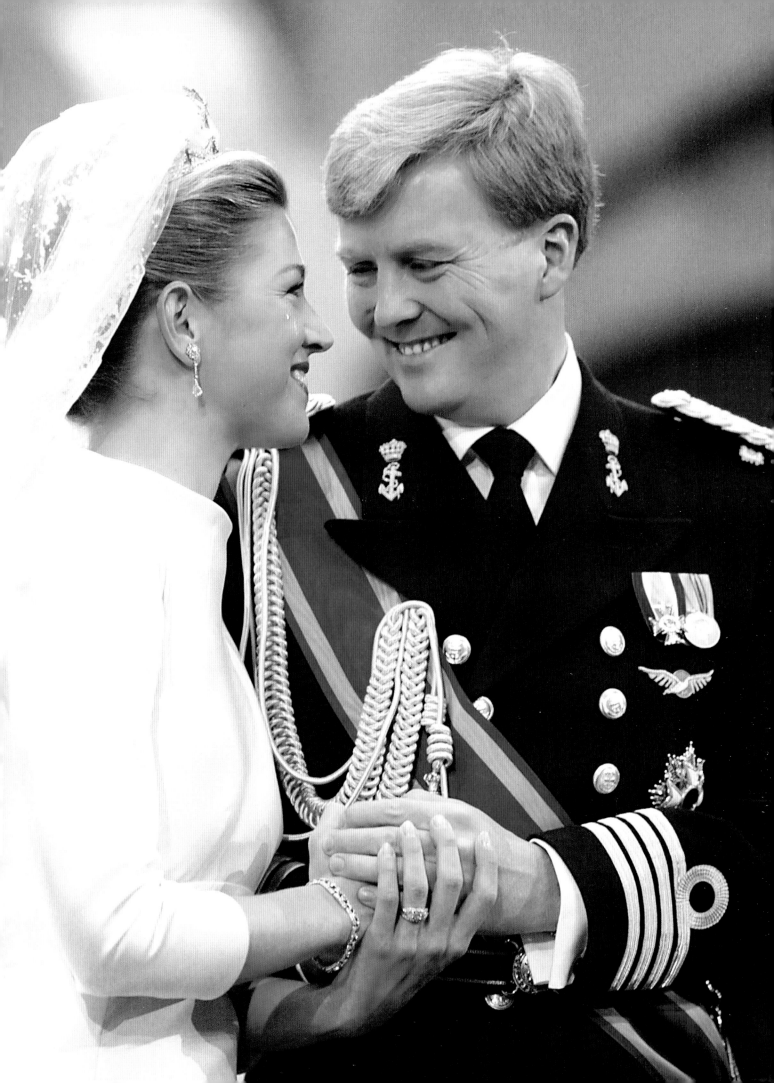

Willem-Alexander & Máxima

Die Tränen der Braut
Niederlande, 2. Februar 2002

The Tears of a Bride
The Netherlands, 2 February 2002

Es war die ansonsten so fröhliche Máxima, die als erste in der Kirche weinte. Beim Klang des Tangos „Adios Nonino" (Auf Wiedersehen, Väterchen) in der Nieuwe Kerk von Amsterdam konnte die Braut ihre Tränen nicht mehr zurückhalten. „I love you" war an den Lippen des niederländischen Kronprinzen Willem-Alexander abzulesen, als er tröstend ihre Hand nahm. Für Máxima Zorreguieta hatte der Tag ihrer Hochzeit einen Wermutstropfen. Ihr Vater und ihre Mutter fehlten in der Hochzeitsgesellschaft. „Ohne die Liebe und Sorge ihrer Eltern wäre Máxima nicht das geworden, was sie ist", sprach Pfarrer Carel ter Linden in seiner Predigt das heikle Problem versöhnlich an.

Kennengelernt hatten sich Máxima und Willem-Alexander auf einer Party im spanischen Sevilla. Schnell war klar, dass die patente Argentinierin genau die Richtige für den lebenslustigen Prinzen war. Beim Schlittschuhlaufen im Park von Schloss Drakensteyn machte er ihr mit einem Meer roter Rosen und einer Flasche Champagner, die er hinter einem Baum versteckt hatte, einen Heiratsantrag. Das heißt, er versuchte es, denn noch bevor er die Frage aller Fragen ausgesprochen hatte, rief Máxima schon „Ja". Das Königshaus freute sich über Willem-Alexanders Wahl. Der Lebenslauf der diplomierten Volkswirtin wies keinerlei Makel auf. Der ihres Vaters allerdings schon. Jorge

The first person to cry in the church was the normally cheerful Máxima herself. When the music of the tango "Adios Nonino" (Goodbye, Daddy) rang out in the Nieuwe Kerk in Amsterdam the bride could no longer hold back her tears. The Dutch Crown Prince Willem-Alexander could be seen to whisper "I love you" as he took her hand to comfort her. For Máxima Zorreguieta the day of her wedding had a bitter side: her father and mother were not there. Minister Carel ter Linden made a conciliatory reference to the delicate subject in his sermon when he said: "Without the love and care of her parents Máxima would not have become the person she is."

Máxima and Willem-Alexander had met at a party in Seville in Spain and it was soon clear that the capable Argentinian was exactly the right partner for the pleasure-loving prince. He proposed to her when they were skating in the park at Drakensteyn Palace, with a sea of red roses and a bottle of champagne he had hidden behind a tree – that is to say, he had tried to, but Máxima cried out "Yes" even before he had reached the vital question. The royal family were pleased with Willem-Alexander's choice: she had a degree in economics and had led a blameless life. The same could not be said of her father. As minister of agriculture Jorge Zorreguieta had played a dubious role during

Zorreguieta hatte als Landwirtschaftsminister eine zwei-felhafte Rolle während der Zeit der Militärdiktatur in Argentinien gespielt. Nach niederländischem Recht muss das Parlament einer Eheschließung des Thronfolgers zustimmen und es zeichnete sich ab, dass einige Abgeordnete querschießen würden. Was nun, Thron oder Liebe? Für Willem-Alexander war die Sache klar. Er zeigte unmissverständlich, dass er zu Máxima stehen würde. Nach wochenlangen Querelen schließ-lich wurde eine Lösung gefunden: Jorge Zorreguieta willigte ein, der Hochzeit seiner Tochter fernzubleiben.

the military dictatorship in Argentina. Under Dutch law parliament must agree to the marriage of the heir to the throne and it looked as if some members of parliament would vote against. So what was to be done? Love or throne? For Willem-Alexander there was no question: he made it abundantly clear that he would stand by Máxima. At long last a solution was found: Jorge Zorreguieta would stay away from his daughter's wed-ding.

On 2 February 2002 the great day had arrived. It began with a drive in a Rolls Royce to the Beurs van

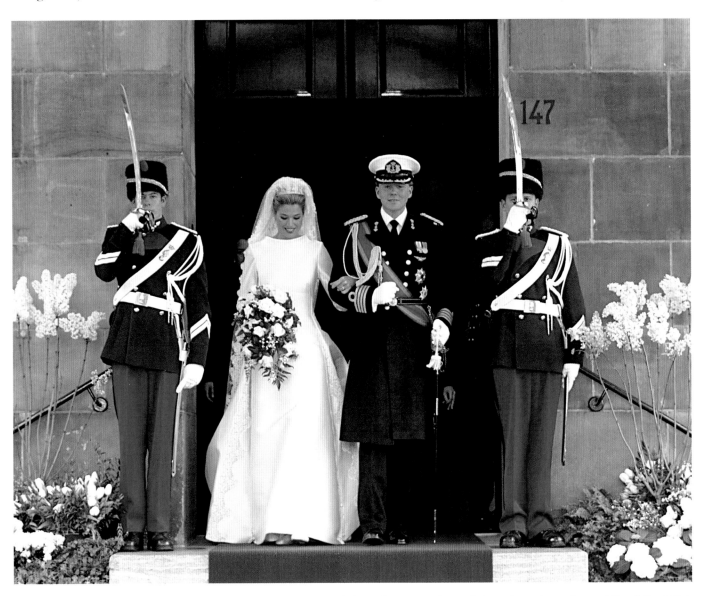

Startklar. Um 10 Uhr morgens brach das Brautpaar gemeinsam vom Königlichen Palast am Voorburgwal Nr. 147 von Amsterdam auf. Der Öffentlichkeit blieb damit der Moment, in dem Willem-Alexander seine schöne Braut zum ersten Mal sah, leider vorenthalten. Da Máximas Vater der Hochzeit aus poli-tischen Gründen fernbleiben musste und so die Braut nicht übergeben konnte, hatte man sich für diese diplomatische Lösung entschieden.

Ready to start. At 10 o'clock the bridal couple left the royal palace at Amsterdam's Voorburgwal No. 147 together. Unfortunately this meant that the public missed the moment when Willem-Alexander saw his beautifully-gowned bride for the first time. As Máxima's father had to stay away from the wedding on political grounds he couldn't give her away, so the court had worked out this diplomatic solution instead.

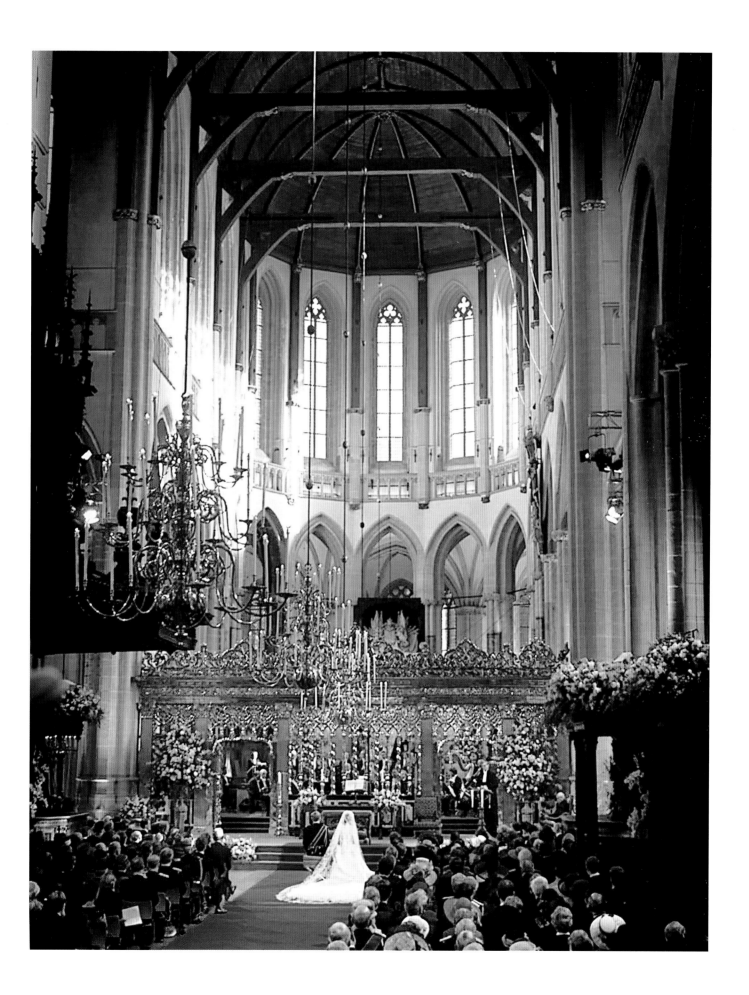

Hand in Hand. Pagen und Blumenmädchen waren mit Kostümen aus rotem Samt und Rüschenkragen für ihren großen Auftritt herausgeputzt. In den ungewohnten schwarzen Lackschühchen konnten die Kinder von Freunden des Brautpaars ein bisschen Halt beim Nachbarn gut gebrauchen.

Hand in hand. Bridesmaids and pageboys were dressed in red velvet, the little ones, children of friends of the couple, with white ruffs. In their unfamiliar patent leather shoes they could do with a little support from their neighbours.

Strammes Programm. Während das Brautpaar sein Eheversprechen noch standesamtlich besiegelte, sammelten sich die Gäste bereits in der Nieuwe Kerk. Die Herren im Cut, die Damen mit Hut – so war es in der Einladung von Königin Beatrix und Prinz Claus erwünscht.

Strict programme. While the bridal couple were exchanging their vows at the civil ceremony the guests were assembling in the Nieuwe Kerk, the gentlemen in morning coats, the ladies with hats, as prescribed in the invitation.

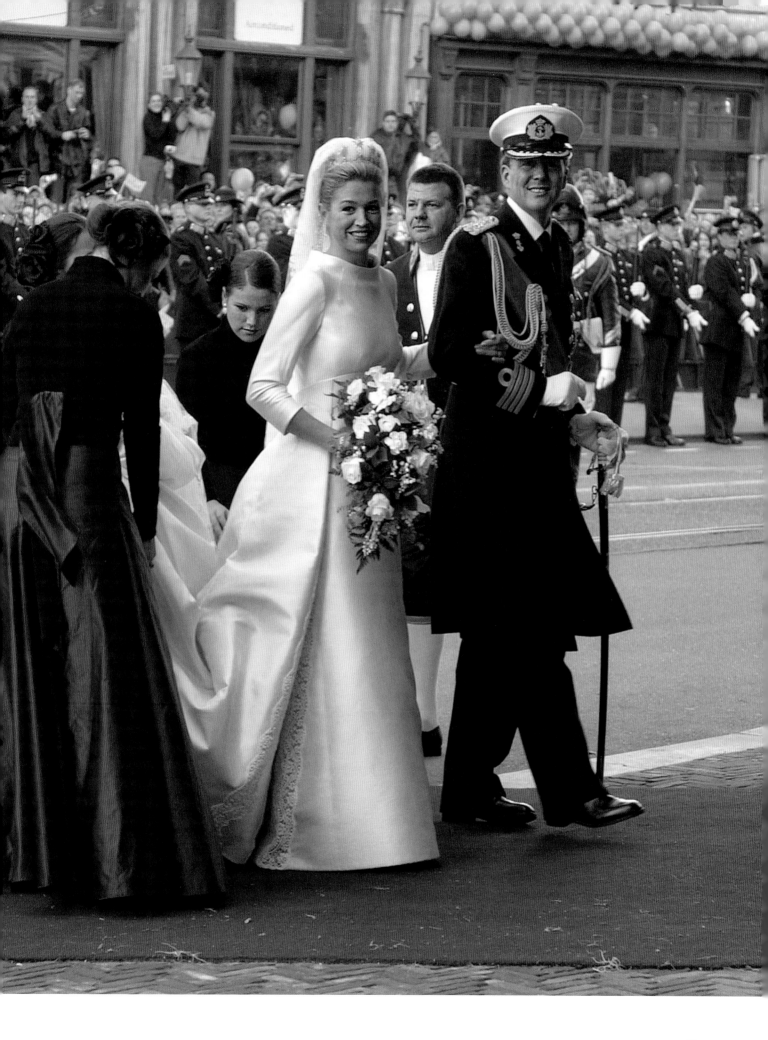

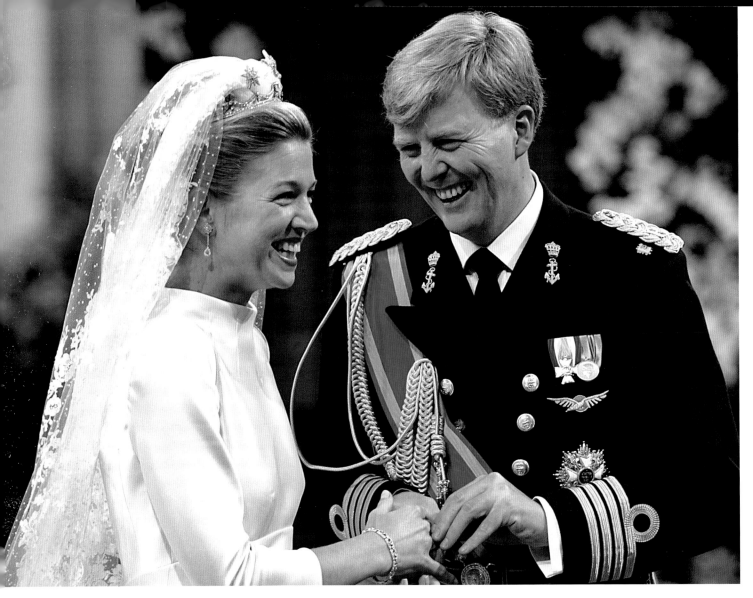

Gefühlsgeladen. Máximas Tränen waren kaum getrocknet, als das Brautpaar das große Lachen überkam, denn vor dem Altar hakte es noch einmal. Der Ring wollte einfach nicht an Máximas Finger passen.

Emotional moments. Máxima's tears were hardly dry before the couple were overcome by laughter at a small setback at the altar: the ring refused to fit on her finger.

Am 2. Februar 2002 dann war der große Tag gekommen. Im Rolls Royce ging es zunächst zur Beurs van Berlage, dem ehemaligen Gebäude der Amsterdamer Börse, wo Bürgermeister Job Cohen um 10:15 Uhr die standesamtliche Trauung vollzog. Auf Wunsch von Máxima stand Königin Beatrix selbst ihrer künftigen Schwiegertochter als Trauzeugin zur Seite. Für die englisch- und spanischsprachigen unter den 600 anwesenden Gästen im Standesamt leistete der Bürgermeister einen Extradienst: „In Dutch the English word ‚Yes‘ and the Spanish word ‚Sí‘ is pronounced as ‚Ja‘", erklärte er, was die meisten wahrscheinlich auch ohne Übersetzungshilfe verstanden hätten. Währenddessen hatten sich in der benachbarten Nieuwe Kerk bereits 1 800 hochrangige Gäste versammelt, darunter der nahezu komplette europäische Hochadel und angese-

Berlage, the former seat of the Amsterdam Stock Exchange, where at 10.15 a.m. Mayor Job Cohen conducted the civil ceremony. Máxima had asked her future mother-in-law to act as witness. For the English or Spanish speakers among the 600 guests at the registry office the mayor helpfully explained: "In Dutch the English word 'Yes' and the Spanish word 'Sí' is pronounced as 'Ja'," which most of them would probably have known even without a translation. Meanwhile 1,800 illustrious guests had assembled in the nearby Nieuwe Kerk, including nearly all of Europe's highest nobility, and eminent politicians like Nelson Mandela and Kofi Annan. As at the registry office the couple's "Yes" was loud and clear.

At the conclusion of the church service the future monarchs drove through Amsterdam in a golden coach

hene Politiker wie Nelson Mandela oder Kofi Annan. Wie schon auf dem Standesamt kamen auch in der Kirche die „Ja-Worte" klar und präzise.

Danach feierten die Niederländer ihr künftiges Königspaar bei dessen Fahrt in einer goldenen Kutsche durch Amsterdam. Viele Schaulustige trugen selbstgebastelte Kronen auf dem Kopf. Orangefarbene Kleidung allerorten, sogar orange gefärbte Pudel wurden gesichtet. Nebelwerfer auf den Dächern verbreiteten eine Wolke in der niederländischen Nationalfarbe über Amsterdam. Und inmitten des orangefarbenen Meeres strahlten Máxima und Willem-Alexander übers ganze Gesicht. Dieses Brautpaar hatte allen politischen Ballast abgeschüttelt und genoss seinen schönsten Tag. Um 13:30 Uhr erschienen sie auf dem Balkon des Königspalastes und küssten sich unter dem aufbrausenden Jubel der Menge. Nicht einmal, sondern wieder und wieder und wieder...

to the cheers of the people, some of whom wore improvised crowns on their heads. Orange-coloured clothes were everywhere and even orange-dyed poodles were to be seen. From the rooftops vapour trails in the Dutch national colours streamed over Amsterdam. Awash in a sea of orange Máxima and Willem-Alexander beamed with joy. They had cast off all political ballast and were enjoying their big day. At 1.30 p.m. they appeared on the balcony of the royal palace and kissed, to the wild applause of the crowd, not once, not twice but again and again ...

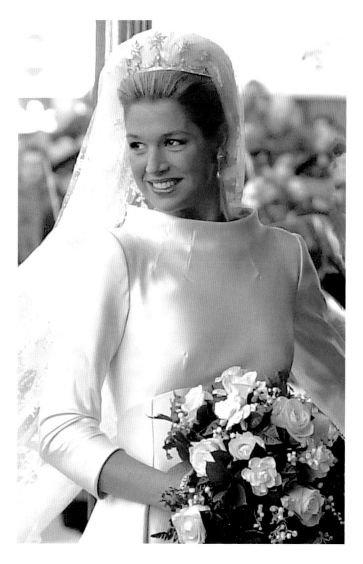

Valentino-Traum. Entgegen der Tradition in fast allen europäischen Königshäusern hatte sich Máxima nicht für einen einheimischen Designer entschieden. Die Wahl fiel auf Valentino. Der italienische Meister der Haute Couture dankte es ihr mit einem hoch geschlossenen, eleganten Entwurf aus elfenbeinfarbener Mikado-Seide mit einer fünf Meter langen Schleppe, über die sich der Schleier aus Seidentüll mit handgestickten Blumenmotiven legte. Der Brautstrauß aus weißen Rosen, Gardenien und Maiglöckchen brachte einen Hauch von Frühling an diesem sonnigen Wintertag.

Dream of Valentino. The bride had departed from the tradition of nearly all the European houses in choosing a foreign designer, in her case Valentino. The Italian grand couturier repaid her with an elegant high-necked design in ivory-coloured Mikado silk. A veil of silk tulle with hand-embroidered flower motifs was draped over a train 15 feet long. The bridal bouquet of white roses, gardenias and lily-of-the-valley brought a breath of spring into that sunny winter day.

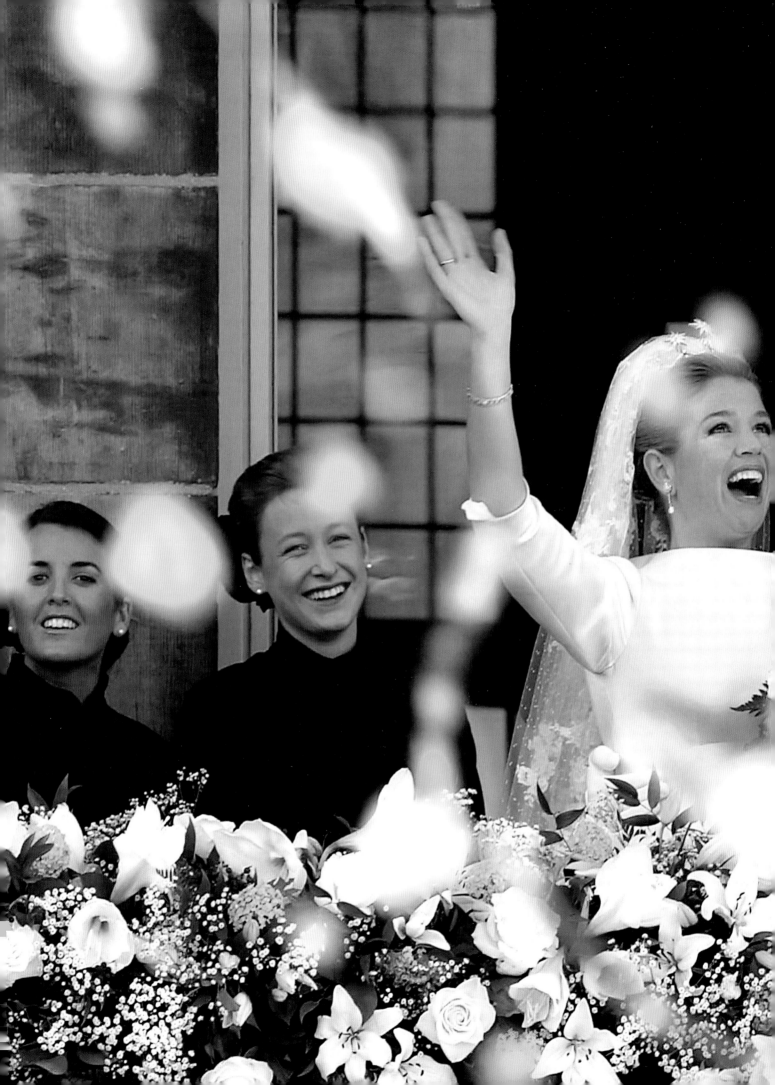

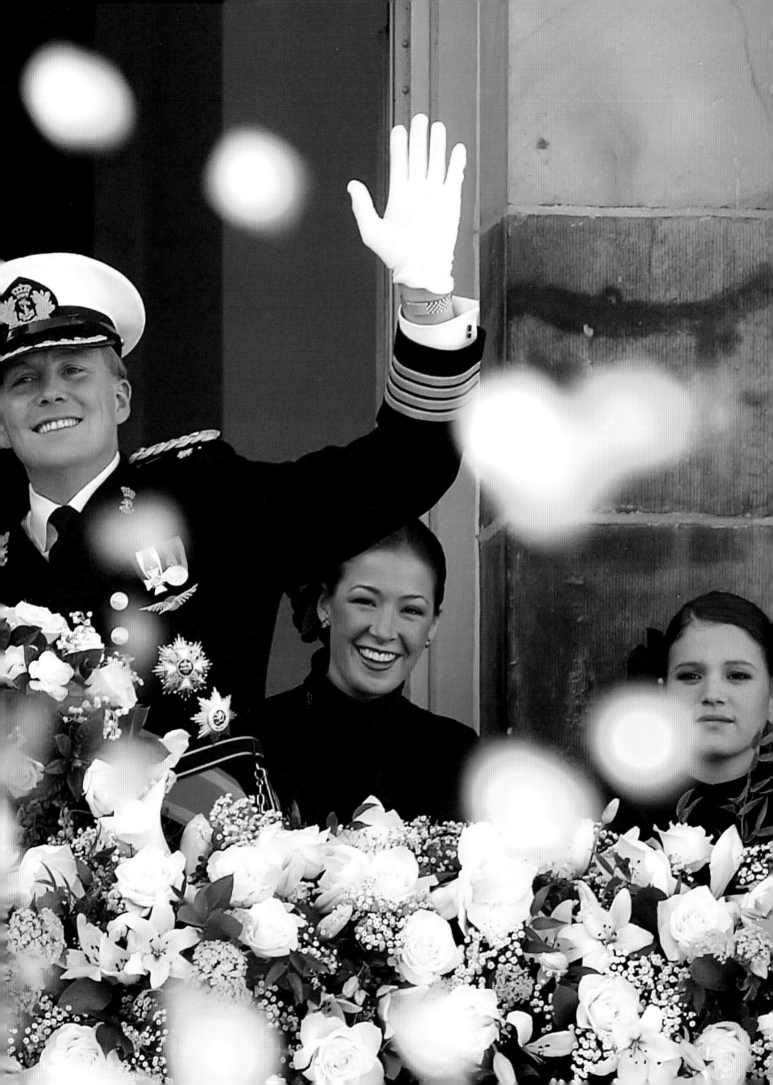

Doppelt bequem. Traditionell fertigen Mitglieder des Deutschen Ordens in Utrecht die Kissen für die antike Kniebank der Hochzeiten im Hause Oranien. Die Brokatkissen für die Trauung von Willem-Alexander und Máxima wurden nach Máximas Vorstellungen bestickt und mit ihren Monogrammen versehen.

Kneelers for two. The kneelers for weddings in the House of Orange were traditionally made by members of the Order of Teutonic Knights in Utrecht. Those for the marriage of Willem-Alexander and Máxima were made to her own design, of brocade embroidered with their monograms.

Erlesene Stärkung. Im Anschluss an die offiziellen Feierlichkeiten wurden die Gäste zu einem festlichen Mittagessen mit Langustenschwänzen, Steinbutt-Törtchen und Medaillons vom Reh gebeten.

A royal meal. After the official ceremonies the guests were invited to a kingly meal of langouste, vol-au-vent of turbot and medaillons of venison.

QUEUES DE LANGOUSTINES
—
TARTELETTE AU TURBOT
SAUCE AU VIN BLANC
—
MEDAILLONS DE CHEVREUIL ROTIS
SAUCE AU THYM
—
CHOU ROUGE
GOLDEN DELICIOUS AUX AIRELLES
POMMES DE TERRE DUCHESSE
MARRONS
—
TARTE DE LA MARIEE
—
MOKA

DEJEUNER
LE 2 FEVRIER 2002

Bleibende Erinnerung. Nicht nur Máxima und Willem-Alexander hatten nach ihrer Hochzeit allen Grund, sich bei ihren Untertanen zu bedanken. Wie bei allen royalen Hochzeiten waren es auch der Jubel und die Begeisterung des Volkes, die aus dem Festtag ein unvergessenes Ereignis gemacht hatten.

Lasting memory. Not only Máxima and Willem-Alexander had grounds for thanking their subjects after their wedding. As at all royal marriages it was the cheers and enthusiasm of the people which made the great day an unforgettable event.

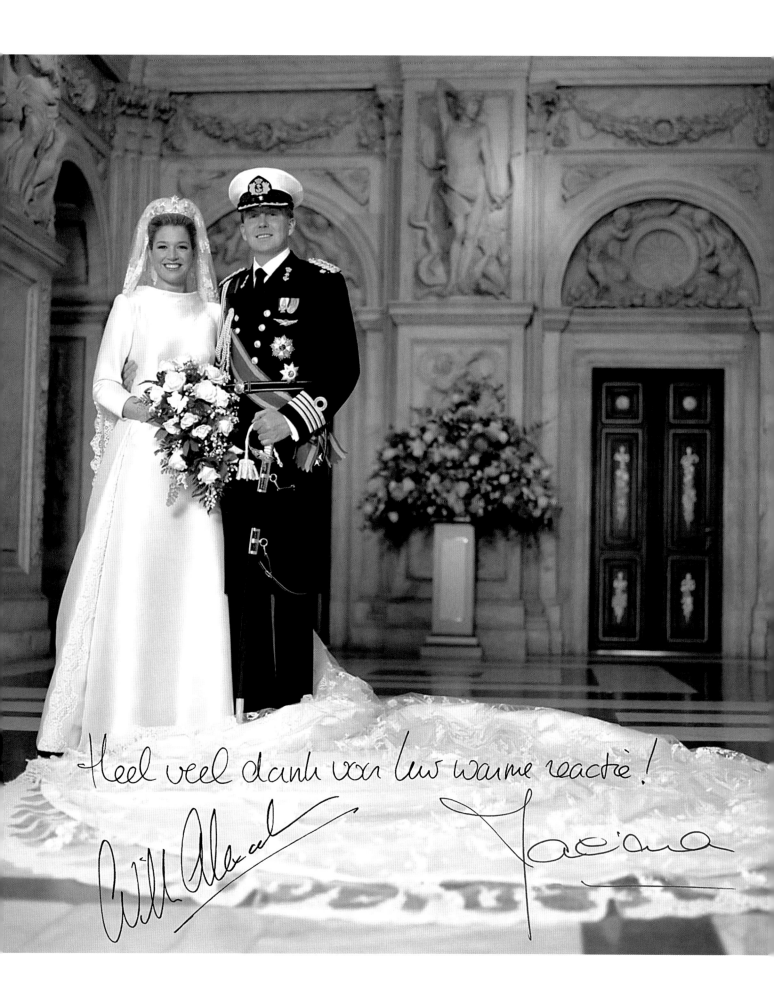

Heel veel dank voor Uw warme reactie!

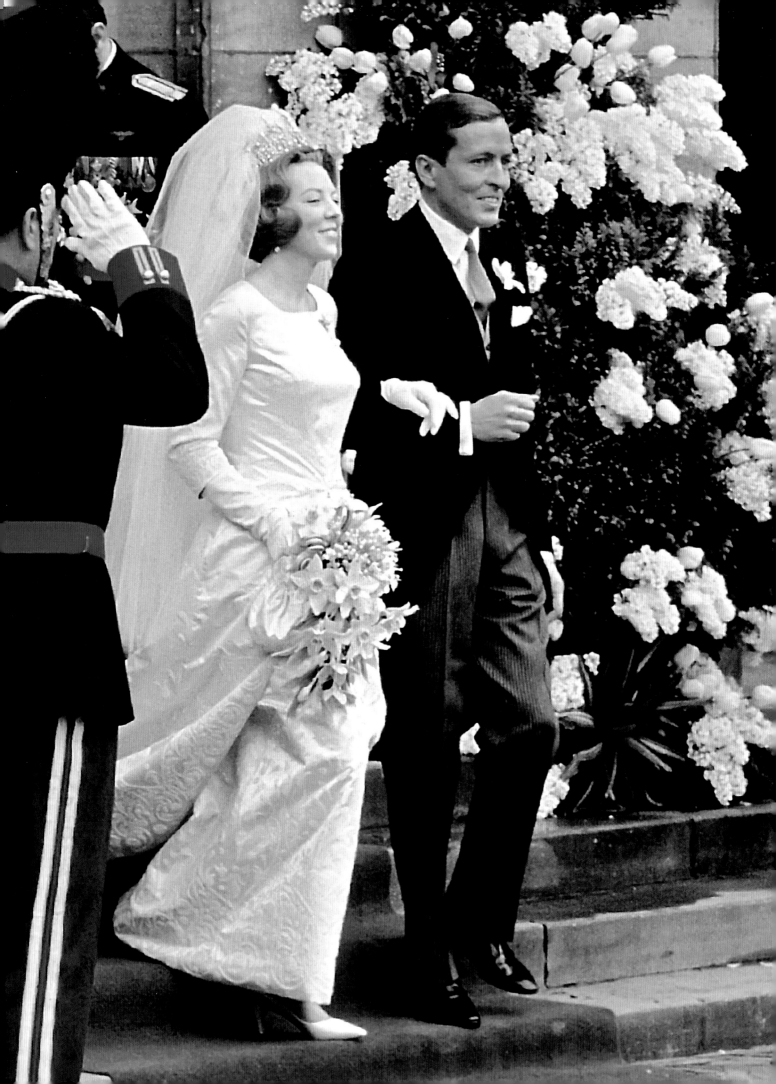

Beatrix & Claus

Die goldene Kutsche mit dem Brautpaar war auf dem Weg zur Westerkerk, als inmitten einer jubelnden Menge eine Rauchbombe explodierte. Noch weitere sechs Mal erschütterten Detonationen die Straßen von Amsterdam, die aus Anlass der königlichen Hochzeit festlich geschmückt waren. Nicht alle Niederländer freuten sich mit ihrer Kronprinzessin Beatrix, die an diesem Tag den Diplomaten Claus von Amsberg zu ihrem Ehemann machen wollte.

An Silvester 1962 waren sich die beiden zum ersten Mal über den Weg gelaufen, doch erst auf dem Polterabend des Prinzen Moritz von Hessen 1964 funkte es zwischen dem stillen Claus und der temperamentvollen Thronfolgerin. Noch gelang es ihnen, ihre Liebe vor der Öffentlichkeit geheim zu halten. Doch Gerüchte kursierten bald, Beatrix sei an der Seite eines jungen Mannes in einem Sportwagen gesichtet worden. Am 1. Mai 1965 erwischte ein Fotograf Beatrix und Claus im Garten von Schloss Drakensteyn. Fünf Tage später prangte das Foto auf dem britischen Daily Express und anschließend in allen niederländischen Gazetten. Aber wer war dieser Mann? In Hochadelskreisen kannte man ihn nicht. „Wenn das mal nur kein Deutscher ist", soll der damalige niederländische Ministerpräsident Jo Cals beim Anblick der Fotos gefleht haben. Doch es war ein Deutscher!

The golden coach carrying the bridal couple was on its way to the church, the Westerkerk, when a smoke bomb went off in the middle of the cheering crowd. Six more exploded later in the streets of Amsterdam, gaily decorated for the royal wedding. Not all the Dutch public were as happy as Crown Princess Beatrix about her marriage to diplomat Claus von Amsberg.

They had met for the first time on New Year's Eve 1962 but it was not until the pre-wedding party of Prince Moritz of Hesse in 1964 that the quiet Claus and the spirited heiress to the throne fell in love. For some time they were able to keep their feelings a secret, but soon rumours began to circulate that Beatrix had been seen at the side of a young man in a sports car. On 1 May 1965 a photographer caught sight of them in the garden of Drakensteyn Palace; five days later the photograph appeared in the British Daily Express and then in all the Dutch newspapers, but who was the young man? In the upper ranks of the nobility he was unknown. On seeing the photographs the then Dutch Prime Minister Jo Cals was heard to say: "I hope to goodness it's not a German," but it was.

Of all things, a "moff", as the hated Germans were called in the Netherlands, a member of the nation which had caused the country so much suffering in the

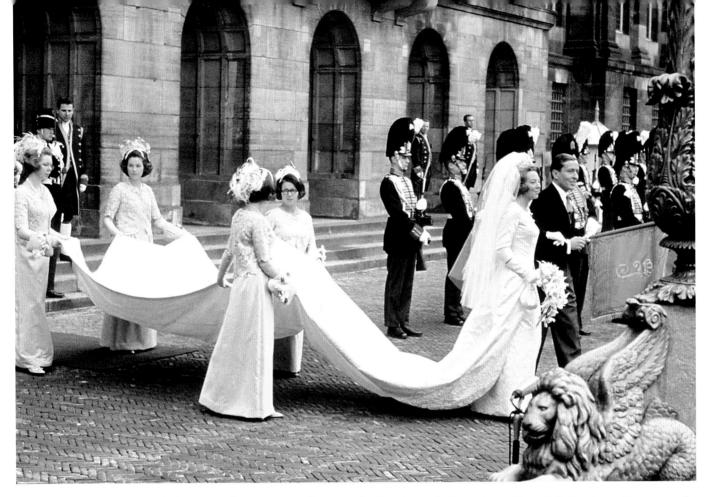

Unerschütterlich. Als Beatrix und Claus am Hochzeitsmorgen zur Trauung aufbrachen, hatten die Amsterdamer „Provos" die Strecke aus Protest gegen das Königshaus bereits mit Rauchbomben präpariert. Zwanzig Unruhestifter wurden an diesem Tag festgenommen, aber wenig später wieder auf freien Fuß gesetzt. 36 Jahre später ließ Willem-Alexander, der Erstgeborene des Paares, bei seiner eigenen Hochzeit orangefarbene Rauchbomben zur Erinnerung an den Hochzeitstag seiner Eltern zünden.

Steadfast. Before Beatrix and Claus set out on their wedding morning the Amsterdam "provos" had planted smoke bombs along the route in protest against the royal family. Twenty suspects were arrested but all released shortly afterwards. 36 years later Willem-Alexander, their eldest son, arranged for orange-coloured smoke bombs to be set off at his own wedding in memory of his parents' wedding day.

Ausgerechnet ein „Moff", wie die Deutschen in den Niederlanden geschimpft wurden, ein Angehöriger der Nation, unter der das Land im Zweiten Weltkrieg so hatte leiden müssen. Zwanzig Jahre nach Kriegsende waren die Wunden noch zu frisch, um einen ehemaligen Hitlerjungen, Flakhelfer und Wehrmachtssoldaten am niederländischen Königshof zu dulden. Die Sache wurde zum Staatsakt, schließlich benötigte die Kronprinzessin nach niederländischem Recht eine Heiratserlaubnis des Parlamentes. Erst nachdem Historiker bewiesen hatten, dass Claus weder an Kriegsverbrechen beteiligt gewesen war noch irgendwelche Zeichen von Antisemitismus gezeigt hatte, gab das Parlament grünes Licht. Doch das Volk war so leicht nicht zu besänftigen. 60 000 Niederländer unterschrieben eine Protestnote an den Hof, die jüdische Gemeinde von Amsterdam kündigte an, das Fest zu boykottieren.

Second World War. Twenty years after the end of the war the wounds were still too fresh for a former member of the Hitler Youth and soldier in the Wehrmacht to be acceptable at the Dutch court. The state itself was involved since under Dutch law the marriage of the heir to the throne had to be approved by parliament. Only when historians had established that Claus had not been guilty of war crimes nor ever shown any signs of anti-semitism did parliament give the green light; but the public was not so easy to convince. 60,000 citizens signed a letter of protest to the court and the Jewish community in Amsterdam announced that they would boycott the ceremony.

On the morning of 10 March 1966 the Dutch television company preparing the broadcast found that an important cable had been cut – clearly sabotage. They were able to repair the damage in time, but it was not a good omen. Some 100,000 courageous people had

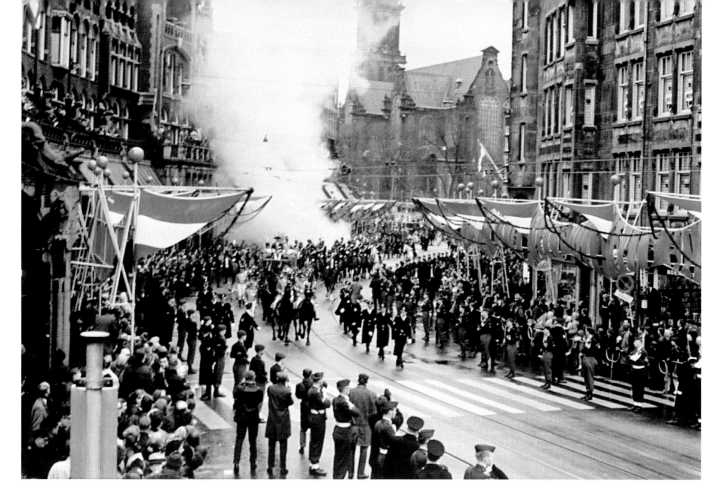

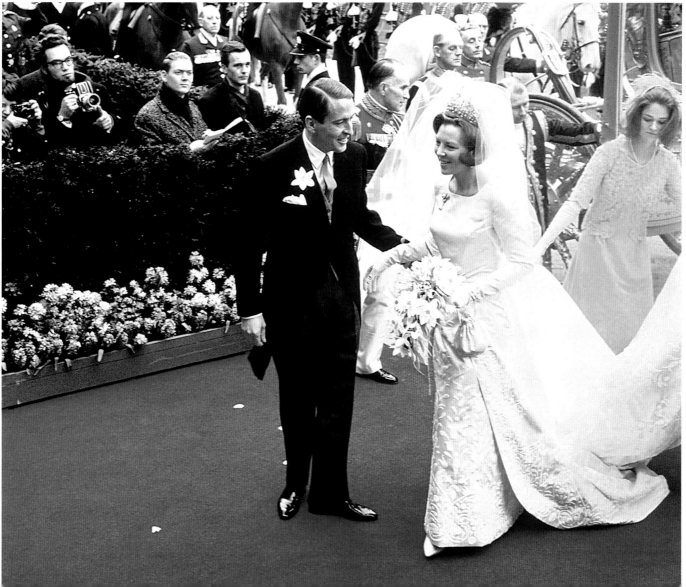

Am Morgen des 10. März 1966 stellte das niederländische Fernsehen bei der Vorbereitung der Übertragung fest, dass ein wichtiges Kabel durchtrennt worden war – offensichtlich Sabotage. Zwar konnte alles noch bis zum Beginn der Feierlichkeiten repariert werden, doch es war kein gutes Vorzeichen. Etwa 100 000 Unerschrockene hatten sich eingefunden, um ihre Solidarität mit der Kronprinzessin zu bekunden, doch stärker machten sich die Demonstranten bemerkbar. „Claus raus" oder „Trix ist nix" – unter solchen Schmährufen mussten sich die Brautleute den Weg in die Kirche bahnen. Aber auch die Rauchbomben, die von sogenannten „Provos", jungen Amsterdamer Anarchisten, gezündet worden waren, konnten Beatrix und Claus nicht von ihrem Entschluss abbringen. Noch als sie vor dem Altar standen, hallten von draußen deutlich hörbare Protestrufe bis in die Stille der Kirche. Das entschiedene „Ja" der Kronprinzessin aber war lauter.

assembled to show their solidarity with the crown princess but the demonstrators made more noise. The bridal couple had to make their way to the church to shouts of "Claus out" and "Who wants Trix", but neither they nor the smoke bombs set off by the "provos", young Amsterdam anarchists, were able to shake Claus' and Beatrix' determination. Even as they stood at the altar shouts of protest could be clearly heard in the silence of the church. But the crown princess's resolute "Yes" was louder still.

What began amidst so much drama turned into one of the best and most loving marriages there had ever been among the highest nobility of Europe. Claus von Amsberg's warm-hearted nature soon made him the most loved member of the royal family. Three sons, Willem-Alexander, Johan Friso and Constantijn, were born, crowning a love which had triumphed over all obstacles. For the rest of his life Prince Claus stood

Entscheidung aus Liebe. Claus von Amsberg hatte mit der Entscheidung für Beatrix auch in die schwierige Rolle als Prinzgemahl eingewilligt. Sein Leben lang würde er im Schatten seiner regierenden Frau stehen müssen. Auf dem Standesamt aber war er ihr noch voraus. Da in den Niederlanden die rechtliche Voraussetzung für eine Heirat bei unter 30-jährigen das „Ja" der Eltern war, wurden in diesem Fall Königin Juliana und Prinz Bernhard gefragt. Der 40-jährige Claus von Amsberg durfte für sich selbst sprechen. Seine Unterschrift machte aus dem deutschen Diplomaten einen Prinz der Niederlande.

All for love. With his decision to marry Beatrix, Claus von Amsberg accepted the difficult role of prince consort. For the rest of his life he would have to stand in the shadow of his reigning wife. Only at the registry office was he the senior partner. Under Dutch law the marriage of a person under 30 required the consent of the parents, in this case Queen Juliana and Prince Bernhard. Claus, aged 40, was able to speak for himself. With his signature the German diplomat became a prince of the Netherlands.

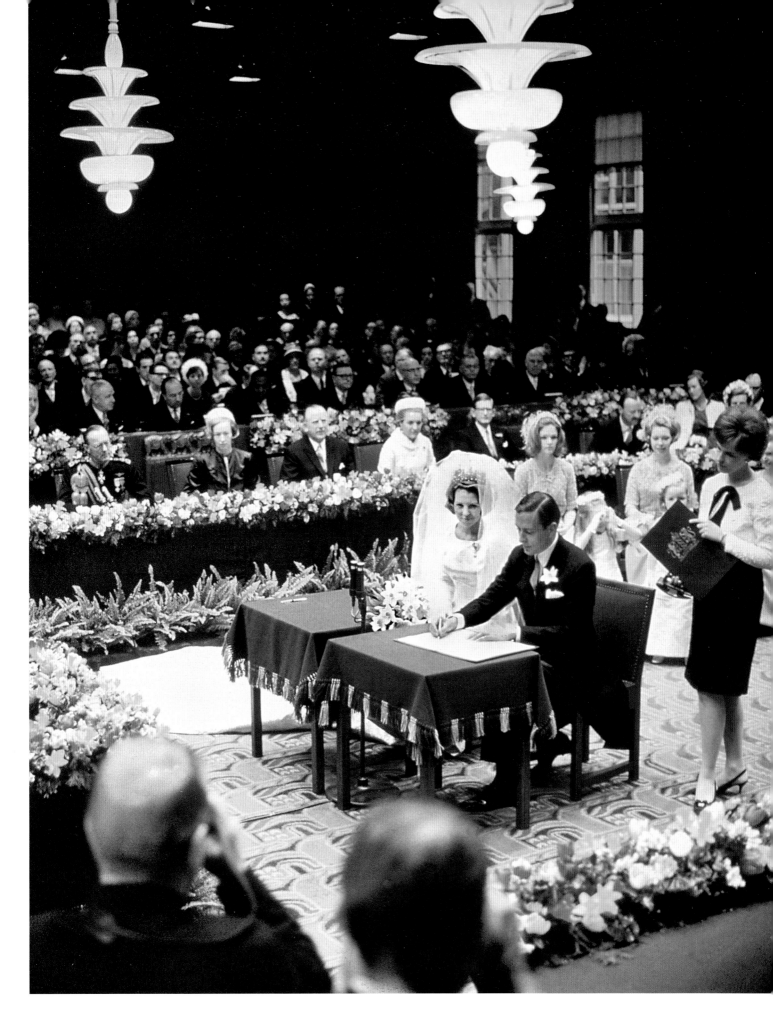

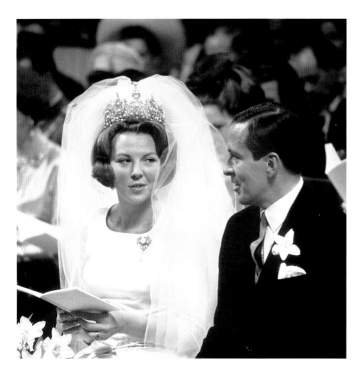

Rührender Moment. In der Amsterdamer Westerkerk besiegelten Beatrix und Claus eine Liebe, die sie skandalfrei bis an das Ende ihres gemeinsamen Lebens begleitete. Königin Juliana und Prinz Bernhard standen hinter dem jungen Paar. Deren eigene Ehe dagegen war nie allzu glücklich gewesen.

Emotional moment. In the Amsterdam Westerkerk Beatrix and Claus set the seal on a faithful love that lasted for the rest of their life together. Queen Juliana and Prince Bernhard stood behind the young couple. Their own marriage had not always been a happy one.

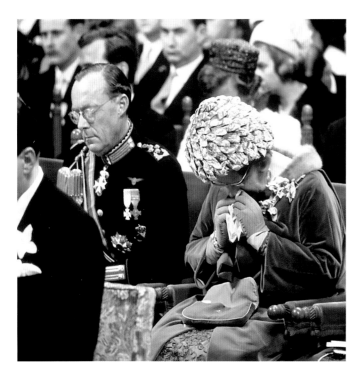

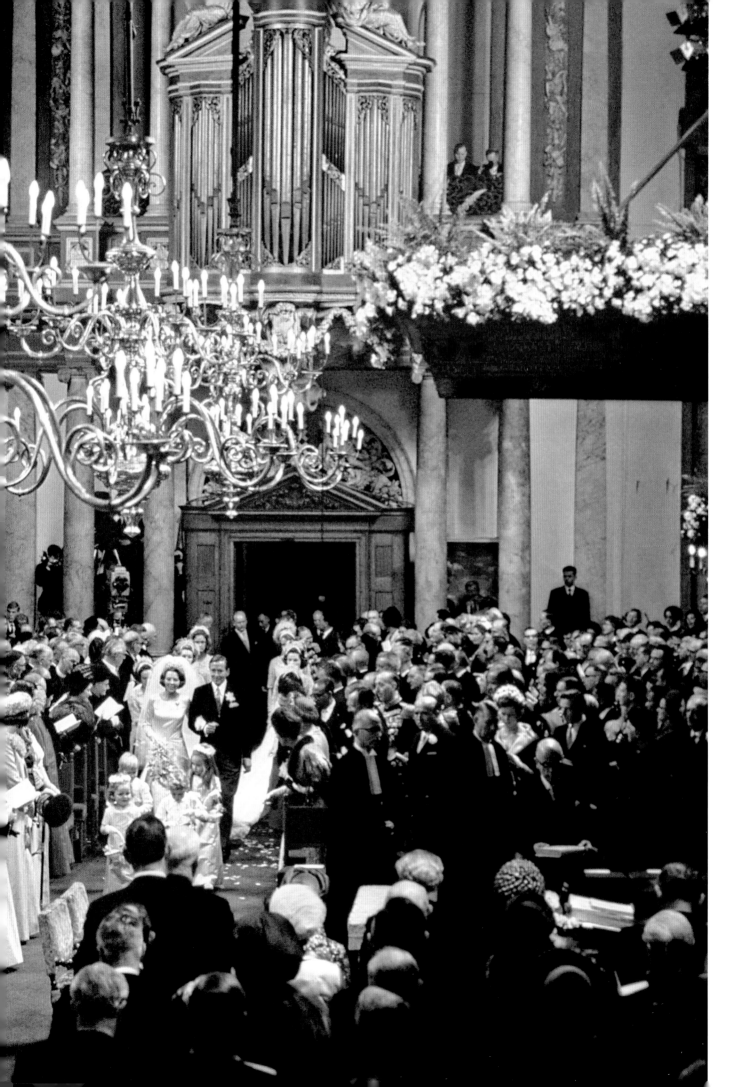

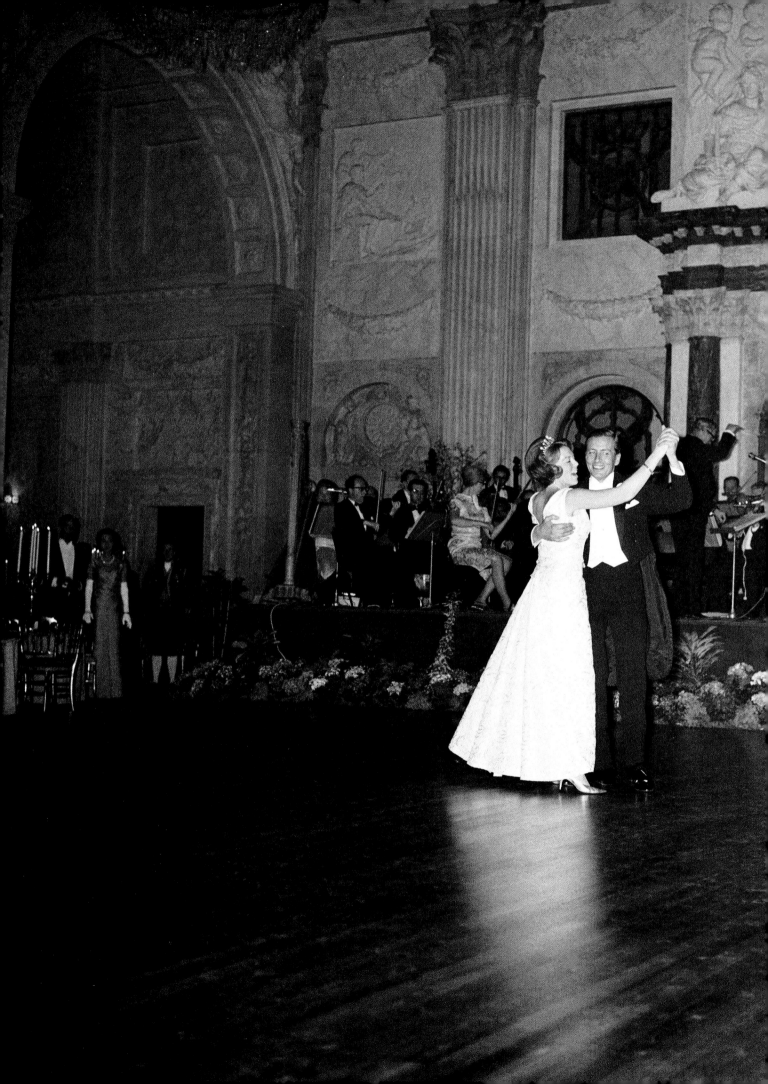

Was so dramatisch begann, wurde eine der schönsten und liebevollsten Ehen, die je im europäischen Hochadel geschlossen wurde. Claus von Amsbergs warmherziges Wesen machte ihn alsbald sogar zum beliebtesten Mitglied des Königshauses. Drei Söhne, Willem-Alexander, Johan Friso und Constantijn, wurden kurz hintereinander geboren und krönten eine Liebe, die sich über alle Hindernisse hinweggesetzt hatte. Prinz Claus stand zeit seines Lebens zurückhaltend hinter seiner Frau, auch als es ihm, von Krankheit gezeichnet, immer schwerer fiel, seinen höfischen Verpflichtungen nachzukommen. Als er im Jahr 2002 starb, litten die Niederländer mit der trauernden Beatrix.

quietly behind his wife, even when illness made it increasingly difficult for him to carry out his official duties. When he died in 2002, the whole country joined Beatrix in mourning.

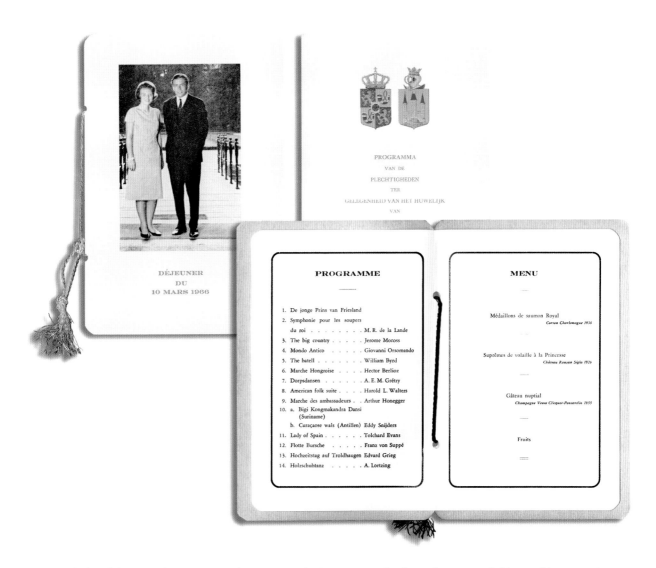

DÉJEUNER
DU
10 MARS 1966

PROGRAMMA
VAN DE
PLECHTIGHEDEN
TER
GELEGENHEID VAN HET HUWELIJK
VAN

PROGRAMME

1. De jonge Prins van Friesland
2. Symphonie pour les soupers
 du roi M. R. de la Lande
3. The big country Jerome Moross
4. Mondo Antico Giovanni Orsomando
5. The batell William Byrd
6. Marche Hongroise Hector Berlioz
7. Dorpsdansen A. E. M. Grétry
8. American folk suite Harold L. Walters
9. Marche des ambassadeurs . . Arthur Honegger
10. a. Bigi Kongmakandra Dansi
 (Suriname)
 b. Curaçaose wals (Antillen) Eddy Snijders
11. Lady of Spain Tolchard Evans
12. Flotte Bursche Franz von Suppé
13. Hochzeitstag auf Troldhaugen Edvard Grieg
14. Holzschuhtanz A. Lortzing

MENU

Médaillons de saumon Royal
Carton Charlemagne 1938

Suprêmes de volaille à la Princesse
Château Rausan Ségla 1926

Gâteau nuptial
Champagne Veuve Clicquot-Ponsardin 1955

Fruits

Tanz ins Glück. Beatrix und Claus bekamen, solange Königin Juliana regierte, die Zeit, ein weitgehend zurückgezogenes Eheleben zu führen. Die dreiwöchigen Flitterwochen verbrachten sie in Mexiko, danach zog das Paar in Schloss Drakensteyn ein. Ein gutes Jahr später wurde Sohn Willem-Alexander geboren und die Thronfolge in der nächsten Generation gesichert.

Waltz into happiness. For as long as Queen Juliana reigned, Beatrix and Claus were able to lead a mostly private life. After three weeks' honeymoon in Mexico they moved into Drakensteyn Palace. A little over a year later their son Willem-Alexander was born and the succession to the throne ensured.

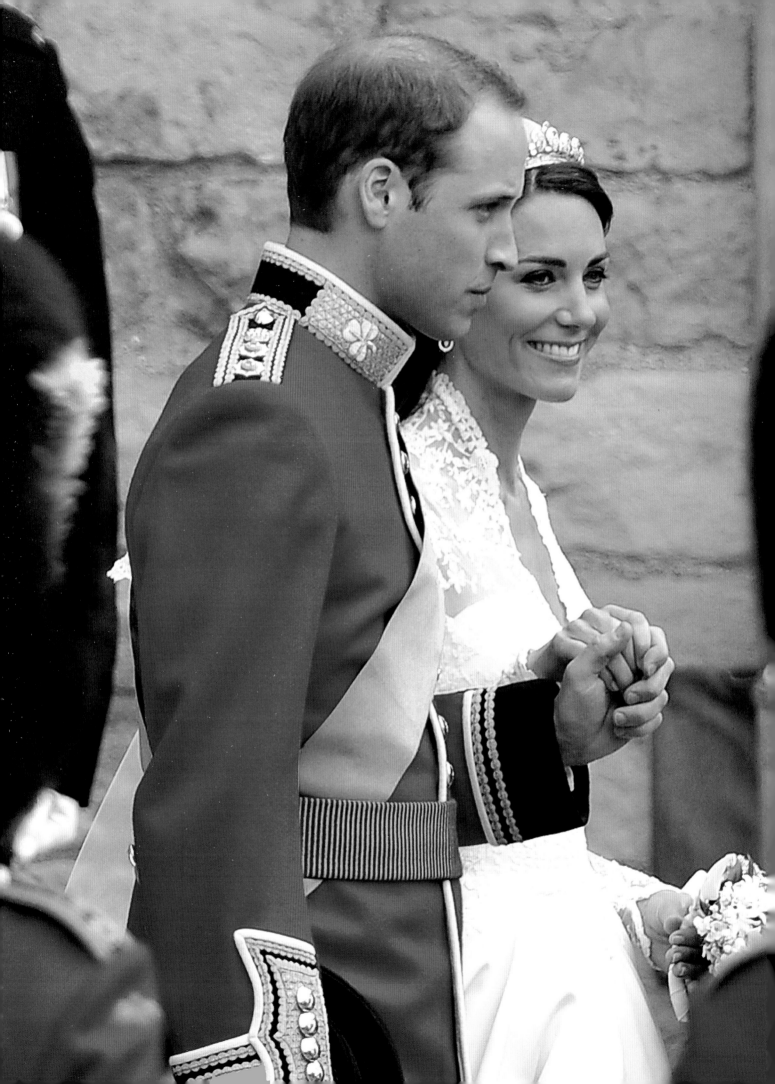

William & Kate

„Oh, Wow"! Auf dem Balkon von Buckingham Palace verschlug es der Braut dann doch noch fast die Sprache. Wie ein endloses Meer breitete sich eine Menge von hunderttausenden Menschen auf der Londoner Prachtstraße „The Mall" zu ihren Füßen aus, angeführt von berittenen Gardisten und alle gekommen, um sie als ihre künftige Königin zu feiern. Und das Mädchen, das noch wenige Stunden zuvor Catherine Middleton hieß, wusste nun, wie es sich anfühlt, zum britischen Königshaus und damit zur bedeutendsten Monarchie der Welt zu gehören. Die routinierten Royals verließen den Balkon, nachdem sich William und Kate unter dem Jubel der Menge geküsst hatten. Zuletzt wandte sich auch das Brautpaar ab, um wieder im Palast zu verschwinden. Doch kurz bevor sie die Tür passierte, drehte sich Kate noch einmal allein um, ganz so, als wolle sie diesen Augenblick noch ein kleines bisschen länger festhalten.

Dass die Geschichte von Prinz William und seiner Kate ein Happy End finden würde, war nicht selbstverständlich. Eine Trennung während der langjährigen Beziehung der beiden war der Presse bekannt, andere wurden vermutet. „Waity Katie" höhnten die Medien über Williams bürgerliche Freundin, die so lange auf einen Antrag warten musste. Aber dass dieser junge Mann zögerte, vor den Traualtar zu treten, war allzu ver-

"Oh, wow" exclaimed the bride, almost speechless, as she stepped out onto the balcony of Buckingham Palace. Like a boundless sea, a crowd in the hundreds of thousands, led by Horse Guards of the Household Cavalry, was spread out at her feet along London's majestic avenue the Mall, all of them come to cheer her as their future queen. And the young woman who a few hours before had been called Catherine Middleton realised now how it felt to belong to the British royal house and thus to the most prominent monarchy in the world. The other members of the royal family, accustomed to public appearances, left the balcony after William and Kate, to the cheers of the crowd, had exchanged the hoped-for kiss. The last to turn away and disappear into the palace were the bridal couple. Just before she crossed the threshold Kate turned back once more, as if she wanted to hold onto this unique moment a little bit longer.

That the story of Prince William and his Kate would have a happy ending was not always a foregone conclusion. The press was aware of at least one break in their long relationship and others were suspected. William's girlfriend, a commoner, who had to wait so long for a proposal of marriage, was mockingly nicknamed "Waity Katie" by the media, but it was not surprising that this particular young man should hesitate

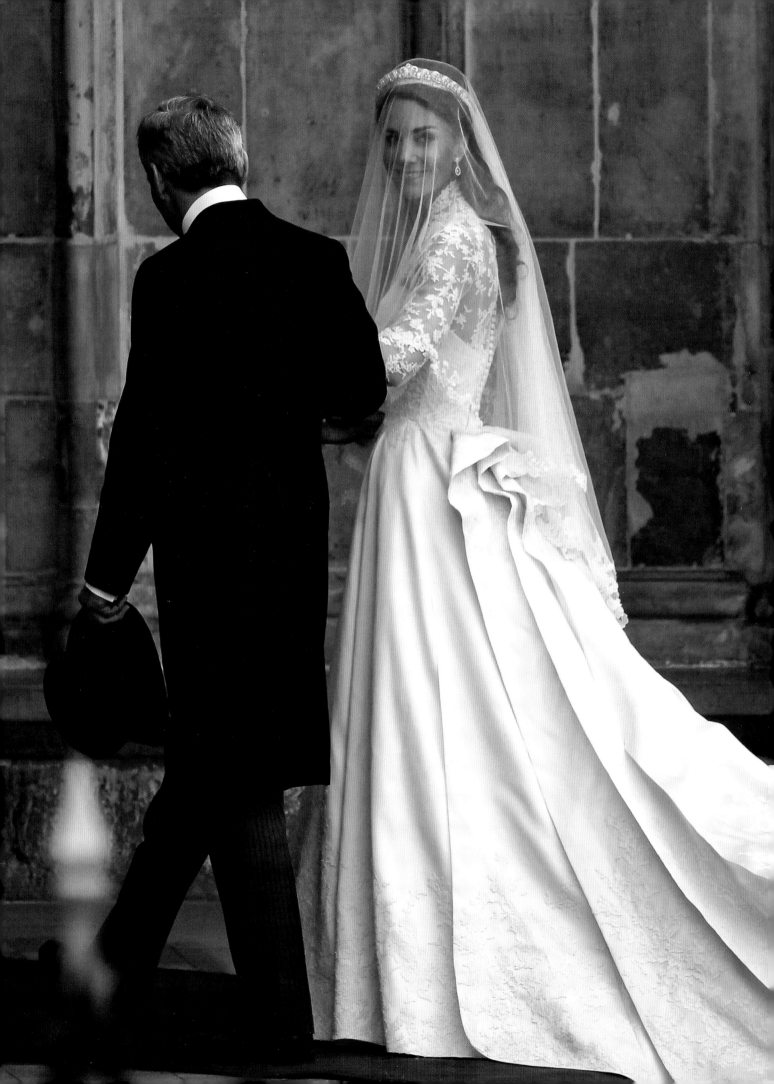

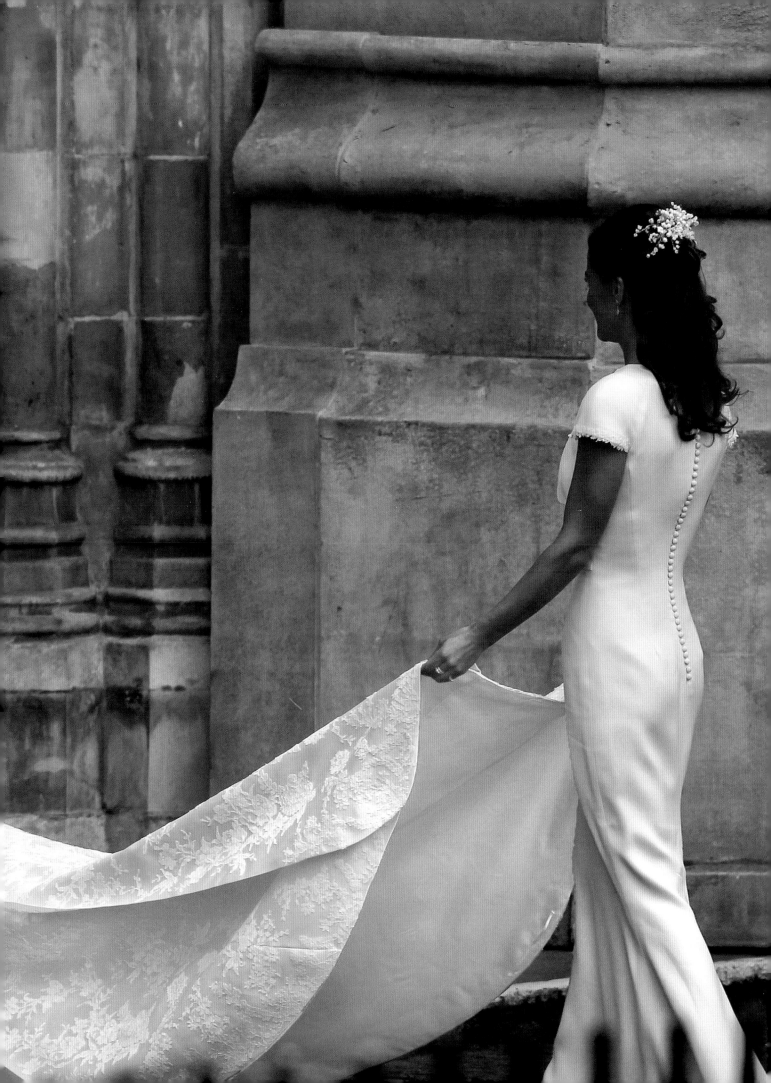

ständlich. William hatte selbst den katastrophalen Verlauf der Ehe seiner Eltern Prinz Charles und Lady Diana erlebt. Der Welt war er noch immer als der Junge in Erinnerung, der so tapfer hinter dem Sarg seiner Mutter schritt, nachdem diese im Blitzlichtgewitter tödlich verunglückt war. Nach acht Jahren belohnte Prinz William den Durchhaltewillen seiner Freundin mit einem romantischen Heiratsantrag in einer einsamen Lodge in Kenia. Die lang erwartete Verlobung setzte die Vorbereitungen für eine Superhochzeit in Gang, wie sie die Welt noch nicht gesehen hatte.

Die britische Monarchie zeigte von Beginn an, dass eine neue Generation die Öffentlichkeitsarbeit übernommen hatte. In tausenden Fanforen im Internet wurde über Wochen jedes Detail ausgetauscht, das Buckingham Palace verbreitete. Twitter, Facebook und ein eigener Kanal auf YouTube bereiteten sich darauf

before leading his bride to the altar. He had himself witnessed the catastrophic course of the marriage of his parents Prince Charles and Lady Diana. By the world he was still remembered as the youth who had walked so bravely behind his mother's coffin after her fatal accident in a blaze of camera lights. But after eight years he rewarded the patience of his girlfriend with a romantic proposal in an isolated lodge in Kenya. The long awaited engagement set in motion the preparations for a super wedding, more magnificent than any before.

From the beginning the British royal family and court showed that a new generation had taken over public relations. Every detail that Buckingham Palace released was discussed for weeks in thousands of fan forums on the Internet. Twitter, Facebook and a special channel on YouTube prepared to report and comment

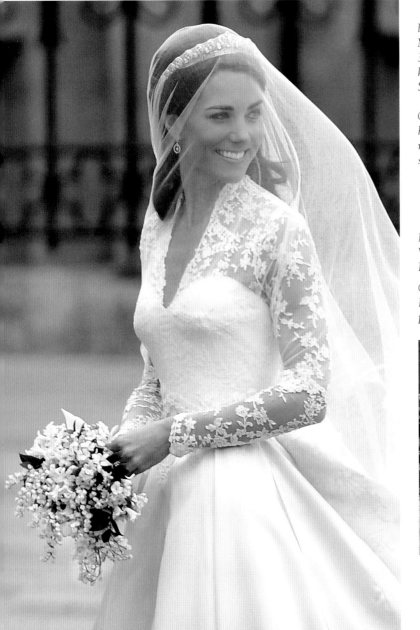

Begehrter Auftrag. Das Kleid der Braut kam aus dem Hause Alexander McQueen und wurde von Chefdesignerin Sarah Burton entworfen. Rund 35 000 Pfund, umgerechnet etwa 40 000 Euro kostete die klassische Seidenkreation. Von der „Royal School of Needlework" in Handarbeit gefertigte Spitze bedeckte Schultern und Arme.

Coveted order. The bridal gown was by Sarah Burton, head designer at the house of Alexander McQueen. The classic creation in white silk, with handmade lace embroidered by the Royal School of Needlework over arms and shoulders, cost around £35,000 (40,000 euros).

Punktlandung. Um 12:01 Uhr entstieg die Braut dem Rolls Royce der Windsors. Nur eine einzige Minute verspätet. Pünktlichkeit ist eben die Höflichkeit der Könige.

On the dot. At exactly 12.01 p.m. the bride stepped out of the Windsors' Rolls Royce, only one minute behind schedule. Punctuality is after all the politeness of kings.

vor, jede Sekunde des Tages live zu berichten und zu kommentieren. Doch die wahren Fans ließen es sich nicht nehmen, persönlich dabei zu sein. Bereits Tage vor der eigentlichen Trauung campierten sie in London, um einen der begehrten Plätze zu ergattern. 8500 Journalisten aus aller Welt reisten an, um über das Fest zu berichten, bei dem schließlich eine Million Menschen in den Straßen der britischen Hauptstadt ausgelassen feierten. Und unfassbare zwei Milliarden Menschen waren per Fernsehen und Internet live dabei, als die Glocken von Westminster Abbey ihr festliches Geläut erklingen ließen, um die Braut zu begrüßen.

Catherine Middleton hielt dem enormen Druck bravourös stand. Fast gelassen stieg sie vor der Abbey aus dem königlichen Rolls Royce aus und ließ sich von ihrem Vater zum Altar führen. Dreieinhalb endlose Minuten musste ihr Bräutigam nun noch durchhalten,

live on every second of the great day, but the most ardent fans insisted on being there in person. Days before the actual wedding they camped out on the street so as to secure one of the coveted vantage points. 8,500 journalists from all over the world arrived to report on the festivities, joined by a million people celebrating in the streets of London. An incredible two billion viewers watched on television or the Internet as the joyful bells of Westminster Abbey rang out to greet the bride.

Catherine Middleton stood up bravely to the immense pressure. Quite relaxed she stepped out of the royal Rolls Royce in front of the abbey and made her way to the altar on the arm of her father. For another three and a half long minutes the bridegroom had to hold out because protocol forbade him to turn round. Fortunately however, William had chosen his

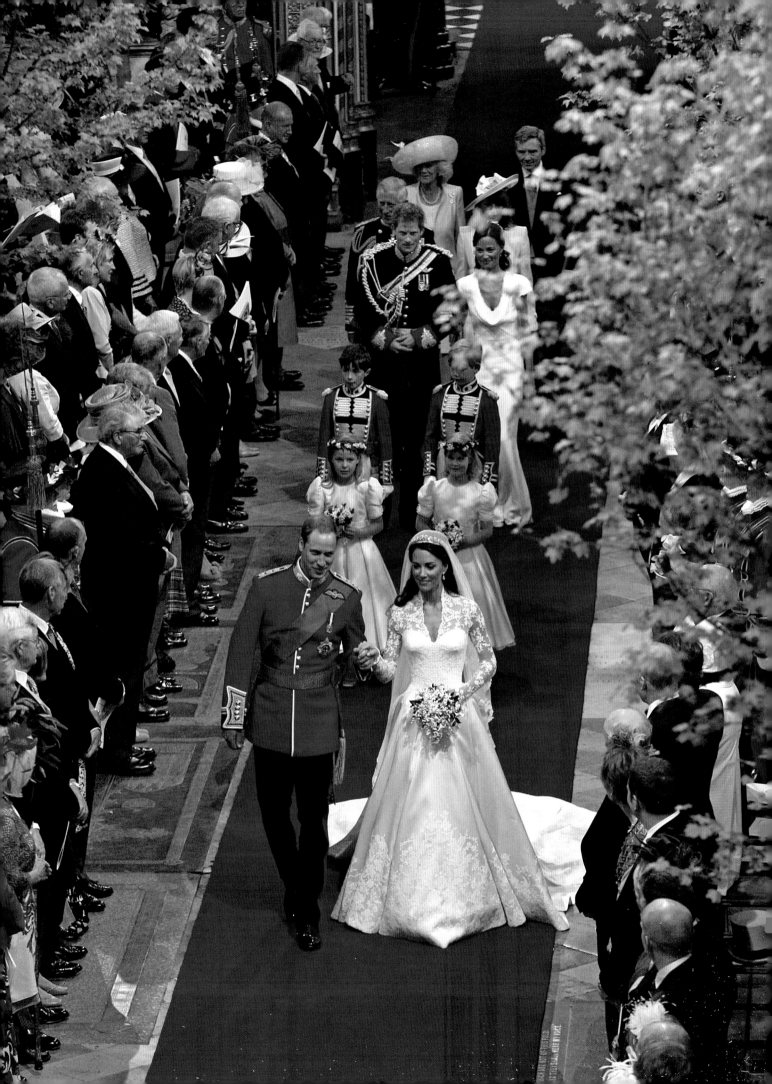

denn laut Protokoll durfte er sich nicht umdrehen. Doch zum Glück hatte William seinen Bruder Harry zum Trauzeugen gemacht und der nahm keine Rücksicht auf das Protokoll, warf einen Blick über die Schulter und flachste: „So, das war's, sie ist da." Und als die Braut dann schließlich neben William stand, war sogar dieser schon wieder zu einem echt britischen Witz in der Lage. „Eigentlich sollte das hier eine kleine Familienfeier werden", flüsterte er dem Vater der Braut zu.

brother Harry as best man, who ignored protocol, glanced over his shoulder and quipped, "Right, here she is now." When finally she stood at his side William was relaxed enough to make a typically English joke, whispering to his future father-in-law: "We're supposed to have just a small family affair."

Composed and word perfect the bride and bridegroom went through the marriage ceremony and then made their radiant way down the central aisle to the door. "Magnificently done" was the unanimous verdict

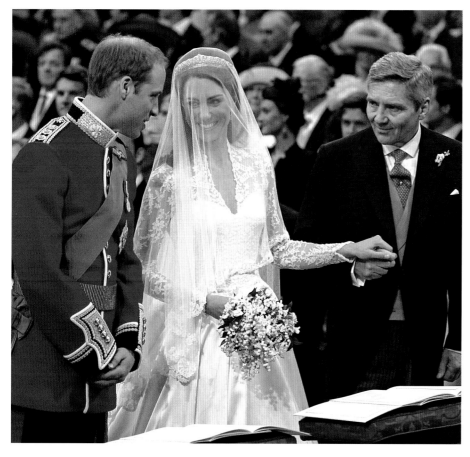

Traditionell. Dass die Braut verschleiert erschien, überraschte viele. Der Brautstrauß enthielt nach Sitte der Windsors auch Myrtenzweige aus einem Busch, den Queen Victoria einst pflanzen ließ. Kleine Nelken namens „Sweet William" waren ein besonderes Extra.

Traditional. Many people were surprised that the bride wore a veil. Her bouquet, following the tradition of the Windsors, included sprigs of myrtle from a bush planted on the orders of Queen Victoria and as an extra touch sweet williams of the carnation family.

Beherrscht und ohne einen Stolperer absolvierten Braut und Bräutigam die festliche Trauung und schritten strahlend durch den Mittelgang nach draußen. „Großartig gemacht", so das einhellige Urteil der Milliarden Zuschauer. Und einem huldvollen Lächeln war zu entnehmen, dass das Brautpaar auch in den Augen der wohl kritischsten Zuschauerin bestanden hatte – der Queen.

of the two billion watching. A gracious smile showed that the bridal couple had done well in the eyes of the most critical observer – the queen.

Willkommen im Adel. Als Herzog und Herzogin von Cambridge zog das Brautpaar aus der Westminster Abbey. Der Titel wird seit dem 17. Jahrhundert an Mitglieder der königlichen Familie verliehen und ging nun als Geschenk der Queen an ihren Enkel und seine Braut.

Welcome to the nobility. The bridal couple left the abbey as Duke and Duchess of Cambridge. Ever since the 17th Century the title has been reserved for members of the royal family and was a present from the queen to her grandson and his bride.

Eine schrecklich nette Familie. Die Brauteltern Michael und Carole Middleton machten zwischen Prinz Charles und seiner Frau Camilla eine gute Figur.

A perfectly ordinary family. The bride's parents, Michael and Carole Middleton, cut a good figure between Prince Charles and his wife Camilla.

Heimliche Stars. Trauzeugin Pippa Middleton kam mit ihrem figurbetonten Seidenkleid nicht nur bei Amtskollege Harry gut an. Die Geschwister des Brautpaars hatten auch die abendliche Party in Buckingham Palace organisiert. Nur 300 Gäste, Familie und enge Freunde, durften mitfeiern.

Surprise stars. Maid of Honour Pippa Middleton in her figure-hugging silk dress was admired by more people than just her opposite number Harry. Pippa and Harry had also organised the evening party in Buckingham Palace. Only 300 guests, family and close friends, received invitations.

87

Geschmacksfragen. An den Hutkreationen mancher Damen schieden sich die Geister. Charlene Wittstock, die zukünftige Fürstin von Monaco, zeigte sich stilsicher. Brautmädchen Grace van Cutsem trug ein perfektes Blumenkränzchen, weigerte sich aber, in den Jubel beim Balkonkuss einzustimmen. Ihr war es sichtlich zu laut.

A matter of taste. Opinions were divided on the hats of some of the ladies. Charlene Wittstock, the future Princess of Monaco, was a picture of classic elegance. Bridesmaid Grace van Cutsem wore a perfect circlet of flowers on her head but refused to take part in the rejoicing at the balcony kiss. It was clearly just too noisy for her.

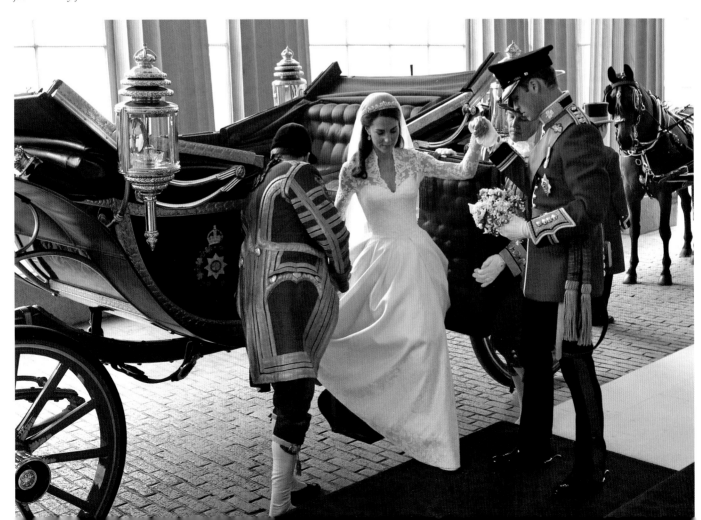

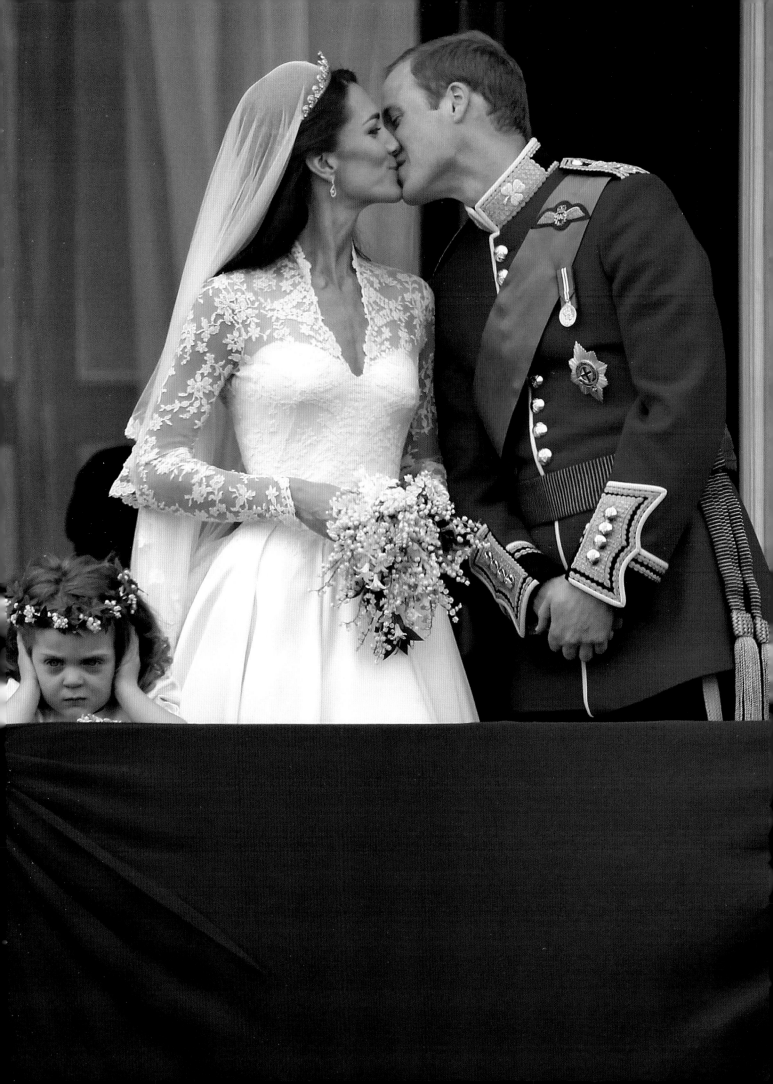

Massenaufgebot. Diszipliniert ließ sich die Menge von den Gardisten zum Buckingham Palace führen. Am Vorabend der Hochzeit hatte Prinz William auf „The Mall" die bereits wartenden Fans mit einem Besuch überrascht. Überall in England war der Hochzeitstag arbeitsfrei. Bis zur letzten Sekunde arbeiteten die Hofkonditoren an der achtstöckigen Hochzeitstorte. Prinz William bevorzugte aber einen Schokoladen-Keks-Kuchen nach Familienrezept, der extra für ihn gemacht worden war.

Joyful order. The disciplined crowds allowed the guards to lead them in their surge to the palace. On the evening before the wedding Prince William had paid a surprise visit to the fans camped out on the Mall. Throughout Britain the day was a public holiday. The confectioners worked on the eight-tiered wedding cake right up to the last minute. Prince William, though, preferred a chocolate biscuit cake made to a family recipe and ordered specially for him.

Spritztour. Das schicke Cabrio, in dem William seine Frau unter dem Jubel der Menge von Buckingham Palace nach Clarence House chauffierte, kam von seinem Vater. Der hatte den 350 000 Pfund (etwa 400 000 Euro) teuren Aston Martin einst von der Queen erhalten. Doch bevor das Paar in die Flitterwochen davonbrausen konnte, ging es für William erst mal wieder zum Militär. Er hatte nach seiner Hochzeit nur ein Wochenende Sonderurlaub genommen.

Short spin. The elegant open Aston Martin in which William, to the cheers of the crowd, drove his wife from Buckingham Palace to Clarence House, came from his father. He in turn had been given the £350,000 (400,000 euros) car by the queen on an earlier occasion. Before the couple could leave for their honeymoon however, William had to go back to his military duties. After his wedding he had taken only a weekend's special leave.

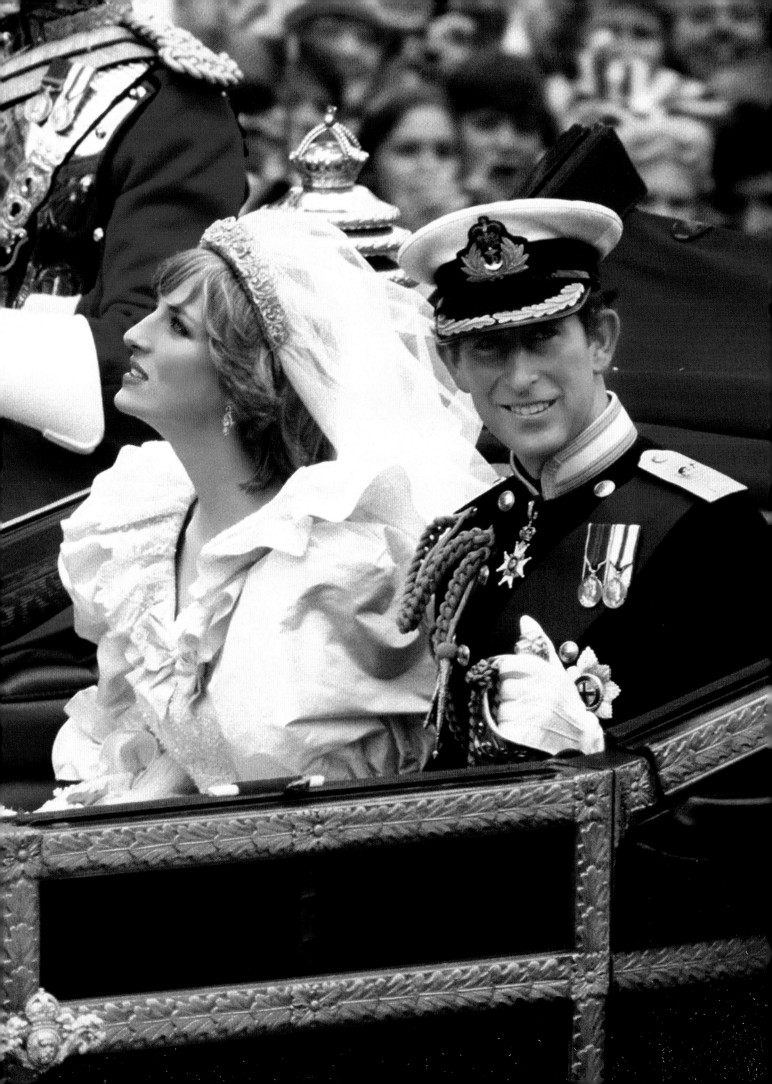

Charles & Diana

Die Jahrhunderthochzeit
Großbritannien, 29. Juli 1981

The Wedding of the Century
Great Britain, 29 July 1981

Für die Zuschauer und die 2 500 geladenen Gäste war es nicht hörbar, aber an der Bewegung seiner Lippen ist es noch heute auf den Fernsehaufnahmen deutlich abzulesen: „Du siehst wundervoll aus", sagte Prinz Charles von Wales zu seiner Braut, als er sie vor dem Altar der St. Paul's Cathedral empfing. „Wundervoll für Dich", flüsterte Diana mit errötenden Wangen zurück.

Auch wenn ihre Ehe tragisch endete – an diesem strahlenden Sommertag rührte die Hochzeit des britischen Thronfolgers mit der gerade 20-jährigen Kindergärtnerin Lady Diana Spencer weltweit 750 Millionen Fernsehzuschauer, so viele wie nie zuvor bei einem derartigen Ereignis. „Das ist der Stoff, aus dem die Märchen sind: Der Prinz und die Prinzessin an ihrem Hochzeitstag", sagte der Erzbischof von Canterbury in seiner Predigt. Seit Monaten waren die Vorbereitungen auf Hochtouren gelaufen. Die Hauptfeierlichkeiten eröffnete am Vorabend der Hochzeit ein rauschender Ball im Buckingham Palace. Die Braut verbrachte die Nacht in Clarence House unter „Aufsicht" der Königinmutter. Sie sagte später, ruhig geschlafen zu haben, doch die letzten Wochen hatten auch an ihren Nerven gezerrt. Nach der Generalprobe war die junge Braut überzeugt gewesen, den Erwartungen nicht gerecht werden zu können, und

The spectators and 2,500 invited guests couldn't hear him but the movement of his lips can still clearly be seen on the television pictures: "You look wonderful," said Charles, Prince of Wales, to his bride when he met her at the altar of St. Paul's Cathedral. "Wonderful for you," whispered Diana, blushing.

Although their marriage was to end tragically, the wedding of the heir to the British throne and the barely 20-year-old Lady Diana Spencer on that bright sunny day touched the hearts of 750 Million television viewers around the world, more than ever before for this kind of occasion. Paraphrasing Shakespeare, the Archbishop of Canterbury in his sermon declared: "Here is the stuff of which fairy tales are made: the prince and the princess on their wedding day." For months preparations had been under way. A glamorous ball at Buckingham Palace on the eve of the wedding marked the beginning of the main celebrations. The bride spent the night at Clarence House under the eye of the Queen Mother. She later said that she had slept well, but the preceding weeks had been a major strain on her nerves. After the dress rehearsal the young bride was convinced that she wouldn't be able to live up to expectations and was constantly in tears. Prince Charles, who had grown up with the stresses of public life, thought of something that might help to soothe her on that nerve-wracking

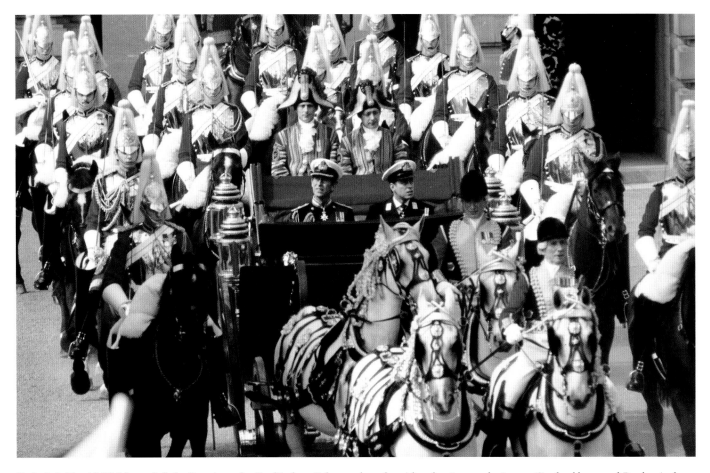

Spektakel. Um 10:32 Uhr verließ der Bräutigam den Buckingham Palace und machte sich, eskortiert von berittenen Gardesoldaten und Bruder Andrew, auf den Weg zur St. Paul's Cathedral. Nie zuvor war eine Hochzeit von so vielen Reportern, Kameras und Zuschauern begleitet worden.

Spectacular. At 10.32 a.m. the bridegroom left Buckingham Palace, accompanied by his brother Andrew and a Horse Guards escort, for St. Paul's Cathedral. Never before had a wedding attracted so many reporters, cameras and spectators.

hatte ununterbrochen geweint. Prinz Charles, der den Druck der Öffentlichkeit von Kindesbeinen an kannte, hatte sich an diesem Abend etwas einfallen lassen, um Diana zu beruhigen. In Clarence House erwartete sie ein Siegelring mit den eingravierten Federn des Prinzen von Wales. Auf eine beiliegende Karte hatte er geschrieben: „Ich bin so stolz auf Dich, und wenn Du morgen kommst, werde ich am Altar für Dich da sein. Schau ihnen einfach in die Augen und hau sie um!"

Und das tat sie wirklich. Diana sah aus wie einem Märchenbuch entstiegen, als sie am nächsten Tag vor der St. Paul's Cathedral die gläserne Kutsche der Windsors verließ. Am Arm ihres Vaters, Earl Spencer, machte sie sich auf den dreieinhalb Minuten dauernden Weg durch den Mittelgang der Kathedrale. Der noch unter den Folgen eines Schlaganfalls leidende Earl allerdings war seiner Tochter weniger eine Stütze, als dass sie ihm durch die Kirche half. Diana meisterte diese Hürde mit Bravour, die Jubelstürme, mit denen ihre

evening: a signet ring engraved with the Prince of Wales' feathers. On the accompanying card he had written: "I'm so proud of you, and when you arrive at the altar tomorrow I shall be there waiting for you. Look the people straight in the eye and stun them."

Stun them she did. Diana looked as if she had stepped out of a fairy tale when on the following day she left the Windsors' glass coach in front of St. Paul's Cathedral. It took three and a half minutes for her to walk slowly down the central aisle of the cathedral on the arm of her father, Earl Spencer. As the earl was suffering from the effects of a stroke it looked as if instead of his supporting his daughter it was she who was guiding him. Diana carried it off perfectly, the rousing cheers that had greeted her on her arrival had given her confidence. There were two amusing slips of the tongue at the altar. Instead of "Charles Philip Arthur George" the bride took as her husband "Philip Charles Arthur George". The bridegroom, under his new name,

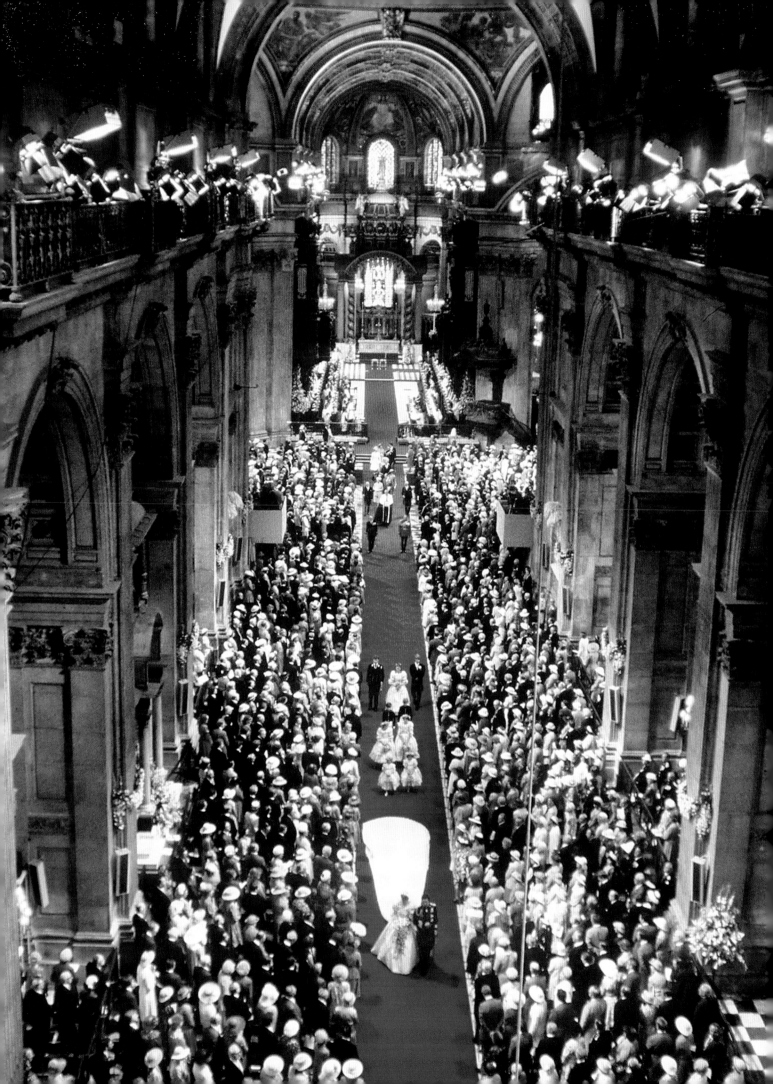

Das Kleid ihrer Träume. Diana hatte das bis dahin wenig bekannte Designerduo Elizabeth und Daniel Emanuel verpflichtet. „Just one Cornetto", einen TV-Jingle auf die Melodie von „O sole mio", sang sie ausgelassen, als die Zofen ihr am Hochzeitsmorgen das Kleid über den Kopf zogen. Die schmale Taille des elfenbeinfarbenen Seidentaftkleides ging über in einen ausladend gerüschten Rock, dem eine siebeneinhalb Meter lange Taftschleppe folgte. Antike, mit Goldfäden durchwebte Spitze, weit geraffte Ärmel – ein Bild, wie es jedes kleine Mädchen aus seinem Märchenbuch kennt. Die Kleidchen der Blumenmädchen waren in ähnlichem Stil gehalten. Die Queen zeigte sich ganz ohne Spitze in Türkis.

The dress of her dreams. Diana had ordered her dress from the little-known designers Elizabeth and Daniel Emanuel. As it was slipped over her head on the morning of the wedding she was happily singing "Just one Cornetto", a television jingle to the tune of "O Sole Mio". The gown, of ivory-coloured silk taffeta, had a slender waist flaring into a full ruched skirt and a taffeta train 25 feet long. Gold-threaded antique lace and long wide puffed sleeves – a picture familiar to every little girl from her book of fairy tales. The bridesmaids' dresses were copies of the bride's and the queen wore turquoise.

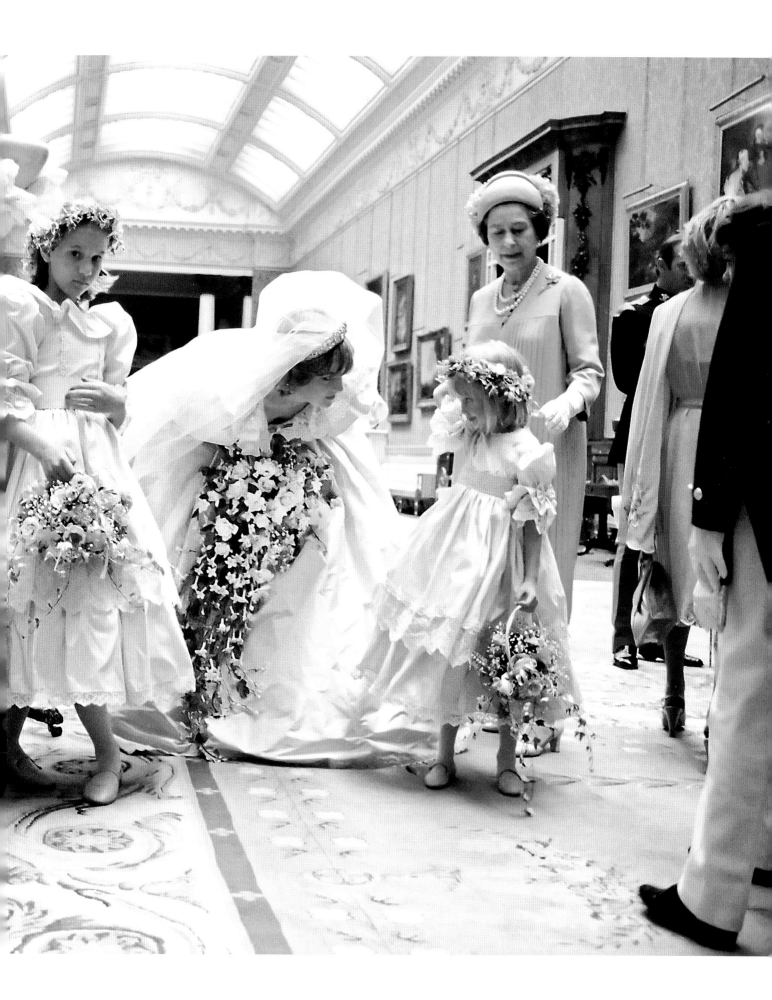

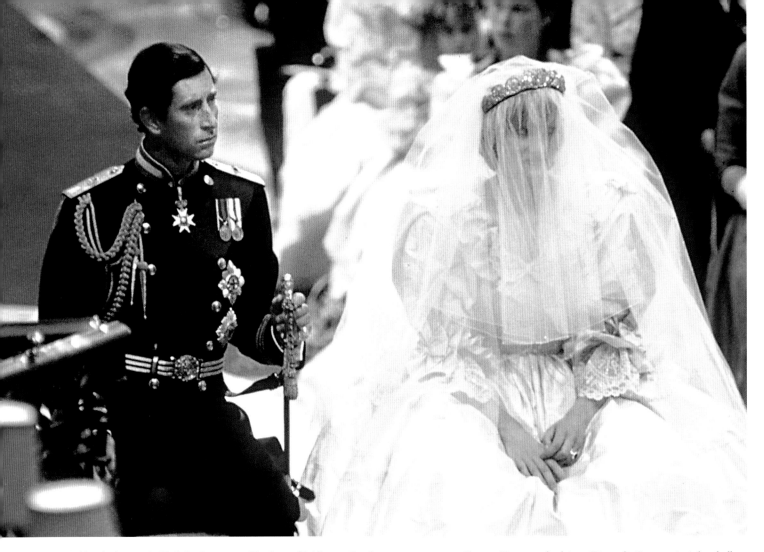

Schleierhaft. Der Anblick der Braut war Charles und Millionen Zuschauern spät gegönnt. Bis zur Trauung absolvierte Diana die Zeremonie tief verhüllt.

Behind the veil. Charles and millions of spectators had to wait before they could see the bride properly. Until the exchange of vows Diana was heavily veiled.

Made in Britain. Der 1,80 Meter hohe englische Fruchtkuchen mit Marzipan war bereits im März gebacken worden, um den gewünschten Geschmack reifen zu lassen. Es dauerte allein eine halbe Stunde, um alle Eier für das 100 Kilogramm schwere Prachtstück aufzuschlagen.

Made in Britain. The six-foot high wedding fruit cake with marzipan had been baked in March so as to develop the desired flavour. Beating the eggs for the 220-pound masterpiece had alone taken a good half hour.

Vorfahrt begrüßt worden war, hatten ihr Mut gemacht. Vor dem Altar aber kam es dann zu einem amüsanten Versprecher. Beim Gelübde verhaspelte sich die Braut, so dass sie anstelle von „Charles Philip Arthur George" einen „Philip Charles Arthur George" zum Ehemann nahm. Dem so umbenannten Bräutigam erging es wenig besser. Er versicherte vor Gott und den Anwesenden, dass er all „ihre" Güter mit Diana teilen wollte, wo er doch selbstredend „seine" Güter hätte versprechen sollen. Für die Zuschauer wurde die Zeremonie dank dieser kleinen Pannen umso liebenswerter. Sie zeigten schließlich, dass auch an einer Jahrhunderthochzeit zwei Menschen vor dem Altar standen – mit all ihrer Nervosität, all ihren Zukunftsängsten und all ihren Hoffnungen.

was no better: he declared before God and those present that he would share with Diana all her ("thy") worldly goods instead of his ("my"). These two small lapses endeared them all the more to the public, since they showed that even at the wedding of the century the two people at the altar were human beings, with all their nervousness and hopes and fears for the future.

To a fanfare of trumpets and the pealing of bells the Prince and new Princess of Wales left the west door of the cathedral to present themselves in the sunshine to the 600,000 spectators who had gathered in the streets of London. In an open carriage they drove to Buckingham Palace, where for the first time in the history of the British royal family a public kiss was exchanged. To the rousing cheers of the crowds Prince

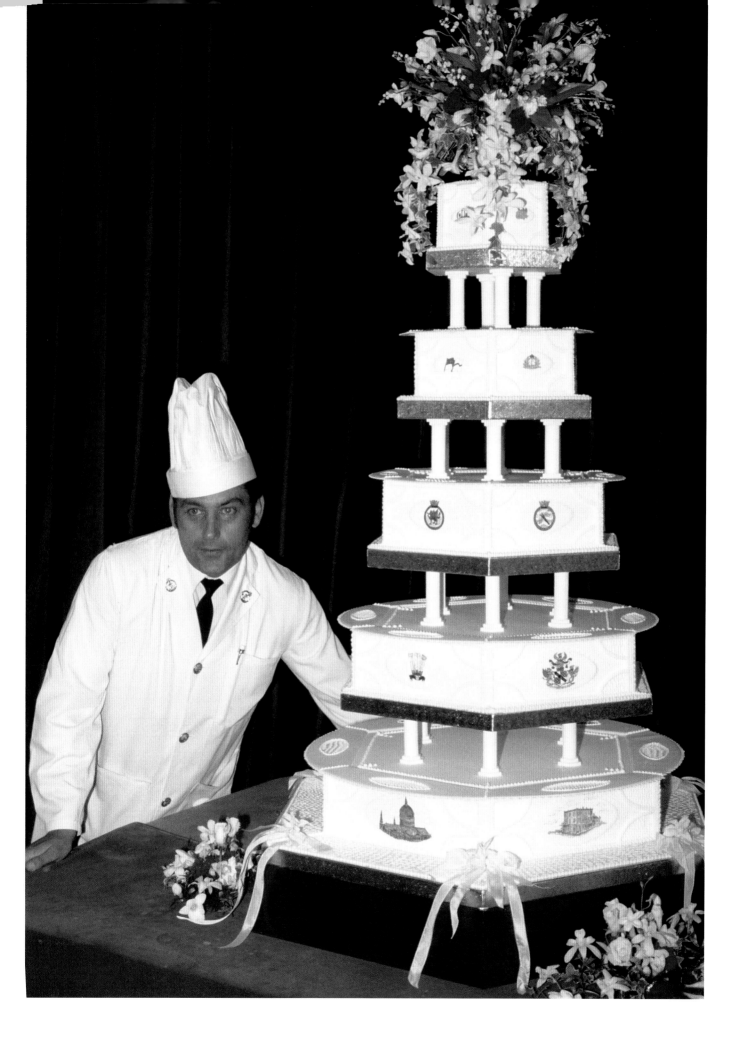

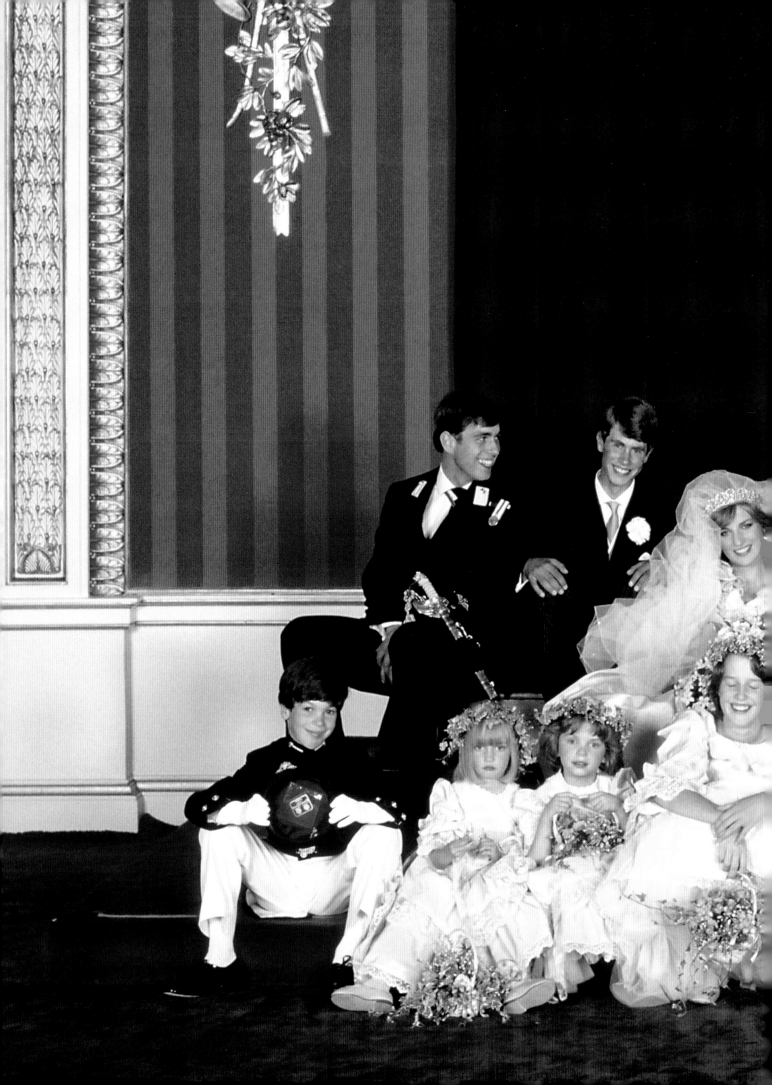

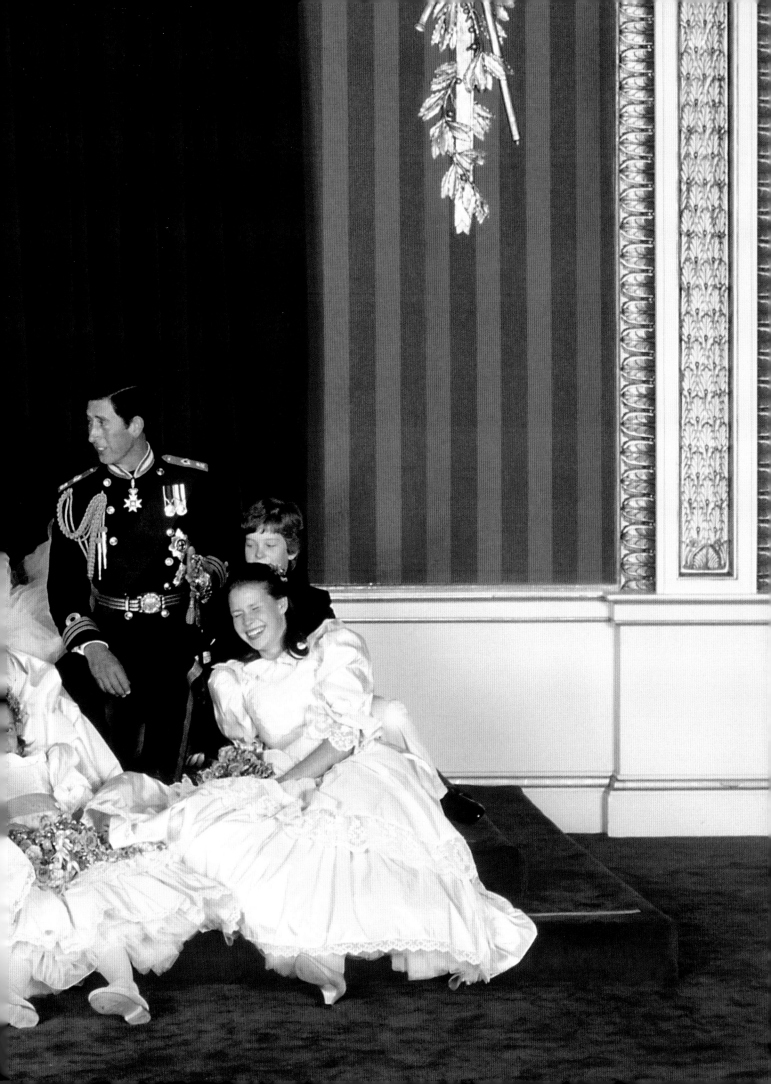

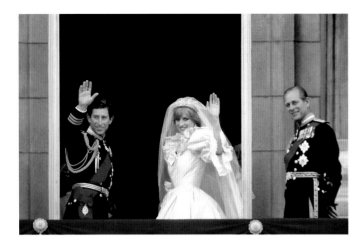

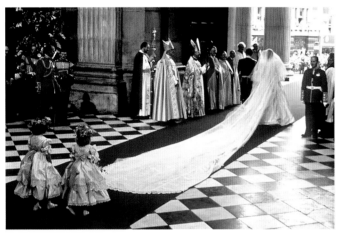

Unterstützung durch die Untertanen. Hunderttausende strömten nach der Trauung über die Mall zum Buckingham Palace und feierten ausgelassen, während das Paar bestens gelaunt für die offiziellen Hochzeitsfotos posierte. Noch Stunden nach dem offiziellen Auftritt auf dem Balkon rief die Menge vor dem Palast nach Diana und Charles. An guten Wünschen für ihre Ehe hat es ihnen nicht gefehlt.

Public support. After the wedding hundreds of thousands streamed along the Mall to Buckingham Palace while the couple, in the best of humour, posed for the official photographs. Hours after the planned appearance on the balcony the crowds before the palace were calling for Diana and Charles. There was certainly no lack of good wishes for their marriage.

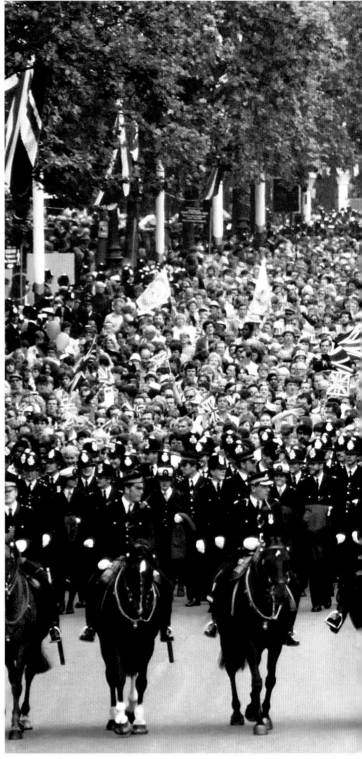

Unter Fanfarenklängen und Glockengeläut verließen der Prinz und die frischgebackene Prinzessin von Wales das Westportal der Kathedrale und präsentierten sich im Sonnenschein den 600 000 Zuschauern, die sich in den Straßen Londons versammelt hatten. In einer offenen Kutsche führte der Weg zum Buckingham Palace, wo zum ersten Mal in der Geschichte der briti-

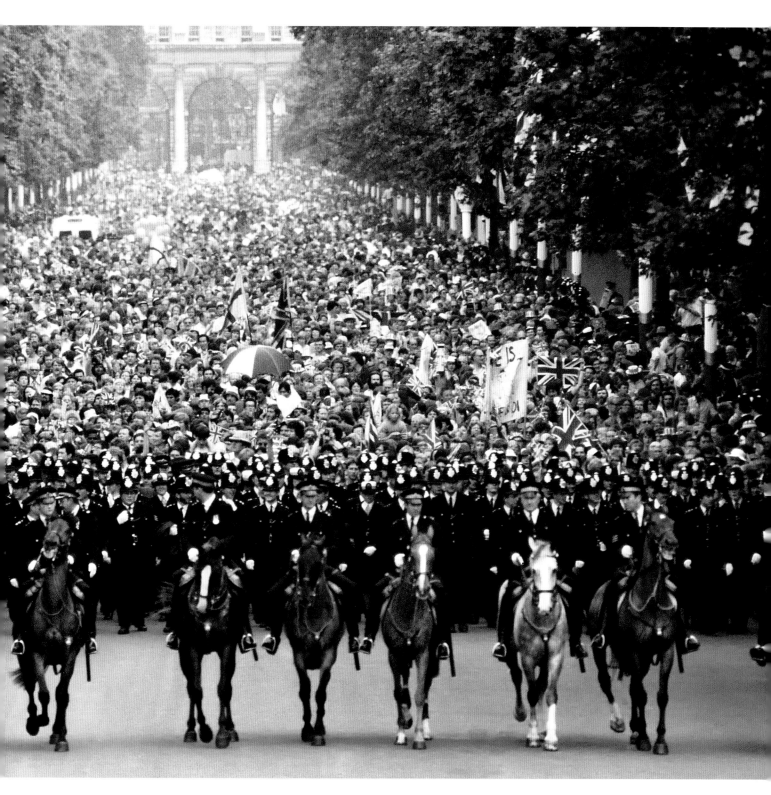

schen Monarchie ein öffentlicher Kuss auf dem Balkon folgte. Unter dem aufbrausenden Jubel der Massen küsste Prinz Charles die Frau leidenschaftlich auf den Mund, die einmal Königin von England werden sollte. Dass es anders kam, konnte an diesem Tag niemand ahnen. Die Bilder dieses strahlenden Festes bleiben dennoch bis heute unvergessen.

Charles gave a passionate kiss on the lips to the woman who would one day be queen. Nobody could then foresee that that was not to be, but the pictures of that glorious day remain unforgettable.

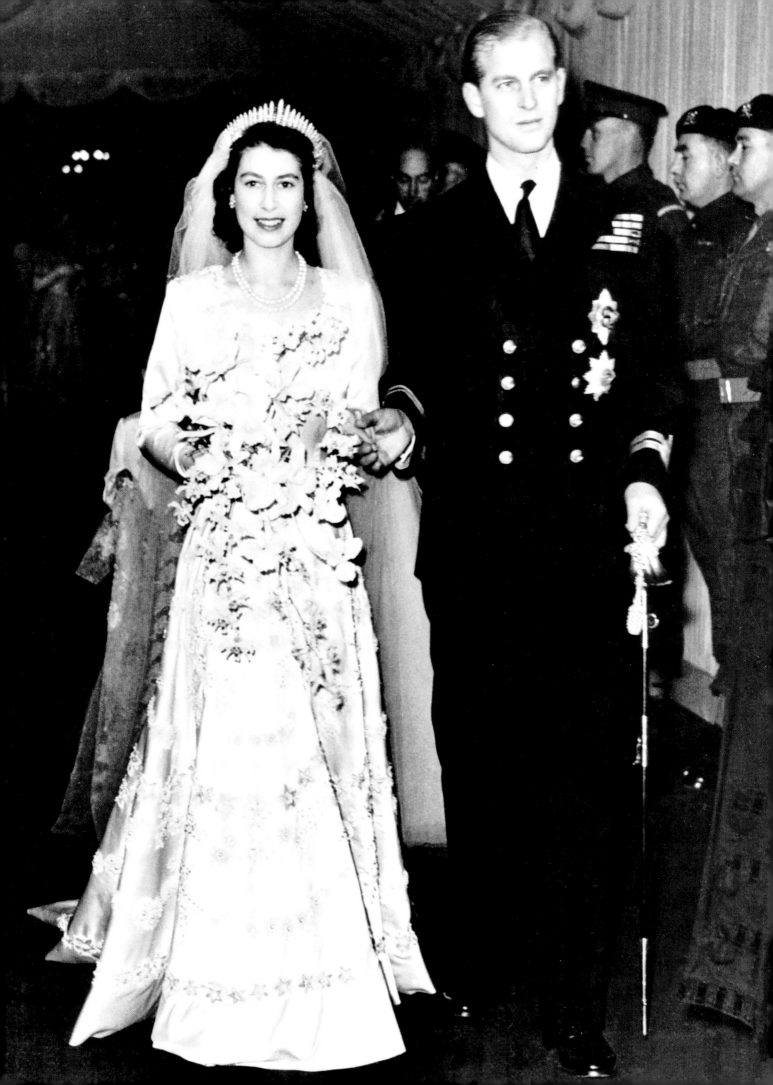

Elizabeth & Philip

Die Nachkriegshochzeit
Großbritannien, 20. November 1947

The Postwar Wedding
Great Britain, 20 November 1947

Einen solchen Hochzeitstag kann sich nur eine waschechte Britin aussuchen. Wie kaum anders zu erwarten, war der 20. November in London bitterkalt und verregnet. Die Thronerbin störte das nicht, denn sie wollte an diesem Tag aus vollem Herzen „Ja" sagen zu einem Mann, den sie bereits seit Jahren liebte. Schon mit 13 Jahren hatte Elizabeth sich in den fünf Jahre älteren Philip Mountbatten verliebt und beschlossen, dass es dieser und kein anderer sein sollte. Ihre Wahl stieß bei den Untertanen zunächst auf wenig Gegenliebe, denn Philips familiäre Wurzeln waren deutsch. Zwei Jahre nach dem Zweiten Weltkrieg war dies für die Engländer eine bittere Pille. Auch König George VI. hätte die Hochzeit gern noch ein wenig hinausgezögert. Ihm war seine geliebte „Lilibet" mit 21 noch ein bisschen jung, doch schließlich lenkte er ein und gab am 9. Juli 1947 die Verlobung bekannt.

Der Hochzeitstag begann für Elizabeth wie jeder andere Tag auch – mit einer Tasse Tee. Das Team von Designer Norman Hartnell begann um 9 Uhr mit dem Einkleiden der Kronprinzessin, die sich in nur einer Stunde in eine strahlende Braut verwandelte. War bis hierher alles glatt gegangen, liefen die Dinge nun etwas aus dem Ruder. Das Diadem, eine Leihgabe der Brautmutter, brach beim Aufsetzen auseinander und musste notdürftig repariert werden. Eine Perlenkette, das

Only a full-blooded Briton could have chosen that as her wedding day. In London 20 November, as was to be expected, was wet and bitterly cold. That didn't deter the heiress to the throne; on that day she intended to say a fervent "I will" to the man she had loved for years. At the age of 13 she had fallen in love with Philip Mountbatten, five years her senior, and decided that he was the one and only man for her. Due to his German background not all her father's subjects were at first in favour of the marriage, a bitter pill only two years after the end of World War Two. Her father, King George VI, would have liked to delay the wedding a little longer. His beloved Lilibet at 21 seemed to him a little too young, but at last he agreed and on 9 July 1947 announced her engagement.

The wedding day began for Elizabeth like any other, with a cup of tea. At 9 a.m. the team from designer Norman Hartnell began to dress her and in only an hour she was transformed into a radiant bride. Until then things had gone well but now they started to run out of control. The tiara, lent by her mother, fell apart when it was put on and had to be hastily mended. A pearl necklace, gift of her parents, could not be found. It was finally discovered in St. James's Palace and rushed to Buckingham Palace by Elizabeth's private secretary. Last of all the bridal bouquet had disappeared

Geschenk der Brauteltern, war plötzlich nicht auffindbar. Erst nach längerem Suchen fand sie sich im St. James's Palace und wurde von Elizabeths Privatsekretär in aller Eile herbeigeschafft. Zu guter Letzt war auch noch der Brautstrauß verschwunden und wurde schließlich in einem Kühlschrank aufgespürt. Um 11 Uhr aber hatte man den Zeitplan wieder eingeholt und Elizabeth machte sich an der Seite ihres Vaters in der Staatskutsche auf in die Westminster Abbey. Philip hatte den Tag entspannt angehen lassen. Seine Marineuniform war flink angezogen und gegen eventuelle Aufregung hatte er sich mit einem Gin Tonic gewappnet. Gelassen absolvierte das Paar die Trauzeremonie. Der König aber konnte und wollte seine Rührung nicht verbergen. „Es ist viel ergreifender, die Tochter zu verheiraten, als

and was eventually found in a refrigerator. By 11 a.m. the programme was on time again and Elizabeth drove with her father in the state coach to Westminster Abbey. Philip's preparations were more relaxed. His naval uniform was quickly put on and to guard against all eventualities he had fortified himself with a gin and tonic. While the bridal couple went through the service with perfect composure the king didn't try to hide his emotion. As he confessed to the Archbishop of Canterbury "Marrying off a daughter is far more moving than one's own wedding."

In spite of the icy weather hundreds of thousands lined the streets, as an open coach brought the newly married couple to Waterloo Station at the start of their honeymoon. Most of the onlookers probably felt, along

Süßer Ehebeginn. Die prächtige Torte war beinahe drei Meter hoch und trug die Familienwappen der Brautleute. Angeschnitten wurde das Meisterstück ganz stilecht mit einem Schwert, das der Bräutigam von König George VI. bekommen hatte.

Sweet beginning. The magnificent wedding cake was nine feet high and decorated with the bridal couple's coats of arms. In keeping with tradition they cut it with a sword, given to the bridegroom by King George VI.

Junggesellenabschied. Am Vorabend der Hochzeit wurde auch die Presse ins Hotel Dorchester geladen. Die Herren beendeten den Fototermin, indem sie die Blitzlichter von den Kameras montierten und zertrümmerten. Unter Ausschluss der Öffentlichkeit wurde dann im Belfry Club richtig gefeiert.

Stag party. On the evening before the wedding the press were invited to a stag party for the bridegroom's male friends at the Dorchester Hotel. The guests ended the photo session by tearing off the flash lights of the journalists' cameras and stamping on them. After that the real party began behind closed doors at the Belfry Club.

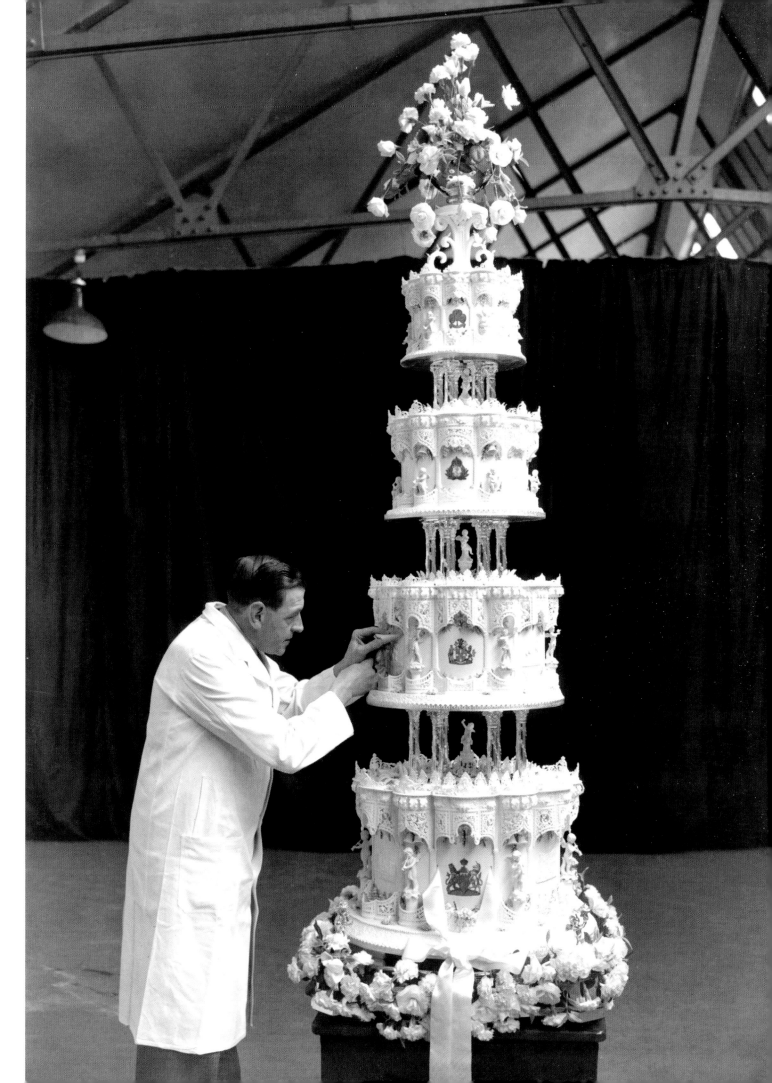

selbst zu heiraten", gestand er dem Erzbischof von Westminster.

Hunderttausende säumten trotz des eisigen Wetters die Straßen, als ein offener Landauer das frisch vermählte Paar zum Bahnhof Waterloo brachte, von wo aus es in die Flitterwochen startete. Die meisten empfanden wohl, was Winston Churchill formulierte: Das Fest gleiche „einem Lichtblick auf der beschwerlichen Straße, die wir gehen müssen". Noch hatten die Briten stark unter den Entbehrungen der Nachkriegszeit zu leiden und selbst Buckingham Palace hatte auf überzogenen Pomp verzichten müssen. So finanzierte Elizabeth ihr Hochzeitskleid mit 200 Extra-Kleidermarken, das Menü bot schlichtes Rebhuhn im Hauptgang – eine der wenigen Fleischsorten, die nicht rationiert waren. Und

with Winston Churchill, that the occasion was "A splash of colour on the hard road we have to travel." Britain was still suffering under the shortages of the postwar years and even Buckingham Palace had had to cut down on too much festivity. Elizabeth's wedding dress cost 200 extra clothing coupons and the main course at the wedding breakfast was partridge, one of the few kinds of meat not rationed. In Westminster Abbey the guests knelt on plywood boxes covered in pink silk. Nevertheless the couple were given a great many presents: 2,500 piled up in the palace on the wedding day. Practical ones, like a washing machine and a sewing machine, but also silver salt cellars and a complete service of Sèvres china. The province of Queensland in Australia sent 500 tins of pineapple and Elizabeth was

Geordnete Verhältnisse. Die Ankündigung der Hochzeit löste in London Hochzeitsfieber aus. Die Polizei tat ihr Bestes, um Gäste und Schaulustige am großen Tag auf den rechten Weg zu bringen.

Under control. The announcement of the wedding sent London into a frenzy. Hundreds of signs directing spectators and traffic on the great day were put up by the police.

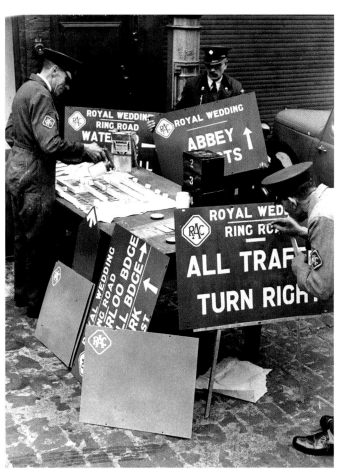

Nicht geladen. Unter den Gästen in der Westminster Abbey fehlten Philips Schwestern. Sie waren mit Deutschen verheiratet und daher nicht erwünscht.

Not invited. Philip's sisters were not among the guests in Westminster Abbey; they were married to Germans and therefore not welcome.

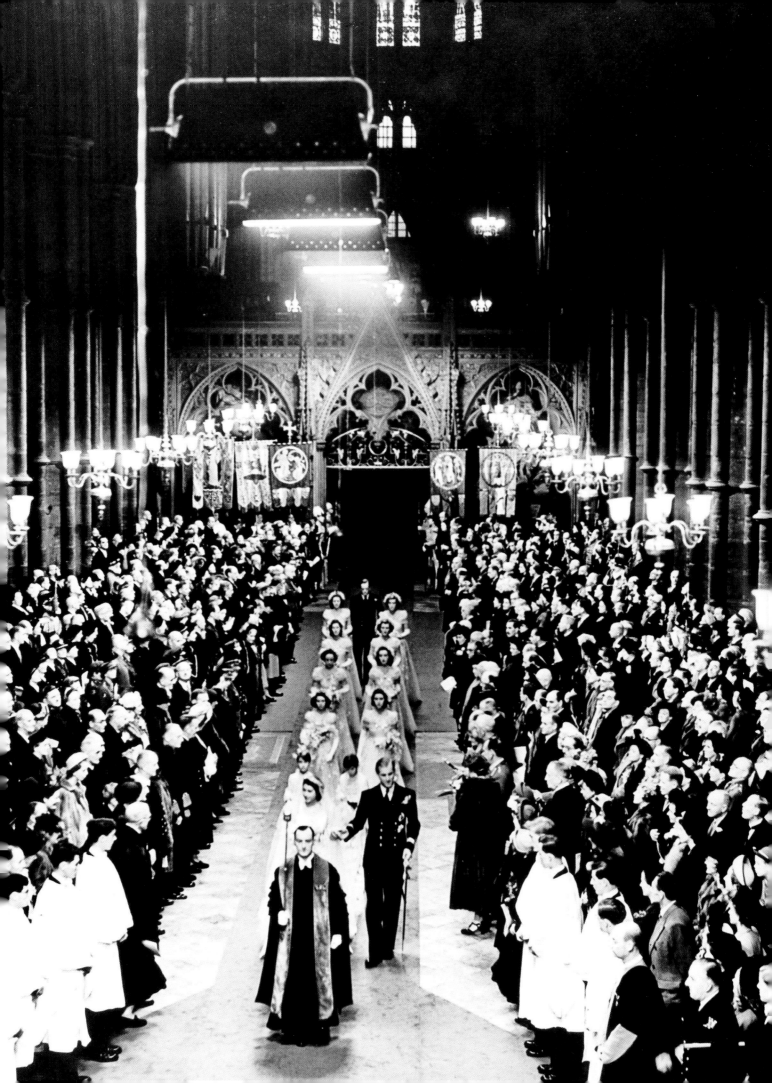

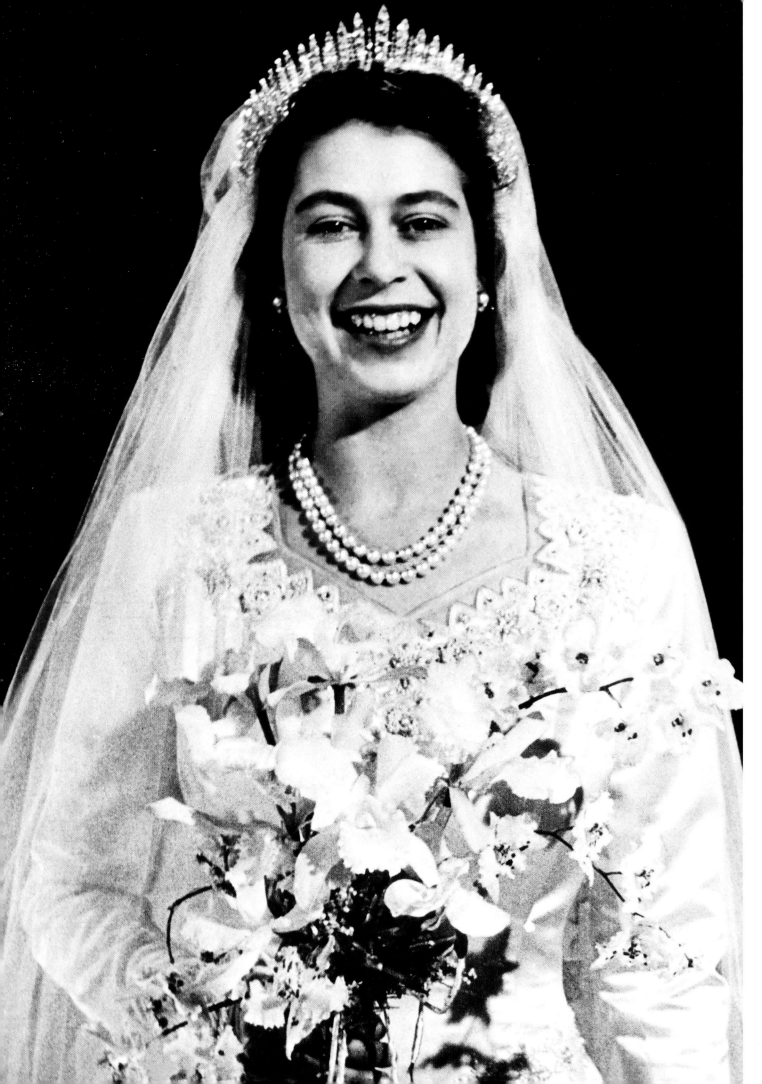

in der Westminster Abbey knieten die Gäste auf Sperr-holzkartons, die man mit rosafarbener Seide umhüllt hatte. Dennoch wurde das Paar reich beschenkt. 2 500 Präsente stapelten sich am Hochzeitstag im Palast: Praktisches, wie eine Waschmaschine und eine Singer-Nähmaschine, aber auch silberne Salzstreuer oder ein komplettes französisches Sèvres-Service. Die Provinz Queensland schickte 500 Dosen Ananas, die Untertanen einige Dutzend Nylonstrümpfe für die Braut. Aus Indien kam von Mahatma Gandhi ein selbst gesponnenes Tuch, worüber die Großmutter der Braut, Königin Mary, alles andere als amüsiert war. Sie hielt es für Gandhis Lendenschurz. Prinz Philips Geschenk an die Braut kostete ihn echte Überwindung: Am Tag der Hochzeit gab er für sie das Rauchen auf.

presented with several dozen pairs of nylon stockings, at that time a great luxury. Mahatma Gandhi sent a piece of cloth he had woven himself; unfortunately Queen Mary, grandmother of the bride, thought it was his loin-cloth and was not amused. Prince Philip's present to Elizabeth represented a real sacrifice – on the day of the wedding he gave up smoking for her sake.

Strahlend schön. Kronprinzessin Elizabeth als Braut. Die 10 000 Perlen, mit denen das elfenbeinfarbene Satinkleid versehen war, hatte Designer Norman Hartnell aus Amerika einfliegen lassen. Das mit Diamanten besetzte Diadem hatte Elizabeth von ihrer Mutter „geliehen" bekommen. Die doppelreihige Perlenkette mit 96 Perlen aus Familienbesitz hatten ihre Eltern als etwas „Neues" zur Hochzeit geschenkt. Die Perlenohrringe dagegen waren „gebraucht" – ein Geschenk von Königin Mary zu ihrem 20. Geburtstag. Weiße Orchideen und Myrten bildeten den Brautstrauß. Letztere waren aus demselben Busch geschnitten, aus dem seit 1850 alle Sträuße königlicher Bräute bestückt worden waren. Auch der, den Königin Elizabeth 50 Jahre später bei den Feierlichkeiten anlässlich ihrer Goldenen Hochzeit trug.

Radiant beauty. Princess Elizabeth as bride. The 10,000 pearls on the dress of ivory-coloured satin had been specially flown in from America by designer Norman Hartnell. The diamond tiara was the traditionally "borrowed" accessory, from her mother; the necklace of a double row of 96 pearls, a family heirloom, was a present from her parents as "something new"; and the pearl earrings were "something old", a present from Queen Mary on Elizabeth's 20th birthday. The bridal bouquet was of white orchids with myrtle, cut from the same bush that has supplied flowers for the bouquets of all royal brides since 1850 and also for Queen Elizabeth's golden wedding 50 years later.

Ehrung der Gefallenen. Am Tag nach der Hochzeit ließ Elizabeth ihren Brautstrauß auf dem Grab des Unbekannten Soldaten in der Westminster Abbey niederlegen.

Remembrance. On the day after the wedding Elizabeth's bridal bouquet was laid on the tomb of the Unknown Warrior in Westminster Abbey.

Standfest. In diesen Schuhen konnte Elizabeth ihren großen Tag ohne Fußschmerzen überstehen. Auch heute noch mag es die Königin eher bequem als hochhackig.

Sure-footed. In these shoes Elizabeth was able to get through her great day without her feet hurting. The queen still prefers comfortable shoes to high heels.

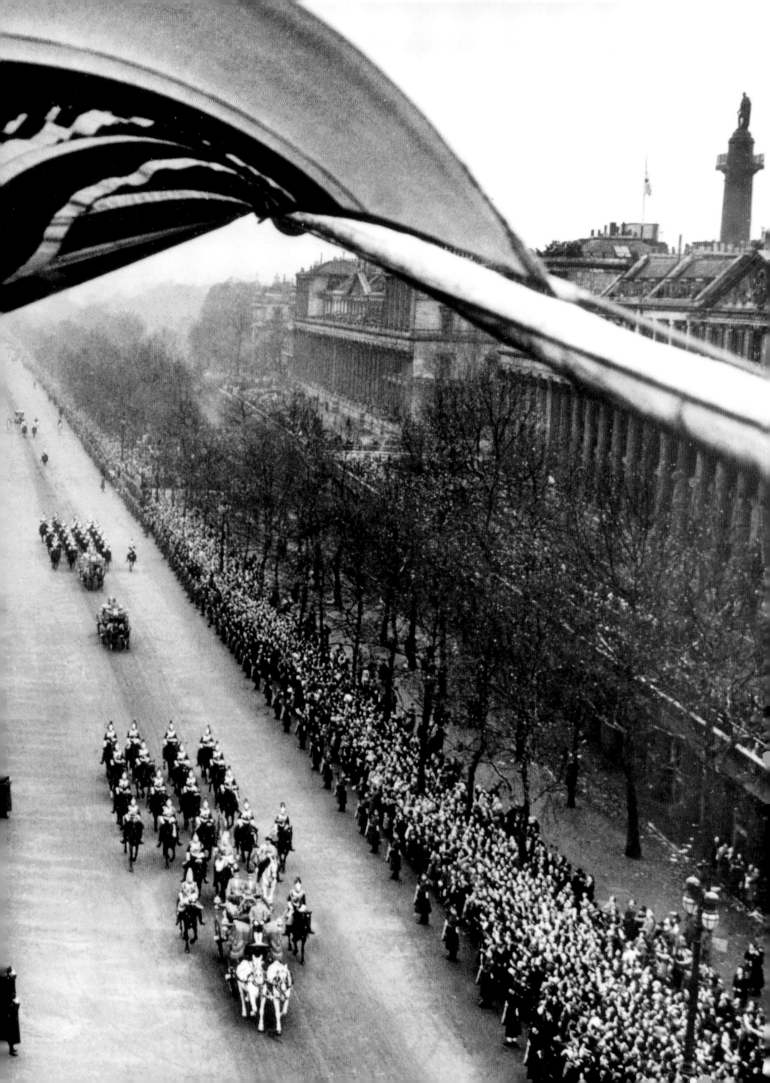

Auszug aus einem Brief von König George VI. an seine Tochter Elizabeth in die Flitterwochen

Ich war so stolz auf Dich und aufgeregt, als Du auf unserem langen Weg durch die Westminster Abbey so dicht neben mir gegangen bist, aber als ich Deine Hand dem Erzbischof übergab, hatte ich das Gefühl, etwas sehr Kostbares verloren zu haben. Du warst im Gottesdienst so ruhig und gefasst und sagtest Deine Worte mit solcher Überzeugung, dass ich wusste, alles war gut.
Deine Abreise hat eine große Lücke in unser Leben gerissen, aber denk immer daran, dass Dein altes Zuhause für Dich da ist, und kehre so lange und so oft wie möglich dahin zurück. Ich sehe, dass Du mit Philip überglücklich bist, was auch ganz richtig ist, aber dass Du uns nicht vergessen mögest, ist der Wunsch von

Deinem Dich immer treu liebenden
Papa

Excerpt from King George VI's letter to his daughter Elizabeth on her honeymoon

I was so proud of you & thrilled at having you so close to me on our long walk in Westminster Abbey, but when I handed your hand to the Archbishop I felt that I had lost something very precious. You were so calm & composed during the Service and said your words with such conviction, that I knew everything was all right.
Your leaving us has left a great blank in our lives but do remember that your old home is still yours & do come back to it as much & as often as possible. I can see that you are sublimely happy with Philip which is right but don't forget us is the wish of

Your ever loving & devoted
Papa

Echt britisch. Nach der Hochzeit konnten die Untertanen die Geschenke an das Brautpaar im St. James's Palace besichtigen. Als wahre Briten ließen sie sich von kilometerlangen Schlangen nicht abschrecken und standen geduldig an.

Typically British. After the wedding the public were allowed to inspect the wedding presents in St. James's Palace. Like true Britons they were not deterred by mile-long queues and patiently waited their turn.

Honeymoon. Noch am Nachmittag fuhr das Brautpaar zum Bahnhof Waterloo, um in die Flitterwochen zu starten. Die Familien verabschiedeten sie mit einem Regen aus Rosenblättern. Die Braut wärmten in der offenen Kutsche zahlreiche Decken und ihr Lieblings-Corgi Susan, der sich unter den Plaids versteckt hatte.

Honeymoon. In the afternoon the bridal couple drove to Waterloo Station to start on their honeymoon. Their families saw them off with a shower of rose petals. In the open carriage the bride kept warm with lots of rugs and her corgi Susan hidden among them.

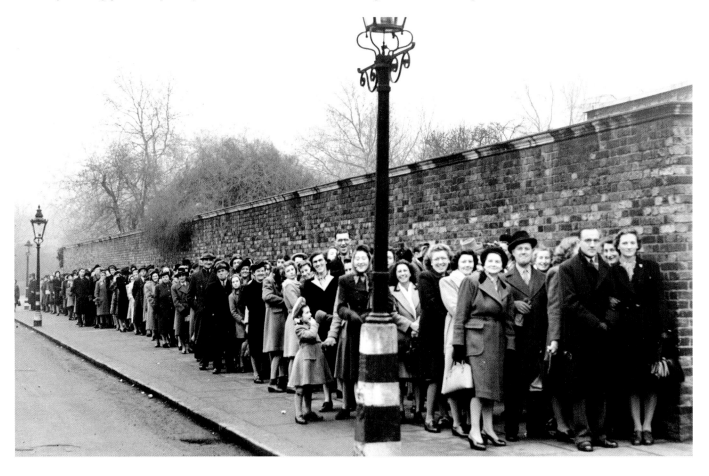

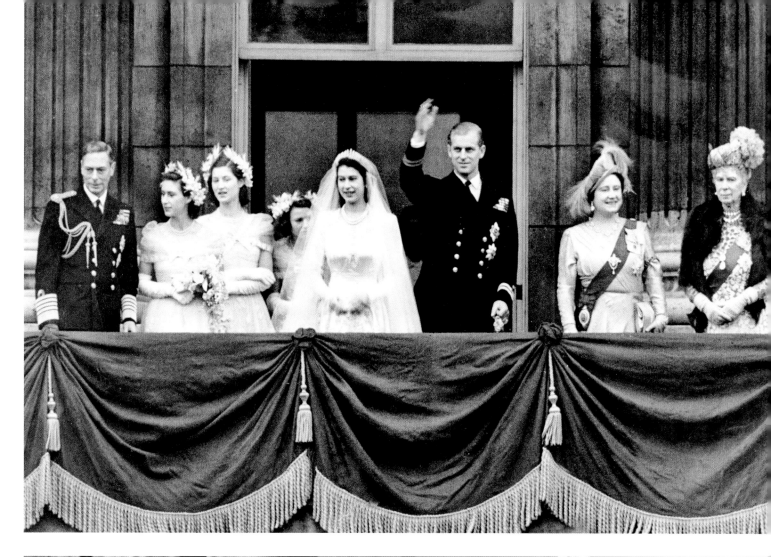

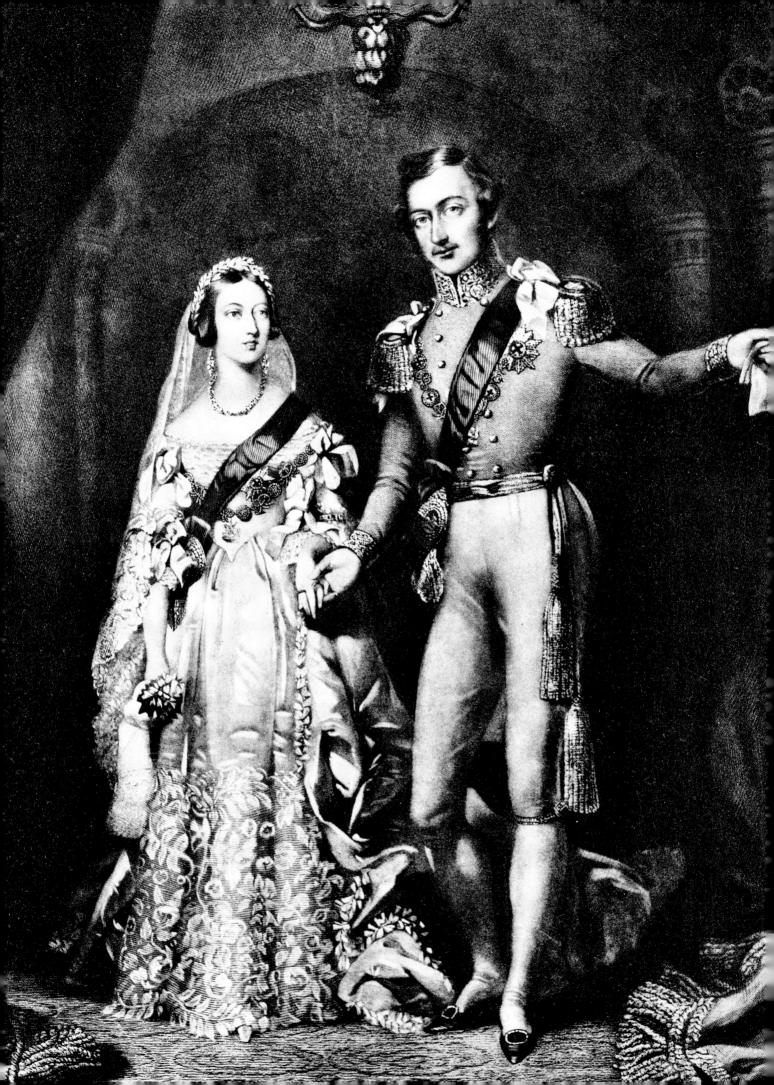

Victoria & Albert

Die Hochzeit ganz in Weiß
Großbritannien, 10. Februar 1840

The White Wedding
Great Britain, 10 February 1840

Ein Raunen erfasste die 300 geladenen Gäste in der Kapelle des St. James's Palace in London, als die Braut eintrat. Königin Victoria von England erschien in einem schulterfreien Satinkleid mit enger Corsage und weit ausladendem Rock. Viel spektakulärer aber – das Kleid und der Schleier waren ganz und gar weiß! Das 19. Jahrhundert kannte alle Farben von Hochzeitskleidern. Das Bürgertum trug oft dunkle Farben, um das Kleid noch an weiteren Festtagen benutzen zu können. Königliche Bräute hatten oft Gold- und Silbertöne bevorzugt, um ihren Reichtum zum Ausdruck zu bringen. Zwar war Victoria nicht die allererste Braut, die ganz in Weiß vor den Altar schritt, doch sie verhalf mit der Wahl ihres Kleides einem Brauch zum Durchbruch, der bis heute in der westlichen Welt vorherrschend ist.

Der Bräutigam für Victoria, ihr Vetter Prinz Albert von Sachsen-Coburg und Gotha, war aus Gründen der Staatsräson ausgewählt worden. Doch in diesem Fall waren Verstand und Herz ganz einer Meinung: Die Königin war vom ersten Moment an hingerissen von dem schönen deutschen Prinzen und freute sich unbändig auf ihren Hochzeitstag. In eisigem Regen und stürmischem Wind hatten sich am 10. Februar zahlreiche tapfere Untertanen versammelt, um ihrer Königin auf dem Weg zur Vermählung zuzujubeln. Doch der Applaus verhallte größtenteils im Klatschen der

A murmur rose from the 300 invited guests in the chapel of St. James's Palace in London when the bride made her entry. Queen Victoria of England was wearing a tight-waisted, off-the-shoulder satin dress with a full skirt. But even more spectacular: dress and veil were all in white! Wedding dresses were of all colours during the 19th Century. The bourgeoisie often wore dark colours so as to be able to use the dress on later occasions, while royal brides sometimes chose gold or silver to demonstrate their wealth. Victoria was not in fact the first bride to go to the altar all in white but she helped to establish a custom followed in the Western world ever since.

The bridegroom, her cousin, Prince Albert of Saxe-Coburg and Gotha, had been chosen for reasons of state, but in this case heart and head were as one. From the first moment the queen had been madly in love with the handsome German prince and was eagerly looking forward to her marriage. On 10 February hundreds of subjects of the queen braved stormy winds and icy rain to cheer her on her way to her wedding. Unfortunately the applause was almost drowned by the splatter of raindrops and the sound of umbrellas blowing inside out. Things were not going to go smoothly on this great day. The bridegroom was not familiar with the ritual of the Anglican Church and had to be told what he

Albert will you marry me?

Frauensache. Der Heiratsantrag musste von Königin Victoria ausgehen, da sie die Ranghöhere war. Am 15. Oktober 1839 gestand sie Prinz Albert nach einer Fuchsjagd ihre Liebe.

Woman power. The proposal had to come from Queen Victoria since she was of senior rank. She posed the question to Prince Albert on 15 October 1839, at the end of a day of hunting.

Regentropfen und dem Geklapper umstülpender Regenschirme. Überhaupt lief nicht alles glatt an diesem Festtag. Der Bräutigam war mit den Gebräuchen der anglikanischen Kirche nicht recht vertraut und benötigte klare Anweisungen, was wann zu tun sei. Zwölf Brautjungfern waren eindeutig zu viel für das kleine Gotteshaus und die eher kurze Schleppe des Brautkleids. Die Damen, die ebenfalls weiß trugen, hatten ihre liebe Mühe, sich nicht gegenseitig auf die Füße zu treten. Und für Erheiterung sorgte der alte Herzog von Cambridge, der offenbar schon vor der Trauung ausgiebig auf das Wohl des Paares angestoßen hatte und nun deutlich zu laut plauderte. Königin Victoria belastete all das in keiner Weise. Sie hielt strahlend den Arm ihres stattlichen Bräutigams, und als die beiden die Kirche verließen, bestätigte der Himmel, dass es sich hier um eine glückliche Verbindung handelte. Die finsteren Wolken hatten sich verzogen und eine Vorfrühlings-

should do and when. Twelve bridesmaids, also in white, were altogether too many for the small chapel and even for Victoria's relatively short train, and found it difficult not to step on each other's toes. A lighter note was struck by the old Duke of Cambridge, who had clearly drunk to the couple's health too heartily before the wedding and now chatted much too loudly. Queen Victoria was quite unperturbed by all this. She was radiant as she left the church on the arm of her good-looking husband and at that moment the heavens seemed to confirm that this would be a happy union. The dark clouds had blown away and an early spring sun shone on the couple on their way to Buckingham Palace.

"This has been the happiest day of my life," wrote an exhausted but still enthusiastic Victoria that evening in her diary. On the next morning the couple rose early. "That's not the way to give us a Prince of Wales," joked

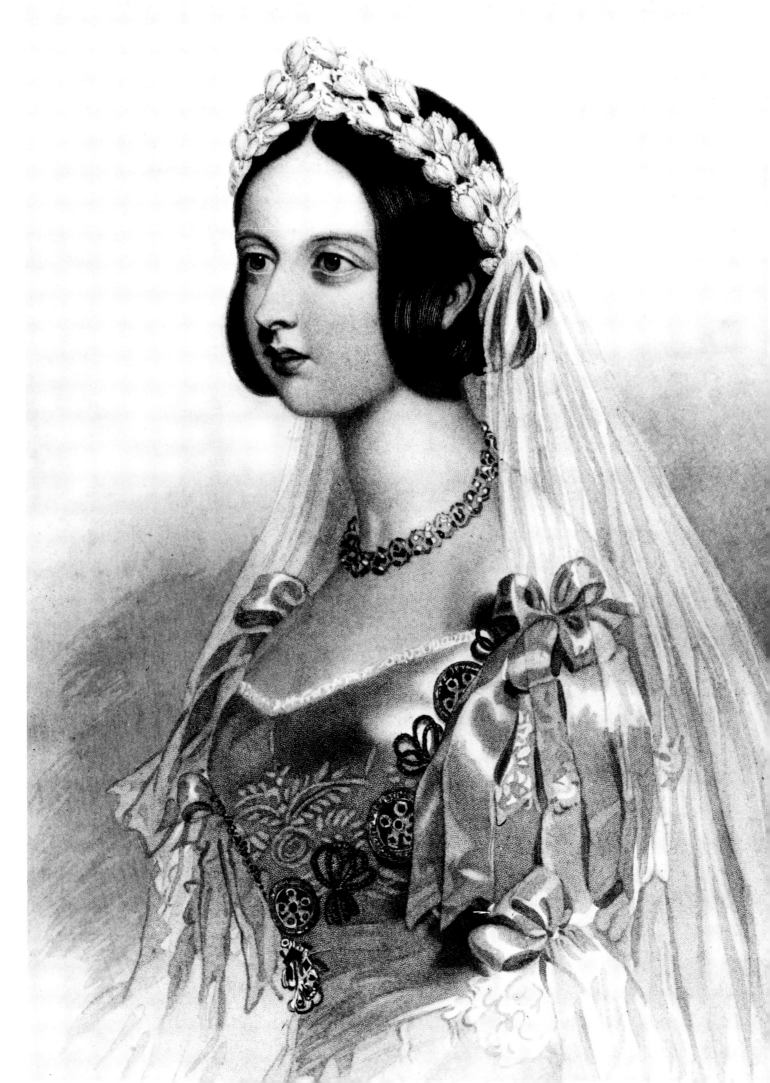

sonne beschien das Paar auf seinem Weg zum Buckingham Palace.

„Das war der glücklichste Tag in meinem Leben“, notierte eine erschöpfte, aber noch immer enthusiastische Victoria am Abend in ihr Tagebuch. Am nächsten Morgen war das königliche Paar bereits früh auf den Beinen. „Das ist nicht die richtige Art und Weise, uns einen Prinzen von Wales zu schenken“, unkte Staatssekretär Charles Greville, der die beiden im Park spazieren gehen sah. Doch er sollte sich gründlich getäuscht haben. „Wir haben nicht viel geschlafen“, schmunzelte die Königin über ihre Hochzeitsnacht in einem Brief vieldeutig. Neun Kinder gingen aus dieser überaus glücklichen Ehe hervor. Als Albert bereits 1861 starb, war Victoria untröstlich. Von diesem Tag an trug sie nur noch schwarz, doch beerdigt wurde sie, wie es ihr letzter Wille war, wieder in Weiß. In ihren Sarg legte man den Brautschleier.

the clerk to the Privy Council Charles Greville, who had seen them walking in the park, but he was quite wrong. "We didn't sleep much," as the queen slyly described her wedding night in a private letter. There were nine children to this happy marriage and when Albert died in 1861 Victoria was inconsolable. From that day she wore only black but she was buried, as she wished, in white. In the coffin they laid her bridal veil.

Haltbarkeitsdatum überschritten. Mittelpunkt des Hochzeitsfrühstücks war ein gigantischer Kuchen, der bei einem Umfang von fast drei Metern rund 140 Kilogramm wog. Bis heute sind Stücke des legendären Backwerks erhalten. Verwandte, die verhindert waren, erhielten ihre Portion in einer Blechdose per Post. Seltene Exemplare haben sich in den Familien weitervererbt und mit ihnen ein Stück der Atmosphäre dieses historischen Hochzeitsfestes.

Past sell-by date. The centrepiece of the wedding breakfast was a huge cake, nine feet round and weighing some 300 pounds. A few slices of the legendary cake are still in existence because relatives who were unable to attend received their share by post. One or two samples have been handed down from one generation of a family to the next, redolent of that historical occasion.

HER MAJESTY'S BRIDAL CAKE.

Von Kopf bis Fuß. Auch Schuhe und Strümpfe waren auf Victorias weißes Brautkleid abgestimmt. Victoria trug Schuhgröße 33, wollte aber dennoch nicht auf elegante Fußbekleidung verzichten. Drei Tage nach der Hochzeit notierte die später oft als prüde bezeichnete Königin in ihr Tagebuch: „Mein liebster Albert zog mir die Strümpfe an. Ich sah ihm beim Rasieren zu. Das war ein großes Vergnügen.“

From head to foot. Elegant shoes and stockings for Victoria's size two feet matched her white wedding dress. Three days after the wedding the queen, who later was often described as prudish, wrote in her diary: "My dearest Albert put on my stockings for me. I went in and saw him shave; a great delight for me."

**Victoria, Queen of Great Britain
(1819 – 1901)**
∞Albert of Saxe-Coburg and Gotha (1819 – 1861)

- - - - - - - = weitere direkte Nachkommen
more direct descendents

Alice (1843 – 1878)
∞Ludwig of Hesse
(1837 – 1892)

Victoria (1840 – 1901)
∞Frederick III,
German Emperor
(1831 – 1888)

**Edward VII, King of
Great Britain (1841 – 1910)**
∞Alexandra of Denmark
(1844 – 1925)

Arthur (1850 – 1942)
∞Louise of Prussia
(1860 – 1917)

Beatrice (1857 – 1944)
∞Henry of Battenberg
(1858 – 1896)

Sophie (1870 – 1932)
∞Constantine I, King of Greece
(1868 – 1923)

**William II, German Emperor
(1859 – 1941)**
∞Auguste Victoria of Schleswig-
Holstein (1858 – 1921)

Margaret (1882 – 1920)
∞Gustav VI Adolf,
King of Sweden
(1882 – 1973)

**George V, King of
Great Britain (1865 – 1936)**
∞Mary von Teck
(1867 – 1953)

Maud (1869 – 1938)
∞Haakon VII, King of Norway
(1872 – 1957)

**Victoria Eugenie
(1887 – 1969)**
∞Alfonso XIII, King of Spain
(1886 – 1941)

**Paul I, King of Greece
(1901 – 1964)**
∞Frederica of Hanover
(1917 – 1981)

**Victoria Louise
(1892 – 1980)**
∞Ernst August III of Hanover
(1887 – 1953)

Gustaf Adolf (1906 – 1947)
∞Sybilla of Saxe-Coburg
and Gotha
(1908 – 1972)

Ingrid (1910 – 2000)
∞Frederick IX,
King of Denmark
(1899 – 1972)

**George VI, King of
Great Britain (1895 – 1952)**
∞Lady Elizabeth Bowes-Lyon
(1900 – 2002)

**Olav V, King of Norway
(1903 – 1991)**
∞Märtha of Sweden
(1901 – 1954)

Juan (1913 – 1993)
∞Maria of Bourbon-
Two Sicilies (1910 – 2000)

Sofia (born in 1938)
∞Juan Carlos I, King of Spain
(born in 1938)

**Elizabeth II, Queen of
Great Britain (born in 1926)**
∞Philip Mountbatten
(born in 1921)

**Harald V, King of Norway
(born in 1937)**
∞Sonja Haraldsen
(born in 1937)

**Carl XVI Gustaf, King of
Sweden, (born in 1946)**
∞Silvia Sommerlath
(born in 1943)

**Margrethe II, Queen of
Denmark (born in 1940)**
∞Count Henri de Laborde
de Monpezat
(born in 1934)

**Juan Carlos I, King of Spain
(born in 1938)**
∞Sofia of Greece
(born in 1938)

Prince Charles (born in 1948)
∞Lady Diana Spencer
(1961 – 1997)
∞Camilla Parker Bowles
(born in 1947)

**Prince Haakon
(born in 1973)**
∞Mette-Marit Tjessem Høiby
(born in 1973)

**Princess Victoria
(born in 1977)**
∞Daniel Westling
(born in 1973)

**Prince Frederik
(born in 1968)**
∞Mary Donaldson
(born in 1972)

Prince Felipe (born in 1968)
∞Letizia Ortiz Rocasolano
(born in 1972)

**Prince William
(born in 1982)**
∞Catherine Middleton
(born in 1982)

Die Großeltern Europas. Victoria und Albert führten eine vorbildliche und treue Ehe. Fast alle europäischen Monarchen stammen direkt von diesem Paar ab. Victoria, die ihren Mann um vier Jahrzehnte überlebte, ließ nach seinem Tod überall im Land Statuen zu seinem Gedenken aufstellen.

The grandparents of Europe. Victoria and Albert enjoyed a faithful and exemplary marriage. Nearly all Europe's monarchs are directly descended from them. Victoria survived her husband by 40 years and after his death ordered statues in his memory to be put up all over the country.

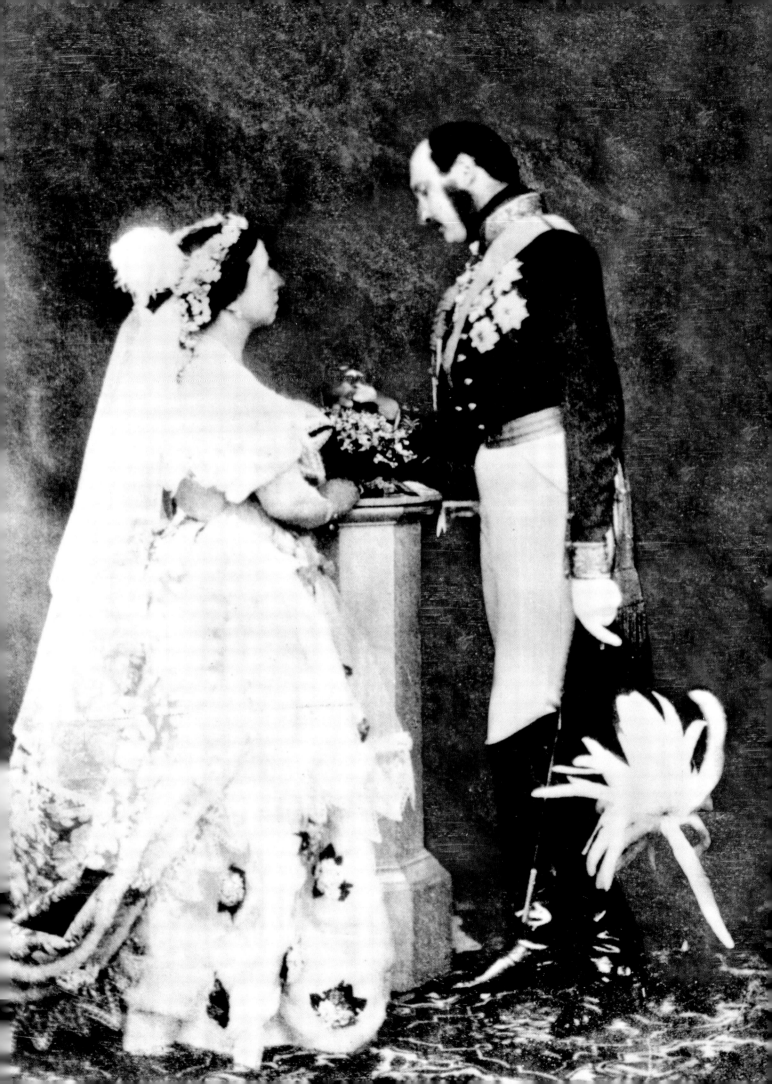

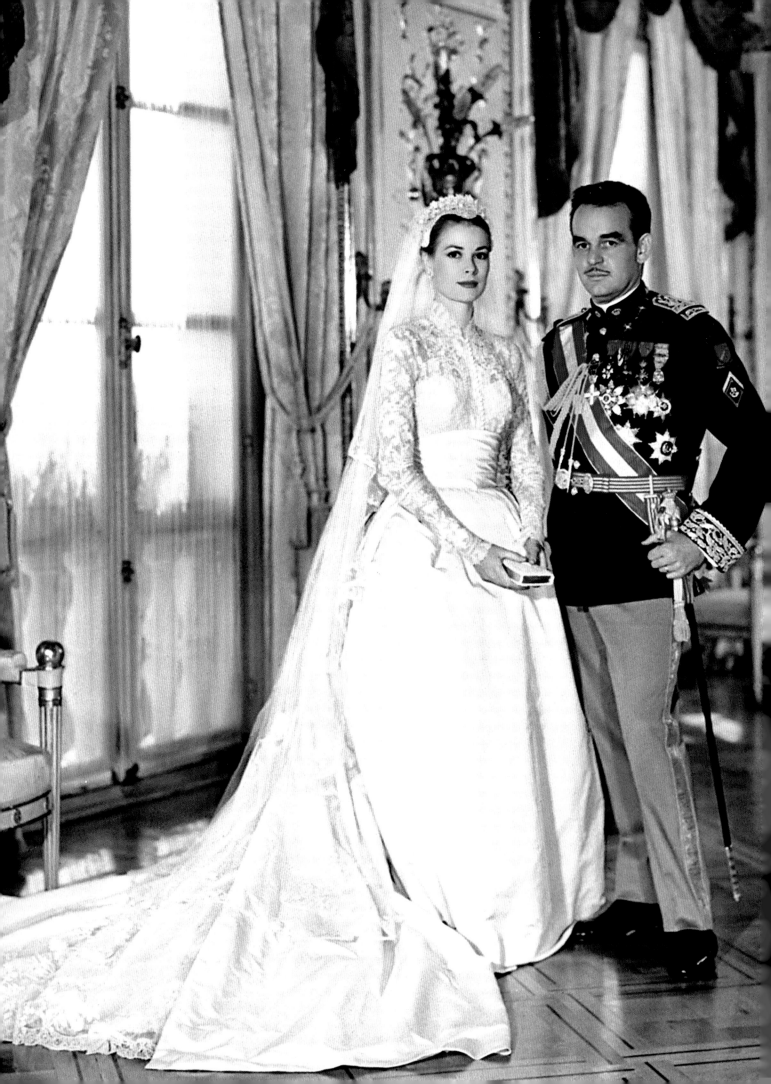

Rainier & Grace

Das Hollywoodmärchen
Monaco, 19. April 1956

The Hollywood Fairy Tale
Monaco, 19 April 1956

Die Ankunft der Braut war spektakulär. Mit einem 65-köpfigen Gefolge erreichte die Schauspielerin Grace Kelly am 12. April 1956 auf dem Ozeandampfer „SS Constitution" den Hafen des Fürstentums Monaco. Ein Regen von roten und weißen Nelken, Salutschüsse, Schiffssirenen und der Jubel von 40 000 Schaulustigen begrüßten die Amerikanerin auf europäischem Boden.

Die Hochzeit von Fürst Rainier und Grace Kelly auf dem Mittelmeerfelsen war das Medienereignis des Jahrzehnts und doch eines, das seine Hauptpersonen völlig zu überrollen schien. Die Oscar-gekrönte Hollywoodikone entstieg dem Schiff, wie man es von ihr gewohnt war – mit vollendeter Klasse. Doch den Mann, dem sie in wenigen Tagen das „Ja-Wort" geben würde, hatte sie bislang nur wenige Male gesehen. Ein Treffen während der Filmfestspiele von Cannes, ein Wiedersehen und dann auch schon eine Verlobung – viel mehr war da noch nicht gewesen. Bei der Begrüßung hatten die Monegassen mit einem leidenschaftlichen Kuss gerechnet. Stattdessen gab der Fürst seiner Verlobten schlicht die Hand. Doch zum Nachdenken blieb nur wenig Zeit. 1600 Journalisten bombardierten den Hof mit Fragen. Sie übertrafen die Zahl der eigentlichen Hochzeitsgäste um mehr als das Doppelte. Der Pressesprecher des Hofes, der zu allem Unglück gar kein Englisch sprach, erlitt einen

The arrival of the bride was spectacular. On 12 April 1956 actress Grace Kelly and a party of 65 landed at the harbour of the Principality of Monaco, aboard the ocean liner "SS Constitution". A sea of red and white carnations, artillery salutes, ships' sirens and the cheers of 40,000 spectators welcomed the American film star to Europe.

The wedding of Prince Rainier and Grace Kelly, on the shores of the Mediterranean, was the media event of the decade and yet one that seemed too overwhelming for the principal actors. The Oscar-winning Hollywood icon stepped from the ship with her accustomed grace and composure, yet she barely knew the man she was to marry a few days later. They had met once during the Cannes Film Festival, once or twice more and then the engagement was announced. The Monégasques had expected the prince to greet his fiancée with a passionate kiss but he simply shook her hand. However there was little time for reflection. 1,600 journalists, more than twice as many as the invited wedding guests, bombarded the court with questions, so that the official spokesman, who unfortunately didn't even speak English, suffered a nervous breakdown. The chaos was only brought under control when a public relations professional from Grace's film company MGM took over, arranged daily press conferences and

Nervenzusammenbruch. Das Chaos lichtete sich erst, als ein Fachmann von Graces Filmkompanie MGM die Sache in die Hand nahm, tägliche Pressekonferenzen anberaumte und die Journalisten zu all den Bällen, Soirées und Empfängen lotste, mit denen die Woche vor der Hochzeit gefeiert wurde.

Gemäß monegassischem Recht musste auch der Fürst vor der festlichen kirchlichen Hochzeit eine standesamtliche absolvieren, die am Morgen des 18. April im engsten Kreise im Thronsaal des Grimaldi-Palastes begangen wurde. Die beidseitigen „Ouis" waren schnell gesprochen, den weitaus längeren Teil der Zeremonie machte die Aufzählung der 142 Titel des Fürsten aus. Seine frisch Vermählte hieß nun Fürstin Gracia Patricia, was allerdings auch nur der erste der 134 Titel war, die

guided the journalists to the various balls and receptions in the week before the wedding.

The Monégasque constitution requires that before the church wedding the prince must celebrate a civil marriage, and this was held on the morning of 18 April before very few witnesses, in the throne room of the Grimaldi Palace. The marriage vows were quickly exchanged; by far the longest part of the ceremony was taken up with reading out the prince's 142 titles. His newly married wife was now called Princess Grace Patricia; that was only the first, however, of the 134 titles she acquired through her husband. In the evening there was a gala at the opera but the list of those present was highly unusual for a princely wedding. No member of the European nobility had seen fit to attend as the

Ihre größte Rolle. Nach achttägiger Überfahrt erreichte die US-amerikanische Schauspielerin Grace Kelly Monte Carlo, um als künftige Fürstin von Monaco im Hafen der Ehe anzulegen. Zum Leidwesen der wartenden Fotografen war ihr Gesicht unter dem ausladenden Hut kaum zu erkennen. In ihrem Arm kuschelte sich beim Weg über die Pier ihr Pudel Oliver. Der Fürst musste noch respektvoll Abstand halten.

Her greatest role. After an eight day voyage the American actress Grace Kelly reached the harbour at Monte Carlo to enter the haven of marriage as the future Princess of Monaco. To the frustration of the waiting photographers her face was barely visible under her wide-brimmed hat. As she walked down the gangway she stroked her poodle, Oliver, nestling on her arm, and the prince had to keep a respectful distance.

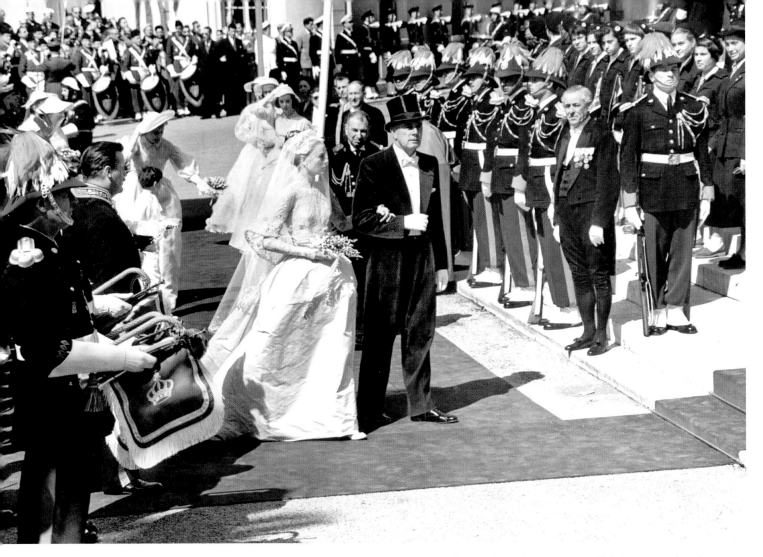

Väterliches Geleit. John Kelly führte seine Tochter in die Kirche. Mit ihrem Aufstieg in die Aristokratie hoffte Grace, endlich den Ansprüchen des gestrengen Vaters zu genügen.

On the arm of her father. John Kelly led his daughter into the church. Grace hoped that with her rise to the nobility she would finally come up to the expectations of her stern father.

sie von ihrem Mann übernahm. Am Abend wurden in der Oper die Gäste zu einer Gala geladen. Die Gesellschaft, die sich dort versammelte, war für eine Aristokratenhochzeit durchaus ungewöhnlich. Kein Vertreter des europäischen Hochadels hatte sich bequemt zu kommen. Das Fürstentum galt nicht als ebenbürtig. Graces Gefolge aus Hollywood aber machte diesen Makel mehr als wett: Cary Grant, Gloria Swanson, Ava Gardner, David Niven feierten vergnügt neben Staatsoberhäuptern und Diplomaten.

Am nächsten Tag dann schritt die neue Fürstin um 9:20 Uhr am Arm ihres Vaters die Stufen zur romanischen Kathedrale hinauf. Der Fürst warte auf niemanden, hieß es, und so traf Rainier unter Fanfarenklängen erst nach seiner Braut ein. Als er vor den Altar trat, wagte Grace kaum aufzublicken. Beide wirkten geradezu ängstlich. „Oui, je veux", hauchte sie kaum vernehmbar. Und auch bei Rainier musste man ganz genau

principality was not considered to be on the same social level. But Grace's friends from Hollywood more than made up for it: Cary Grant, Gloria Swanson, Ava Gardner and David Niven thoroughly enjoyed their evening among diplomats and heads of state.

At 9.20 a.m. on the following day the new princess mounted the steps of the Romanesque cathedral on the arm of her father. The rule was that the prince waits for nobody and so Rainier arrived, with a fanfare of trumpets, after his bride. As he stepped up to the altar Grace hardly dared to raise her eyes and both of them seemed positively nervous. Grace's whispered "Oui, je veux" was hardly audible and one had to listen hard to hear Rainier speak his marriage vows. When the couple left for their honeymoon a few hours later they were both completely exhausted. Grace's sister reported later that it was a whole year before Grace and Rainier felt able to watch the MGM film of the wedding, which had

hinhören, um ihn zu verstehen, als er sein Eheverspre- chen gab. Als die beiden wenige Stunden später in die Flitterwochen aufbrachen, waren sie komplett er- schöpft. Graces Schwester berichtete später, Grace und Rainier hätten sich den MGM-Film von der Hochzeit, der überall in Europa und den USA zum Kinoschlager wurde, erst ein Jahr später in Ruhe anschauen können.

Für das Paar begann jetzt eine Zeit, sich wirklich kennenzulernen. Beide haben im Nachhinein bekannt, dass ihre Liebe erst mit der Zeit gewachsen ist. Doch auch eine solche Ehe kann glücklich sein. Nach Fürstin Gracias tragischem Unfalltod im Jahre 1982 trauerte der Fürst sein Leben lang. Man sah nie wieder eine andere Frau an seiner Seite.

meanwhile become a box office hit throughout Europe and America.

Now the two had to get to know each other. Both later confessed that their love only developed over time. Yet even this kind of marriage can be a happy one. After Princess Grace's tragic death in an accident in 1982 the Prince mourned for the rest of his life. No other woman could ever replace her.

Filmreif. Die MGM-Filmstudios spendierten das 8 000 Dollar teure Brautkleid, das von Studiodesignerin Helen Rose entworfen worden war, und sicherten sich die Filmrechte. Manche Szene musste zu diesem Zweck sogar wiederholt werden. Die eigentliche Leinwandkarriere der Hollywoodikone aber war nun beendet. „Die Oberen Zehntausend" mit Frank Sinatra und Bing Crosby war ihr letzter Spielfilm.

Ripe for Hollywood. MGM film studios paid for the 8,000 dollar wedding dress, made by studio designer Helen Rose, and secured the film rights. To this end some scenes even had to be re-enacted. But the Hollywood star's screen career was effectively ended. "High Society" with Frank Sinatra and Bing Crosby was her last film.

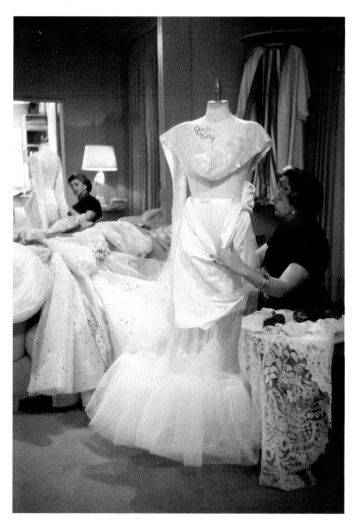 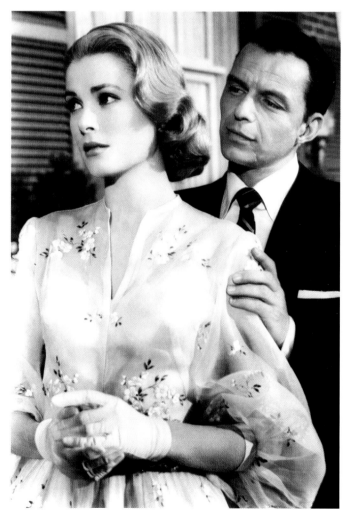

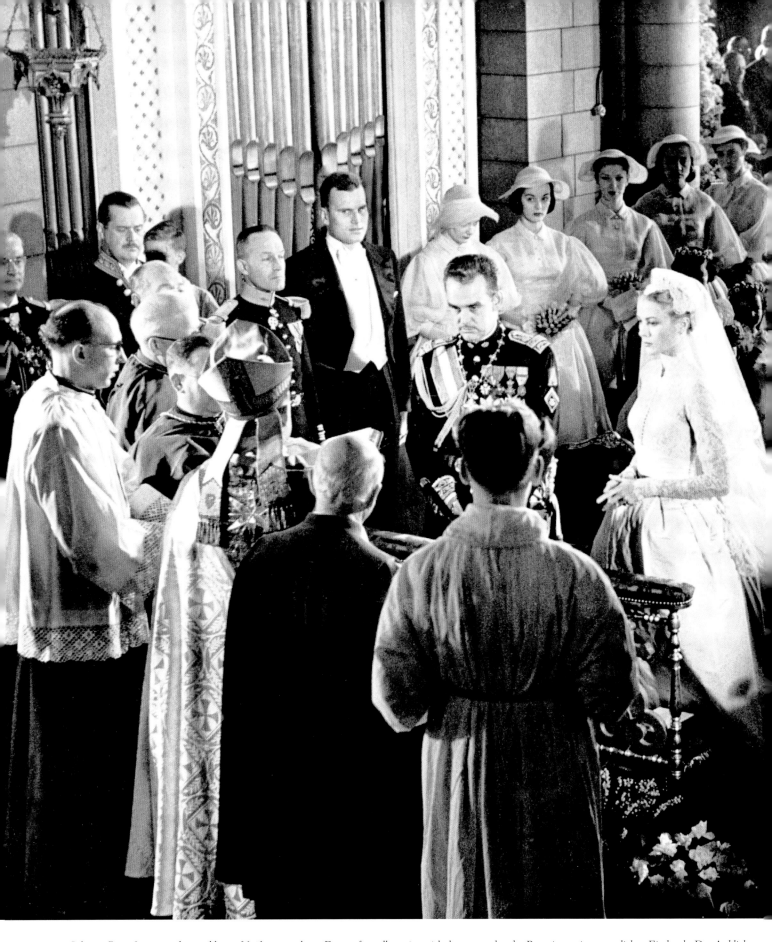

Schönes Paar. In einer schwarz-blauen Uniform, an deren Entwurf er selbst mitgewirkt hatte, machte der Bräutigam einen stattlichen Eindruck. Der Anblick der Braut aber verschlug den Zuschauern den Atem. Ihr Hochzeitskleid machte die 26-jährige Grace endgültig zur Stilikone der 1950er Jahre. Sechs Wochen lang hatten die Schneider unter höchster Geheimhaltung 46 Meter Seide, 110 Meter venezianische Spitze und abertausende Perlen zu einem Traumkleid verarbeitet, das noch heute von Bräuten in aller Welt imitiert wird.

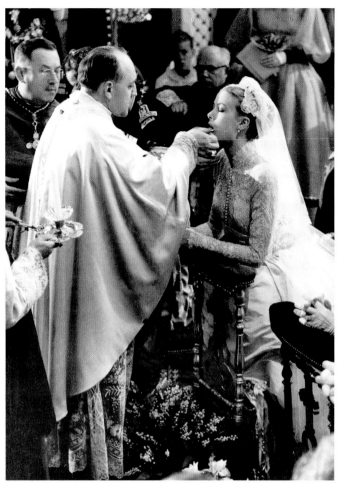

Bis dass der Tod uns scheidet. Weihnachten 1955 machte Fürst Rainier im Haus der Kellys seine Aufwartung und hielt um Graces Hand an. In Anlehnung an Graces Spielfilm „Über den Dächern von Nizza" („To Catch a Thief") erhielt der Verlobungsring von Cartier mit einem 10,47-Karat-Diamanten den Namen „To Catch a Prince". Von ihrer Ankunft in Monaco bis zur Hochzeit schenkte der Fürst seiner Braut täglich ein Schmuckstück.

Till death us do part. Prince Rainier presented himself at the house of the Kellys and asked for Grace's hand at Christmas 1955. In an allusion to her film "To Catch a Thief" the 10·47-carat diamond engagement ring, designed by Cartier, bore the name "To Catch a Prince". From her arrival in Monte Carlo until the wedding the prince gave his bride a new piece of jewellery every day.

A handsome couple. In a blue and black uniform he had helped to design himself, the prince was an impressive figure but the sight of the bride took the spectators' breath away. With her wedding dress the 26-year-old Grace became the effective style icon of the fifties. In utmost secrecy the dressmakers had taken six weeks to create from some 150 feet of silk, 360 feet of Venetian lace and thousands of pearls, a dream gown which is still being copied by brides all over the world today.

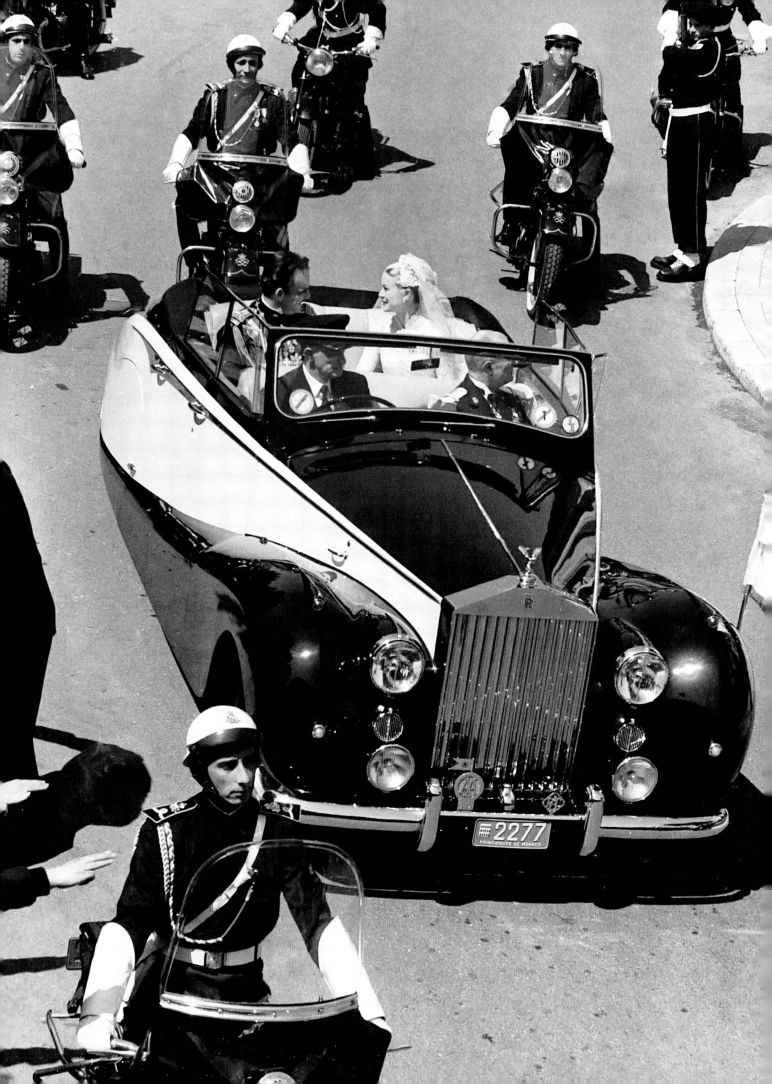

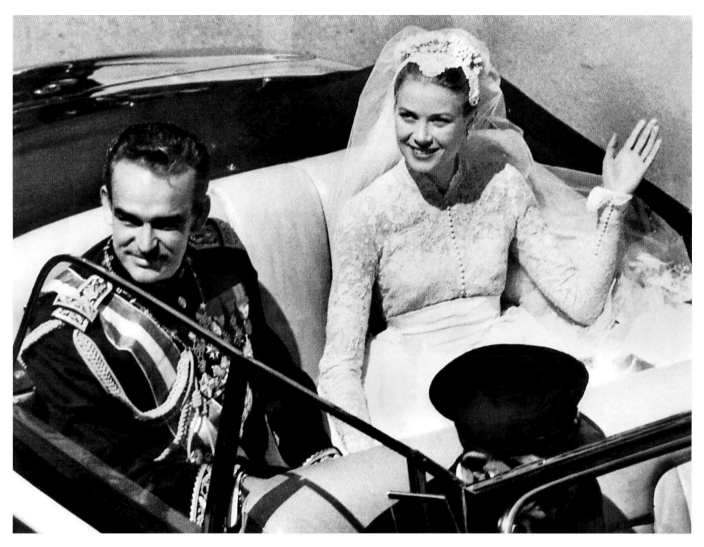

Unter der Haube. Mit ihrer Eheschließung waren die beiden begehrtesten Singles der 1950er Jahre vom Markt. Für Graces Schwester war diese Verbindung perfekt: „Jeder andere wäre als Herr Kelly in ihrem Schatten erblasst. Sie suchte einen starken Mann wie unseren Vater, zu dem sie aufschauen konnte. Rainier war das."

Safely married. With their wedding the two most eligible marriage partners of the fifties were no longer available. In the opinion of Grace's sister it was a perfect match. "Any other man would have been entirely overshadowed, a mere 'Mr. Kelly'. She needed a strong man she could look up to, like our father. That's what Rainier was."

Rasche Rundfahrt. Im Anschluss an die Trauzeremonie fuhren die frisch Vermählten im offenen Rolls Royce durch Monacos Straßen. In dem gerade einmal zwei Quadratkilometer großen Zwergstaat war die Umrundung allerdings trotz Schritttempos bereits nach 30 Minuten beendet. Die neue Fürstin Gracia Patricia kannte die Riviera vor allem von den Dreharbeiten zu „Über den Dächern von Nizza" und ihrem folgenschweren Besuch bei den Filmfestspielen von Cannes. Doch auch wenn ihr die französische Sprache an diesem Tag noch fremd war, lebte sie sich mit den Jahren am Mittelmeer ein. Und wenn ihr die Gassen von Monte Carlo gar zu eng wurden, zog sie sich nach Roc Agel, den Landsitz der Grimaldis, zurück.

Brief tour. After the ceremony the newly married couple drove through the streets of Monte Carlo in an open Rolls Royce but as the mini state measures only a little over two square kilometres the tour, although at walking pace, was over in 30 minutes. The new princess's main contacts with the Mediterranean had been at the filming of "To Catch a Thief" and her momentous visit to the Cannes Film Festival. But although at the time of the wedding she spoke no French, over the years she settled into Mediterranean life, and when she felt too hemmed in by the narrow streets of Monte Carlo she retired to Roc Agel, the country estate of the Grimaldis.

Kleines Volk, große Begeisterung. Nur wenige Tausend echte Monegassen durften Fürst Rainier III. und Fürstin Gracia Patricia ihre Untertanen nennen. Doch kaum einer hatte es sich nehmen lassen, an diesem großen Tag persönlich zum Palast zu eilen, um zu gratulieren.

Limited population, unlimited enthusiasm. Prince Rainier III and Princess Grace Patricia ruled over only a few thousand genuine Monégasques but every one of them made their way to the palace that day to wish them luck.

Ein Blick auf den Geschenketisch
Das Volk von Monaco beschenkte das Brautpaar mit einem creme-schwarzfarbenen Rolls Royce Silver Cloud Cabriolet, in dem Grace und Rainier ihre Rundfahrt durch das kleine Fürstentum absolvierten. Eine weiße Taube kam ebenfalls von den Untertanen.
Der Sultan von Marokko schickte ein Löwenpärchen für den Privatzoo des Fürsten.
Die Hollywoodfreunde von Grace Kelly überraschten sie mit einem Filmprojektor und einer Leinwand, um auch im fernen Europa immer über die neuesten Streifen der amerikanischen Filmindustrie auf dem Laufenden zu sein.
Das wohl ungewöhnlichste Präsent aber schickte Alfred Hitchcock. Der Regisseur, der mit Grace Kelly in der Hauptrolle einige seiner größten Erfolge erlebt hatte und ihr Ausscheiden aus dem Filmgeschäft sehr bedauerte, ließ einen Duschvorhang überreichen. Eine Anspielung auf die Mordszene in „Psycho". Was Hitchcock der Braut allerdings damit sagen wollte, blieb sein Geheimnis.

A glance at the Presents
The people of Monte Carlo gave the bridal couple a black and cream open Rolls Royce Silver Cloud, in which Grace and Rainier made their brief tour through the small principality. As well as a white dove.
The Sultan of Marocco sent a pair of lions for the prince's private zoo.
Grace Kelly's friends in Hollywood gave her a film projector and screen so that even in distant Europe she could keep up with the latest American film industry productions.
The most unusual present came from Alfred Hitchcock, who had directed Grace Kelly in the main role of some of his greatest successes and bitterly regretted her departure from films; his gift was a shower curtain, an allusion to the murder scene in "Psycho". What message he meant to convey to the bride was not clear.

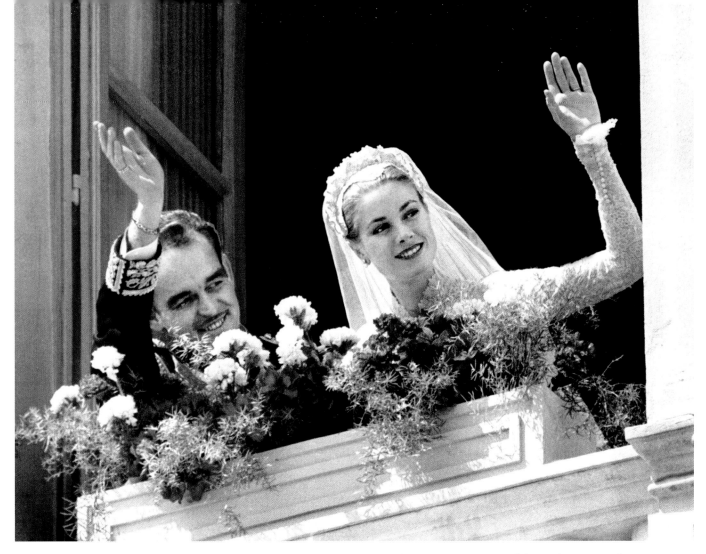

Eine Hollywoodikone als Landesmutter? Was viele nicht für möglich gehalten hatten, gelang. Die Monegassen verliebten sich spontan in ihre neue Fürstin. Sie brachte Glamour ins Fürstentum und half ihrem Mann, den kleinen Felsenstaat zum Mekka der Reichen und Schönen zu machen.

A Hollywood icon as a caring first lady? What many people thought impossible actually came to pass. The Monégasques fell in love with their new princess. She brought glamour to the principality and helped her husband to make his small "kingdom" into a Mecca for the rich and beautiful.

Ende einer Festwoche. Grace und Rainier hatten mit ihren Gästen unzählige Bälle, Soirées und Empfänge absolviert. Aufmerksame Beobachter registrierten, dass niemals zuvor in ein so kleines Land von so vielen Damen so viel Gepäck für so kurze Zeit gebracht wurde. Am Hochzeitstag gab es zum Abschluss jetzt nur noch einen Happen von der siebenstöckigen, 90 Kilogramm schweren Hochzeitstorte.

End of a festive week. Grace and Rainier had entertained their guests with numerous balls, dinners and receptions and observant onlookers noticed that never before had so many ladies brought so much luggage into such a small country for so short a time. The wedding day concluded with a slice of the seven-tier, 200-pound wedding cake.

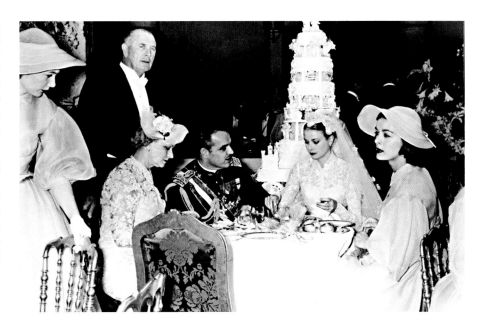

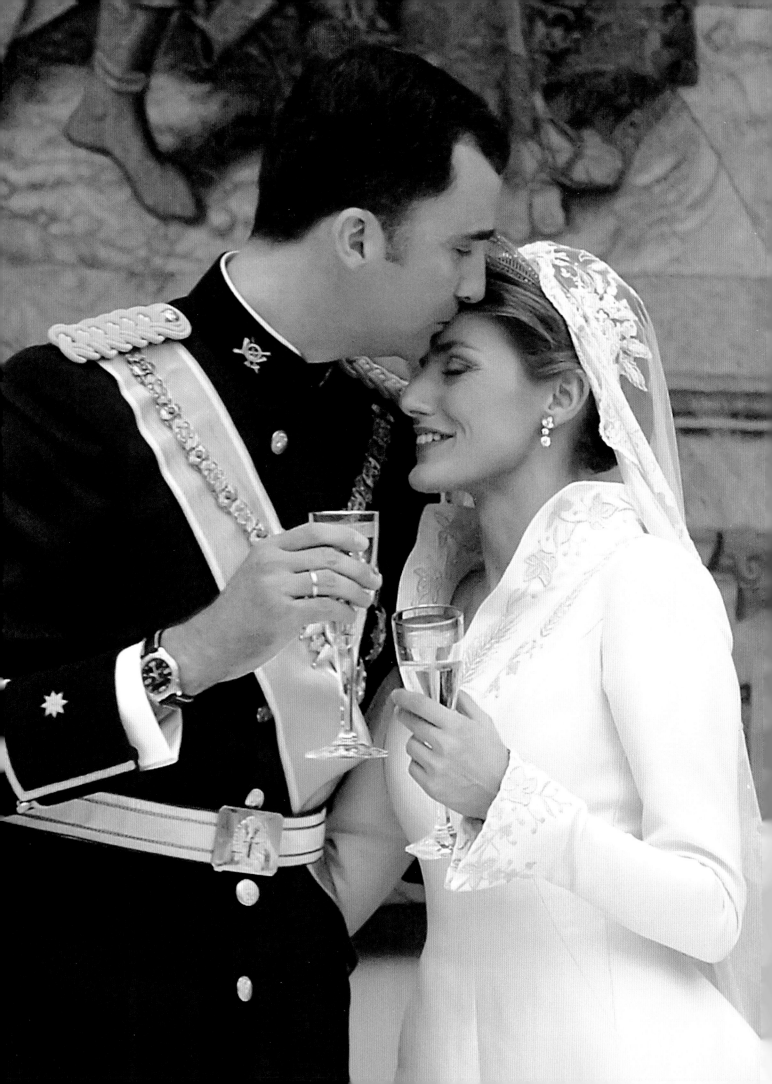

Felipe & Letizia

Die Hochzeit im Regen
Spanien, 22. Mai 2004

The Wedding in the Rain
Spain, 22 May 2004

Für Felipe waren es die längsten Minuten seines Lebens: Mutterseelenallein stand er vor dem Altar der Almudena-Kathedrale von Madrid. Immer wieder schaute er sich um, aber die Kirchentür blieb geschlossen. 1400 geladene Gäste, darunter die Regierungschefs von 30 Ländern und fast alle gekrönten Häupter Europas, und etwa eine Milliarde Fernsehzuschauer sahen den spanischen Thronfolger, der Minute um Minute auf seine Braut warten musste. Dann endlich öffnete sich das Portal und am Arm ihres Vaters trat Letizia Ortiz ein. In einem traumhaften Kleid und doch mit angespannter Miene. Kein Wunder, denn das Wetter hatte dem Verlauf des Festes einen gründlichen Strich durch die Rechnung gemacht.

Als die ersten Gäste über den roten Teppich in die Kirche gingen, hatte es zu tröpfeln begonnen, als Felipe in Begleitung seiner Mutter kam, war aus dem Tröpfeln bereits ein Regen geworden und dann öffnete der Himmel endgültig seine Schleusen. Im Königspalast begannen hektische Diskussionen. Wie nun die Braut in die Kirche bekommen? Unter einem Schirm? Niemals! Warten, bis der Himmel aufklart? Nicht mehr möglich! Die Gäste warteten bereits über eine Stunde auf den harten Kirchenbänken und die Fernsehsender mussten sich an ihre Programmplanungen halten. Schließlich fiel die Entscheidung: Letizia würde in einem Rolls Royce

For Felipe they were the longest minutes of his life, standing all by himself in front of the altar in the Almudena Cathedral in Madrid. He kept looking round, but the heavy doors of the church stayed firmly closed. 1,400 invited guests, including the heads of state of 30 countries and nearly all the crowned heads of Europe, together with about a billion television viewers, looked on as the Spanish crown prince waited minute after long minute for his bride. At last the doors opened and Letizia Ortiz entered on the arm of her father, wearing a dreamlike gown but visibly tense; no wonder, since the weather had seriously disrupted the course of the festivities.

It had already started to drizzle when the first guests began to arrive; when Crown Prince Felipe and his mother arrived it was raining steadily and then the heavens opened. Hectic consultations began in the palace. How should they get the bride to the church? Under an umbrella? Never! Wait until the rain stopped? Impossible! The guests had already been waiting for over an hour in the hard pews and the television stations had to keep to their schedule. At last the decision was taken: Letizia would be driven there in a Rolls Royce. Shortly after eleven the car splashed its way through the sheet of water before the cathedral. On leaving the car the bride was protected from the heavy

vorfahren. Um kurz nach elf pflügte der Wagen regelrecht durch den Wasserteppich vor der Kathedrale. Die Braut wurde beim Aussteigen von einem Baldachin vor den Fluten geschützt und gelangte trockenen Fußes bis vor den Altar, wo sie Felipe mit einem Wangenkuss begrüßte.

Dem Brautpaar waren die nervlichen Belastungen der vergangenen Monate anzumerken. Das spanische Königspaar hatte die Wahl des Kronprinzen genau hinterfragt. Zwar war Letizia eine prominente Fernsehjournalistin, aber eine Bürgerliche und geschieden noch dazu. Auch die Medien hatten die selbstbewusste junge Frau lange kritisch beäugt. Der Druck, an ihrem großen Tag keinen Fehler zu machen, schien am 22. Mai sichtbar auf ihren schmalen Schultern zu lasten. Erst das beidseitige „Ja-Wort" brachte ein erlöstes Lächeln in die Gesichter der Brautleute. Nach altem spanischem Brauch tauschten Felipe und Letizia 13 Goldmünzen als symbolisches Versprechen, alles im Leben miteinander zu teilen. Auch in der Kathedrale löste sich nun die Spannung. Vor allem Felipes Neffe Froilán sorgte für Erheiterung. Als ihm die Zeremonie zu langweilig wurde, stand er auf, trat einem Brautmädchen kräftig vor's Schienbein und setzte sich zufrieden wieder hin.

rain by a canopy and so she reached the altar with her feet dry. Once there she greeted Felipe with a kiss on his cheek.

The nervous strain of the preceding months had visibly taken its toll on the bridal couple. The Spanish king and queen had questioned the crown prince's choice. Letizia Ortiz Rocasolano was a prominent television journalist, but a commoner and divorcee. The media too had long been critical of the self-confident young woman and on 22 May her anxiety not to make a mistake on her big day clearly weighed on her narrow shoulders. Only after they had exchanged marriage vows did the couple relax a little with a relieved smile. In accordance with an old Spanish custom Felipe and Letizia exchanged 13 gold coins as a symbolic promise to share everything in their lives. In the cathedral too the tension was eased, not least by Felipe's nephew Froilán, who when he found the ceremony too boring, stood up, gave one of the bridesmaids a hearty kick on the shin and then returned satisfied to his seat.

The Prince and new Princess of Asturias left the Almudena Cathedral to the cheers of the crowd. Meanwhile the guests were to proceed to luncheon in a huge

Protokollarisch perfekt. Mit einer persönlichen Chipkarte wurde jeder Gast in der Almudena-Kathedrale an seinen Platz geleitet. So war der korrekte Einmarsch nach Rang gesichert. Je später der Gast kommen durfte, umso höher seine Stellung. Nur Queen Elizabeth von England erschien nicht. Sie schickt grundsätzlich ihre Kinder zu den Aristokratenhochzeiten. Zuletzt zog die spanische Königsfamilie in die Kathedrale ein.

Perfect protocol. Each guest was guided to his place in the Almudena Cathedral with a personal chipcard, ensuring that the order of precedence was maintained. The later a guest was allowed to enter the church the higher his social rank. The only absentee was Queen Elizabeth of England, who customarily sends one of her children to noble weddings. Last of all the Spanish royal family entered the church.

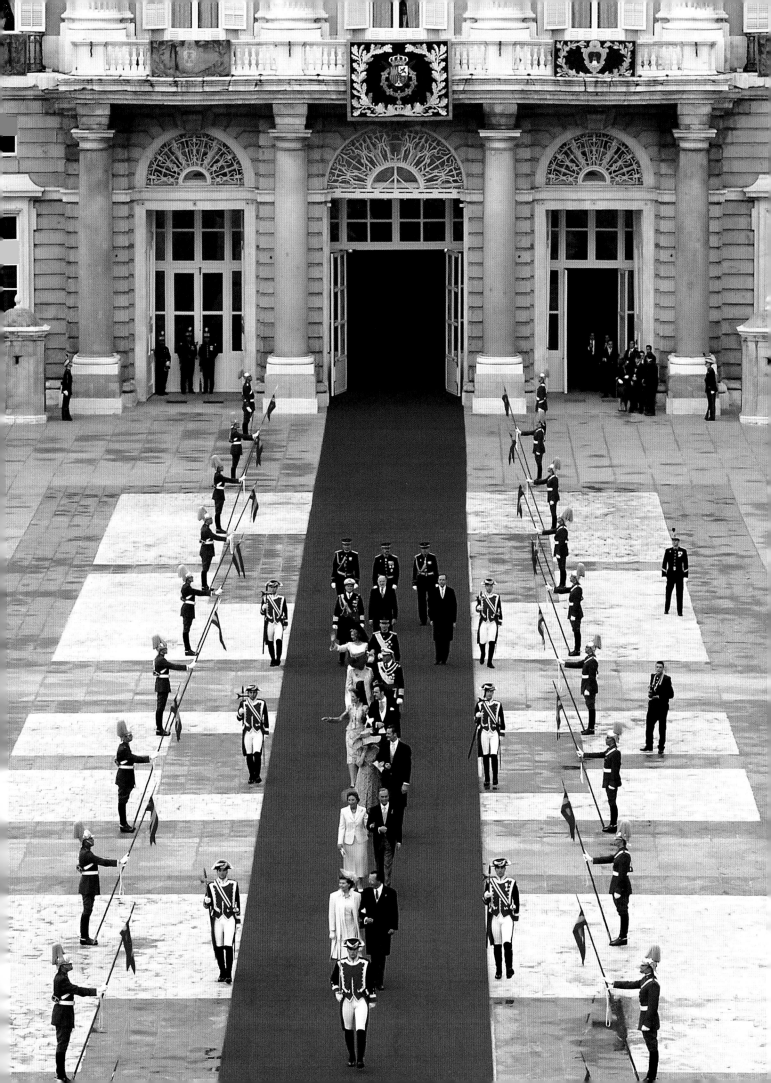

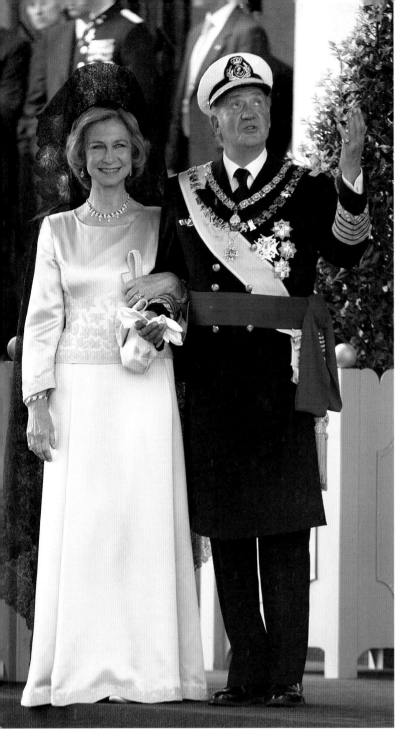

Begehrtes Blatt. Wer diese Einladung erhielt, konnte sich geehrt fühlen. Auf Wunsch des Königspaars waren viele spanische Granden, die Hochadeligen des Landes, unter den Gästen. Aber auch Letizias Freunde waren zahlreich vertreten und lockerten die Veranstaltung auf. Die Kosten für den Druck der Einladungskarten wurden auf 36 000 Euro geschätzt. Insgesamt kostete das Fest mehr als vier Millionen Euro.

Much-prized. An invitation to the lunch was a great honour. At the wish of the king and queen the guests included numerous Spanish grandees but there were also many of Letizia's friends, who introduced a less formal note. The invitation cards were estimated to have cost 36,000 euros out of 4 million euros spent on the festivities as a whole.

Wo bleibt die Sonne? König Juan Carlos scheint um besseres Wetter zu flehen. Seit 22 Jahren, so die Meteorologen, hatte es an einem 22. Mai in Madrid nicht mehr geregnet. Doch alle Prognosen halfen nichts.

Where's the sun? King Juan Carlos seems to be entreating it to shine. In 22 years, according to the meteorologists, it had never rained in Madrid on 22 May but all forecasts proved false.

Unter dem Jubel der Bevölkerung verließen der Prinz und die Prinzessin von Asturien die Kathedrale. Zur gleichen Zeit machten sich die Gäste auf den Weg zum Mittagessen in einem gigantischen Festzelt, das im Innenhof des Palacio Real errichtet worden war. An einen Fußweg war kaum zu denken, denn das im Hof stehende Wasser hätte die teure Garderobe komplett ruiniert. Dementsprechend warteten die meisten brav, bis sie von Bussen abgeholt wurden. Nur Prinz Charles nahm die Sache selbst in die Hand. Aus seinem künftigen Königreich an Dauerregen gewöhnt, schnappte er sich einen Schirm und stiefelte ganz allein durch den Regen zu Tisch.

marquee in the courtyard of the royal palace, the Palacio Real. But to go there on foot was unthinkable: the ankle-deep water would have ruined their expensive clothes. So most of them waited patiently to be transported by bus. Only the Prince of Wales took matters into his own hands. Accustomed to this kind of weather in his future kingdom Charles seized an umbrella and strode alone through the rain to the lunch.

At 2.20 p.m. Felipe and Letizia appeared on the balcony of the palace, but anyone expecting to see a passionate kiss was disappointed. Spanish court protocol allowed only a discreet kiss on the cheek. None-

Um 14:20 Uhr präsentierten sich Felipe und Letizia auf dem Balkon des Palastes. Doch wer einen leidenschaftlichen Kuss erwartet hatte, sah sich enttäuscht. Es gab lediglich ein zartes Küsschen auf die Wange, entsprechend dem spanischen Hofprotokoll. Doch immerhin: In diesem Moment riss zum ersten Mal an diesem Tag der Himmel auf und die Sonne strahlte auf ein glückliches Brautpaar.

theless, at that very moment the clouds parted for the first time that day and the sun shined on a happy bridal couple.

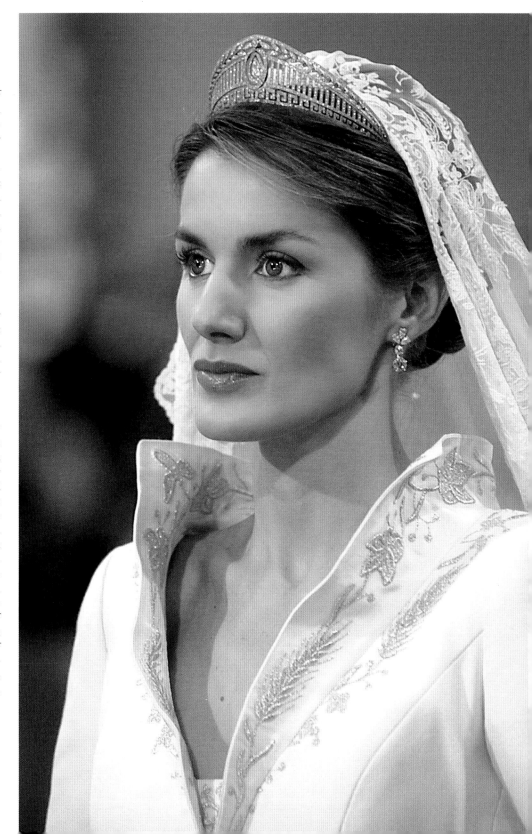

Der perfekte Auftritt. Letizia hatte sich auf Anraten von Königin Sofia für den 86-jährigen Designer Manuel Pertegaz entschieden. In engster Absprache mit der Braut entstand ein seidener Traum, der die zarte Silhouette Letizias betonte. Die valenzianische Seide war nachts gewebt worden, damit möglichst wenige die Beschaffenheit des Stoffs vor der Hochzeit sehen konnten. Ein 20-köpfiges Team hatte hinter verschlossenen Türen das Kleid mit besticktem Kaminkragen und viereinhalb Meter langer Schleppe konfektioniert. Den mit Lilien bestickten Schleier hatte der Prinz seiner Braut geschenkt, die Diamantohrringe waren ein Geschenk des Königspaars. Das Diadem hat eine lange Hochzeitstradition: Kaiser Wilhelm II. schenkte es seiner Tochter Viktoria Luise anlässlich ihrer Vermählung mit Ernst August von Hannover. Wilhelms Enkelin Friederike trug es bei ihrer Hochzeit mit Paul von Griechenland, die es schließlich ihrer Tochter Sofia für die Hochzeit mit Juan Carlos vererbte.

A perfect entry. On the advice of Queen Sofia, Letizia had chosen to have her dress created by the 86-year-old designer Manuel Pertegaz. The result, in close consultation with the bride, was a dream of silk that emphasised Letizia's slender figure. So that as few people as possible should see the unique material before the wedding it was specially woven at night. The gown with its embroidered stand-up collar and 15-foot train was then put together behind closed doors by a team of 20 seamstresses. The veil, with embroidered lilies, was a present from the prince to his bride and the diamond earrings a present from the king and queen. The tiara had a long history of weddings behind it: Emperor Wilhelm II of Germany had given it to his daughter Viktoria Louise on her marriage to Ernst August of Hanover, his granddaughter Frederica wore it for her wedding to King Paul of Greece, and gave it in turn to her daughter Sofia for her marriage to Juan Carlos.

Zurück im Schoß der Kirche. In monatelangen Vorbereitungen hatte man Letizia in das komplexe spanische Hofzeremoniell eingeführt. Auch Religions-unterricht hatte zum Tagesprogramm der künftigen Kronprinzessin gehört. Zwar war sie katholisch getauft, gab jedoch offen zu, mit der Kirche nur noch wenige Berührungspunkte gehabt zu haben. Da ihre erste Ehe nicht kirchlich geschlossen worden war, sahen die Bischöfe hier zum Glück kein Problem.

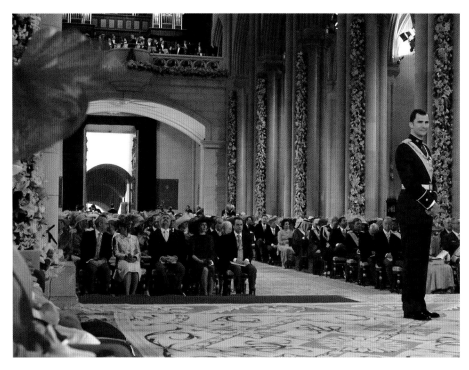

Prinz in Not. Von 10:52 bis 11:10 Uhr dauerte die Wartezeit des Kronprinzen vor dem Altar.

Princely patience. The crown prince had to wait at the altar from 10.52 until 11.10 a.m.

Musik in der Almudena-Kathedrale / Music in the Almudena Cathedral

Einzug von König Juan Carlos I / Entry of King Juan Carlos I
Marcha Real Española, national anthem of Spain

Einzug von Doña Letizia / Entry of Doña Letizia
Allegro, organ concerto op. 7 no. 3 in B-flat major, Georg Friedrich Händel

Während der Messe / During the mass
Gloria, Misa Pro Victoria, Tomás Luis de Victoria
Halleluja, Cristóbal de Morales
Sancta Maria, mater Dei KV 273, Wolfgang Amadeus Mozart
Sanctus, Misa Pro Victoria, Tomás Luis de Victoria
Benedictus, Misa Pro Victoria, Tomás Luis de Victoria
Agnus Dei, Misa Pro Victoria, Tomás Luis de Victoria
Tantum ergo, KV 197, Wolfgang Amadeus Mozart
O salutatis, Juan Crisóstomo de Arriaga
Pan Divino, Francisco Guerrero
Regina Coeli, Tomás Luis de Victoria
Lobe den Herrn, meine Seele, cantata no. 69, Johann Sebastian Bach

Auszug des Prinzen und der Prinzessin von Asturien / Departure of the Prince and Princess of Asturias
Halleluja, Georg Friedrich Händel

Auszug der Gäste / Departure of the guests
Meine Seele erhebet den Herrn, chorale prelude for organ, BWV 648,
Johann Sebastian Bach
Ach bleib bei uns, Herr Jesu Christ, chorale prelude for organ, BWV 649,
Johann Sebastian Bach

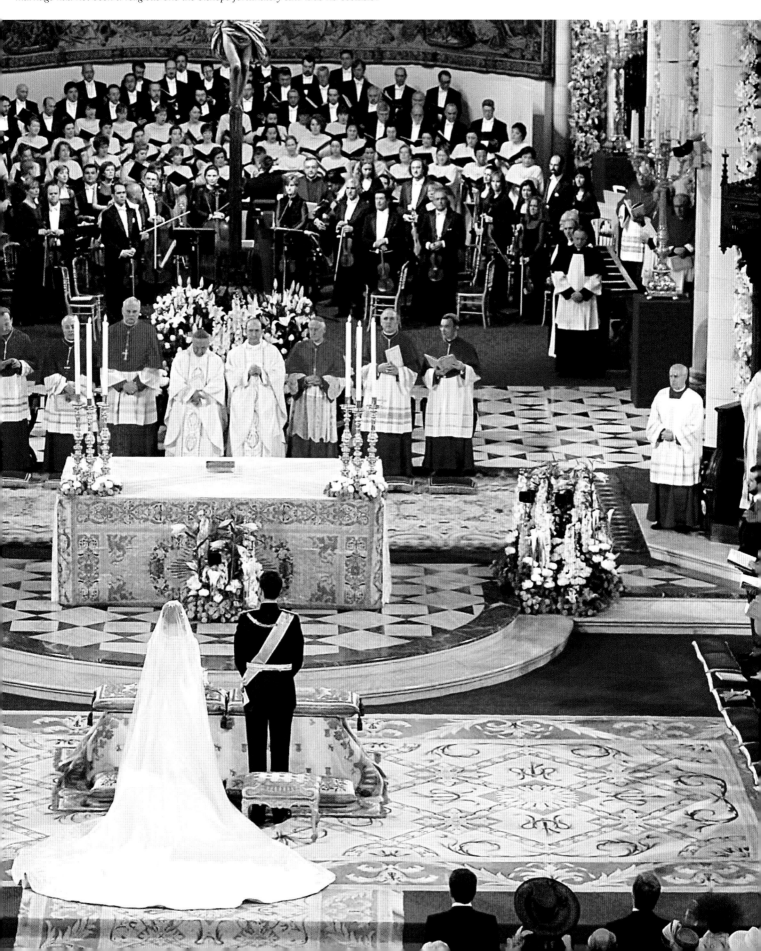

Back to the bosom of the church. In months of preparations Letizia had been introduced to the ceremonial complexities of the Spanish court and had to receive religious instruction as well. She had been baptised a Catholic but admitted openly that in her adult life she had had little to do with the church. As her first marriage had not been a religious one the bishops fortunately saw it as no obstacle.

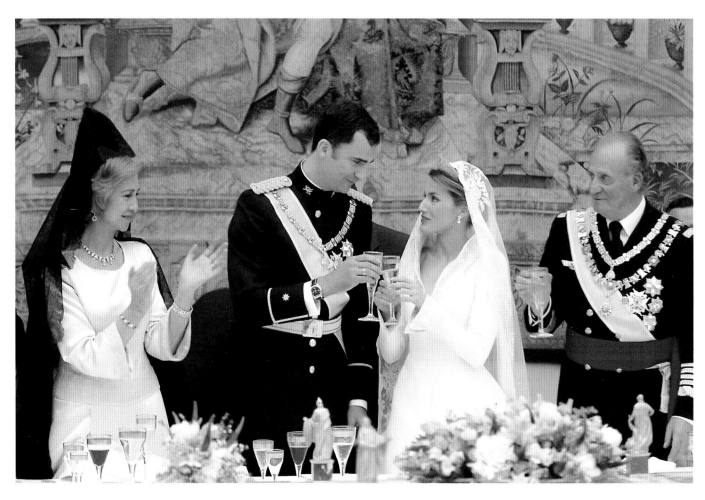

MENÚ

—————

TARTALETA HOJALDRADA
CON FRUTOS DE MAR SOBRE FONDO DE VERDURAS

*PUFF-PASTRY TARTLET
WITH SEAFOOD ON A BED OF VEGETABLES*

—————

CAPÓN ASADO AL TOMILLO
FRUTOS SECOS

*ROAST CAPON WITH THYME
AND NUTS*

—————

TARTA

CAKE

—————

Blanco D.O. Rías Baixas
Tinto D.O. Rioja
Cava

*White Wine: D.O. Rías Baixas
Red Wine: D.O. Rioja
Cava*

—————

PALACIO REAL, 22 DE MAYO DE 2004

Salud! Nur für die Fotografen stießen Braut und Bräutigam beim Bankett an. Letizia hielt sich während des ganzen Tages an alkoholfreie Getränke. Felipe wurde mit einem heimlichen Bierchen gesehen.

Salud! The bride and groom toasted each other only for the benefit of the photographers. Throughout the day Letizia kept to non-alcoholic drinks; Felipe was seen with a secret glass of beer.

Spanische Etikette. Nach einem dreigängigen Mittagessen mit erlesenen Weinen wurden den Herren Zigarren gereicht, deren Banderole mit dem Wappen des spanischen Königshauses etikettiert war.

Spanish etiquette. After a three-course lunch with superb wines the gentlemen were offered cigars with a band bearing the coat of arms of the Spanish royal house.

Kleine Wegbegleiter. Die acht Blumenkinder trugen Gewänder, die den Gemälden des Altmeisters Goya nachempfunden waren. Felipes Neffen und Nichten, Letizias Nichte und die Tochter einer Freundin vor ihrem großen Einsatz.

Small companions. The eight little bridesmaids and pageboys wore costumes based on the paintings of Goya. Felipe's nieces and nephews, Letizia's nieces and the daughter of a friend, before going into action.

Probleme einer Großmutter. Königin Sofia versucht, ihre Enkel zur Generalprobe zu bewegen. Offenbar mit mäßigem Erfolg. Zu allem Überfluss brannte bei der Probe auch noch eine Orgel durch. Sie konnte aber bis zum großen Tag repariert werden.

Problems of a grandmother. Queen Sofia tries, evidently with little success, to persuade her grandchildren to come to the dress rehearsal. On top of everything an organ then caught fire, but was fortunately repaired in time for the great day.

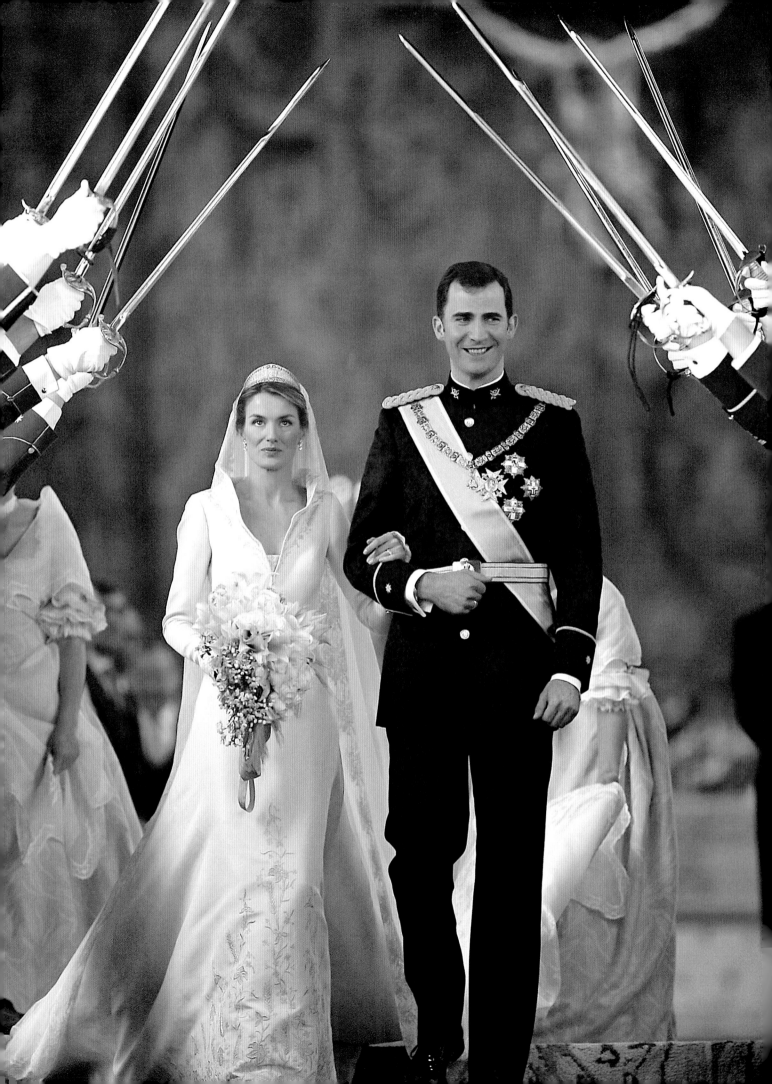

Dresscode. Cutaway für die Herren und ein kurzes Kleid für die Damen, so war es in der Einladung für die kirchliche Trauung vermerkt. Prinzessin Caroline von Monaco erschien elegant wie eh und je in Chanel. Die norwegische Prinzessin Märtha Louise an der Seite ihres Mannes Ari Behn hatte den Dresscode besonders originell interpretiert. Und Königin Rania von Jordanien hielt sich einfach nicht daran. Die stilsichere Monarchin trug stattdessen einen bodenlangen eleganten Rock mit sportlicher Bluse.

Dress code. Morning coat for the gentlemen and short dress for the ladies was prescribed for the church ceremony. Princess Caroline of Monaco appeared elegant as ever in Chanel. The Norwegian Princess Märtha Louise, accompanied by her husband Ari Behn, had interpreted the dress code in a highly original way and the stylish Queen Rania of Jordan had simply ignored it, wearing instead an elegant floor-length skirt and casual blouse.

Es grüßen: der Prinz und die Prinzessin von Asturien. Im Anschluss an die Trauung fuhr das Brautpaar durch die Straßen Madrids zur Basilika der Madonna von Atocha. Hier legte Letizia ihren Brautstrauß aus weißen Rosen und Lilien an der Statue der Schutzheiligen der Bourbonen nieder.

The Prince and Princess of Asturias greet the crowds. After the wedding the bride and groom drove through the streets of Madrid to the Basilica of the Madonna of Atocha, where Letizia laid her bouquet of white lilies and roses before the statue of the patron saint of the Bourbons.

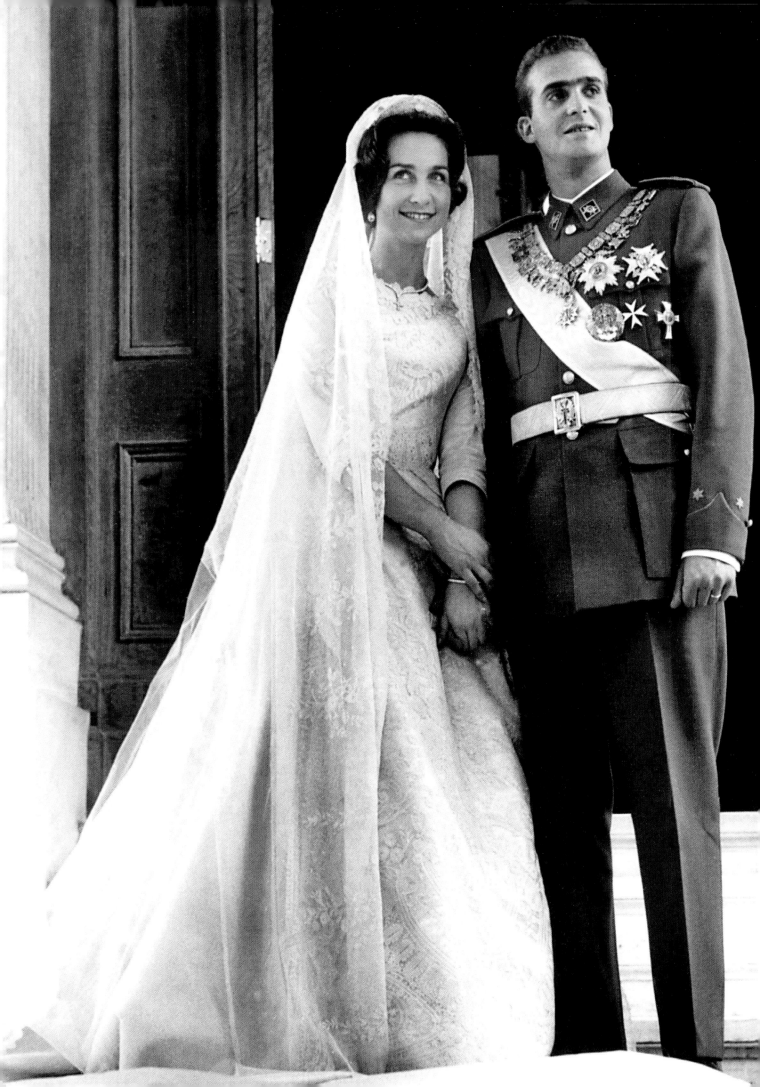

Juan Carlos & Sofia

Als Don Juan Carlos mit seiner Braut Sofia vor den Traualtar trat, war er ein spanischer Adelsspross mit ungewisser Zukunft, sie aber die Tochter des regierenden Königs von Griechenland. Sofia war für ihn die perfekte Partie – das hatte Juan Carlos schnell begriffen, als er 1961 bei der Hochzeit des Herzogs von Kent ihr Tischherr war. Die stille schöne Griechin war die ideale Ergänzung zu dem heißblütigen Bourbonen, der in Spanien Thronfolger im Wartestand war. Noch regierte Diktator Franco und niemand wusste, ob er seine Zusage, zu gegebener Zeit die Monarchie wieder einzuführen, auch tatsächlich einhalten würde.

Königin Friederike von Griechenland war äußerst angetan vom Galan ihrer Tochter. Unverhohlen versuchte sie, eine Annäherung der beiden tatkräftig zu unterstützen, und lud Juan Carlos in die „Villa Mon Repos" auf Korfu ein, wo das Paar einen ungestörten Sommer mit Badeausflügen und romantischen Sonnenuntergängen verbrachte. Doch Nachhilfe war längst nicht mehr nötig – Juan Carlos und Sofia hatten sich so ineinander verliebt, dass am Ausgang dieser Ferien kein Zweifel bestehen konnte: 100 Salutschüsse verkündeten am 13. September 1961, dass Prinzessin Sofia ihre Wahl getroffen hatte. Verlobungsringe, die aus Gold der Zeit Alexanders des Großen gefertigt worden waren, besiegelten das Heiratsversprechen.

When Don Juan Carlos and his bride Sofia walked to the altar he was a Spanish nobleman with an uncertain future and she the daughter of the reigning king of Greece. Sofia was the perfect match for Juan Carlos, as he had immediately realised when he sat next to her at the wedding of the Duke of Kent. The quiet and beautiful Greek princess was the ideal complement to the hot-blooded Bourbon, the Spanish crown prince-in-waiting. Dictator Franco was still in power and nobody knew whether he would keep his promise to reintroduce the monarchy when the time was ripe.

Queen Frederica of Greece was much taken with her daughter's suitor. She made no secret of her efforts to encourage a liaison and invited Juan Carlos to stay at the "Villa Mon Repos" on Corfu where the couple spent an idyllic summer with swimming and romantic sunsets over the sea. No outside help was needed though: Juan Carlos and Sofia were so deeply in love with each other that by the end of the holiday the outcome was crystal clear. On 13 September 1961 a 100-gun salute announced that Princess Sofia had made her choice. Engagement rings of gold from the time of Alexander the Great confirmed the engagement.

However smooth the course of their love so far, serious problems now arose. Juan Carlos was a Catholic, Sofia Greek-Orthodox. If she was one day to be queen of

Bräutigam an Bord. Mit der „Canaris", dem größten Schiff der spanischen Kriegsflotte, reiste Juan Carlos nach Athen, wo er vom Jubel der griechischen Bevölkerung empfangen wurde. Eine große Abordnung hochrangiger Spanier gab ihm an Bord standesgemäßes Geleit.

Bridegroom aboard. On board the "Canaris", the biggest ship in the Spanish navy, Juan Carlos sailed to Athens, where he was greeted by jubilant Greek crowds. As required by protocol he was accompanied by a cortège of suitably high-ranking Spaniards.

Schöner Kavalier. Kurz vor der Hochzeit schreibt Juan Carlos einen Brief an seine Verlobte. Die Brautmutter schwärmte: „Juanito ist unwahrscheinlich schön. Er hat dunkle Augen mit langen Wimpern, ist groß und athletisch und setzt seinen Charme gekonnt ein."

Handsome cavalier. Shortly before the wedding Juan Carlos writes a letter to his fiancée. The bride's mother was enchanted: "Juanito is incredibly handsome. He has dark eyes and long lashes, is athletic and knows how to charm."

Doch so einfach sich diese Liebe angebahnt hatte – jetzt wurde es richtig kompliziert: Juan Carlos war Katholik, Sofia aber gehörte der griechisch-orthodoxen Kirche an. Sollte Sofia eines Tages Königin von Spanien werden, musste sie fraglos zum katholischen Glauben konvertieren, doch die stolzen Griechen wären von einem schnellen Konfessionswechsel ihrer Königstochter zutiefst verletzt gewesen. Hinter den Kirchenmauern begannen hektische Überlegungen. Juan Carlos' Vater, der Graf von Barcelona, plante bereits eine Trau-

Spain she would have to convert to Catholicism, but the proud Greeks would have been deeply offended if the daughter of their king were to change her religion overnight. Hectic consultations began within the ranks of the church. Juan Carlos' father, the Count of Barcelona, was already planning a wedding to be celebrated by Pope John XXIII. Archbishop Theoklitos, the head of the Greek church, was incensed. Finally it was agreed, chiefly as a result of wise counsel by the Pope, to have two wedding ceremonies.

ung durch Papst Johannes XXIII. Hochwürden Theoklitos, das Oberhaupt der griechischen National-kirche, war entsetzt. Schließlich einigte man sich, vor allem dank des mäßigenden Einflusses des Papstes, auf eine doppelte Trauung.

Am 14. Mai 1962 war Athen Ziel des gesamten europäischen Hochadels. Fast alle regierenden oder im Exil lebenden Monarchen folgten der Einladung, so dass schließlich 137 Königinnen und Könige, Prin-zessinnen und Prinzen versammelt waren. Königin

On 14 May 1962 the entire upper ranks of the European nobility were assembled in Athens. Virtually all the monarchs of Europe, reigning or in exile, had accepted the invitation, adding up to the impressive number of 137 kings and queens, princes and princesses. Queen Frederica later confessed that she had been so excited that for the first time in her life she had had to take a tranquilliser.

The slender bride wore a cream-coloured dress of silk brocade, with a 20-foot train carried by eight

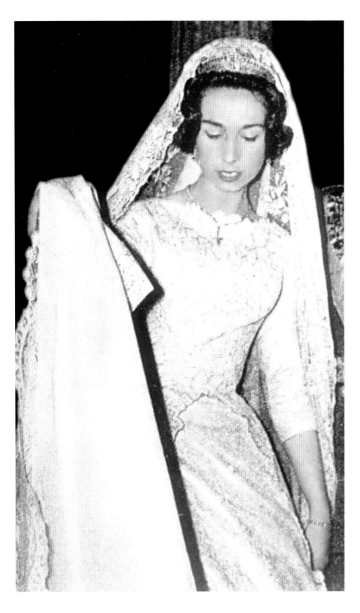

Friederike gab später zu, so aufgeregt gewesen zu sein, dass sie an diesem Tag zum ersten Mal in ihrem Leben Beruhigungsmittel nehmen musste.

Der griechische Modeschöpfer Jean Dessès hatte für die zierliche Sofia eine cremefarbene Robe aus Seidenbrokat entworfen. Acht Brautjungfern trugen die sechs Meter lange Schleppe. Bereits am Morgen fand die erste Trauung in der römisch-katholischen Kathedrale statt. Danach ging es per Kutsche durch die jubelnden Massen zu einer kleinen Verschnaufpause in den Palast, denn schon wenig später stand die zweite Trauung auf dem Programm. Diesmal nach byzantinischem Ritus in der griechisch-orthodoxen Kathedrale. Für Sofia war dieser Teil des Tages der emotionalste. In der weihrauchgeschwängerten Luft des Gotteshauses leitete der Primas der orthodoxen Kirche in einem

bridesmaids, created by the Greek couturier Jean Dessès. The first wedding took place in the morning in the Roman Catholic cathedral, followed by a drive in a coach through the cheering crowds to the palace. Here there was a brief rest, badly needed since the second wedding ceremony, this time in accordance with Byzantine ritual in the Greek-Orthodox cathedral, was to take place shortly afterwards. For Sofia this part of the day was the most emotional. With incense heavy in the air the head of the Orthodox church, clad in gold and white, conducted the service. Twelve members of the holy synod and twelve bishops assisted him in the various rites, familiar to the daughter of the king since her childhood. When her father, King Paul I of Greece, held the symbolic crowns over the heads of the bridal couple Sofia battled with her tears. After this service too

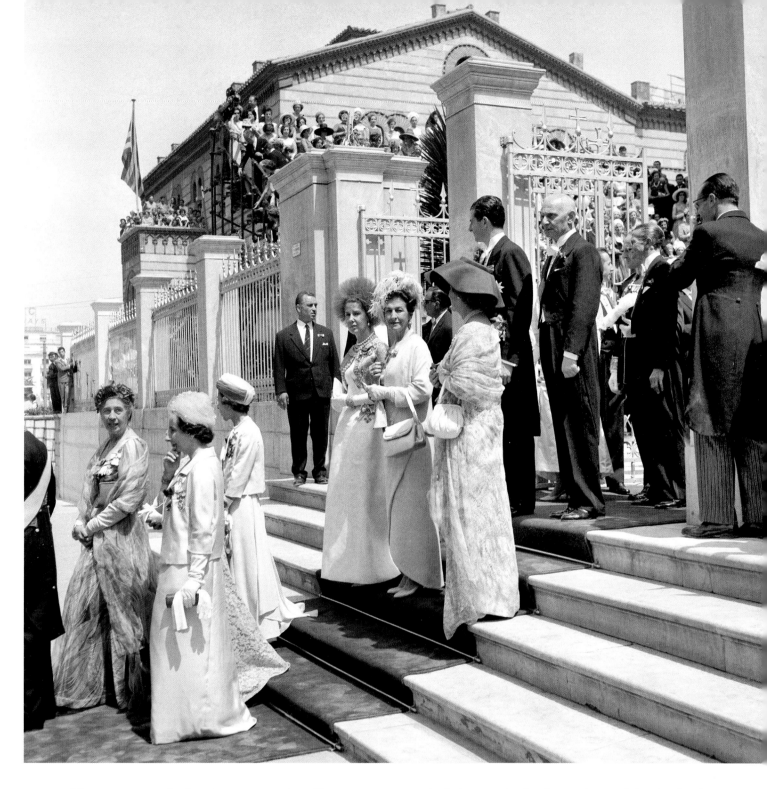

weiß-goldenen Gewand die Zeremonie. Zwölf Mit-
glieder der Heiligen Synode sowie zwölf Bischöfe assis-
tierten ihm bei den feierlichen Gebräuchen, die der
Königstochter seit ihrer Kindheit bekannt waren. Als ihr
Vater, König Paul I. von Griechenland, die symboli-
schen Kronen über das Brautpaar hielt, kämpfte die
Prinzessin mit den Tränen. Nachdem auch diese
Zeremonie ihr Ende gefunden hatte, musste im Palast
dann tatsächlich zum dritten Mal „Ja" gesagt werden,
denn erst hier besiegelte die standesamtliche Trauung,
dass Juan Carlos und Sofia nun ein Ehepaar waren.

was concluded, vows had to be exchanged for the third
time, in the palace, since only the civil ceremony con-
firmed officially that Juan Carlos and Sofia were now man
and wife.

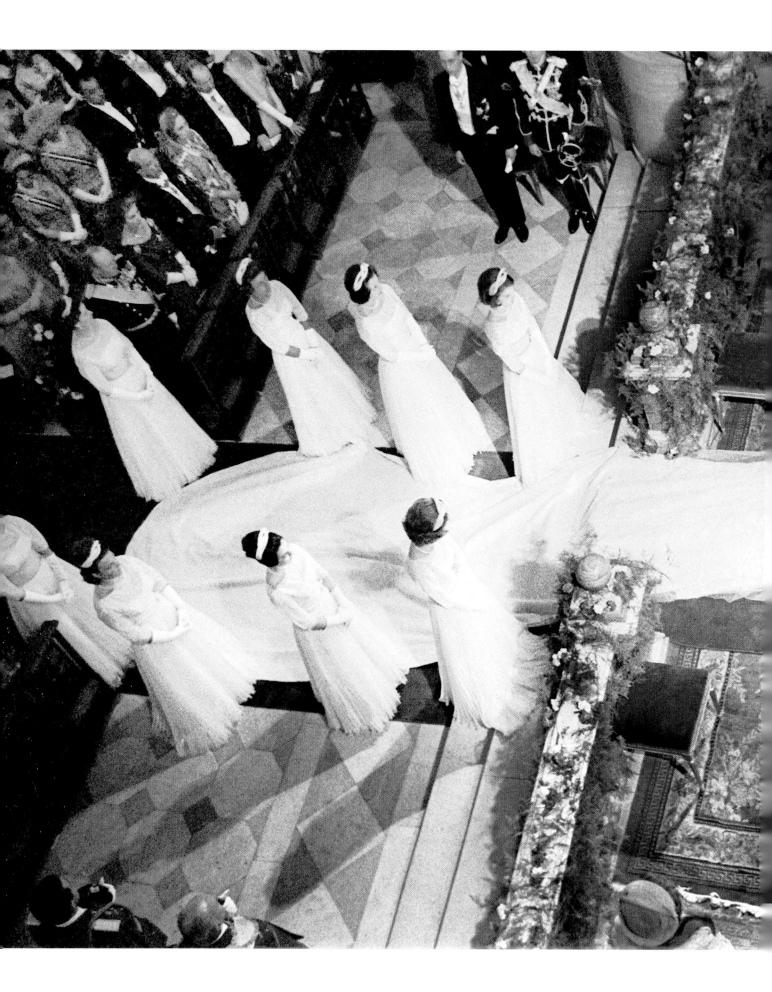

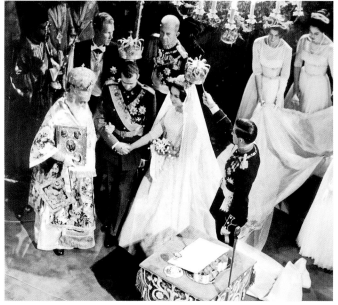

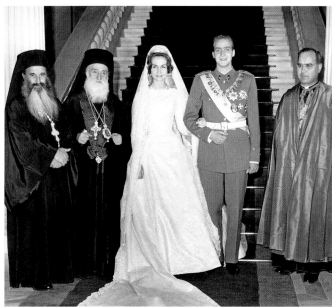

Himmlischer Beistand. Das Brautpaar am Hochzeitstag mit den Priestern beider Konfessionen. Am 31. Mai 1962 konvertierte Sofia zum katholischen Glauben. Bereits vier Tage später war das Ehepaar zur Audienz beim Papst eingeladen.

Divine assistance. The bridal couple pose on their wedding day with the priests of both religions. On 31 May 1962 Sofia converted to Catholicism. Only four days later the couple were invited to an audience with the Pope.

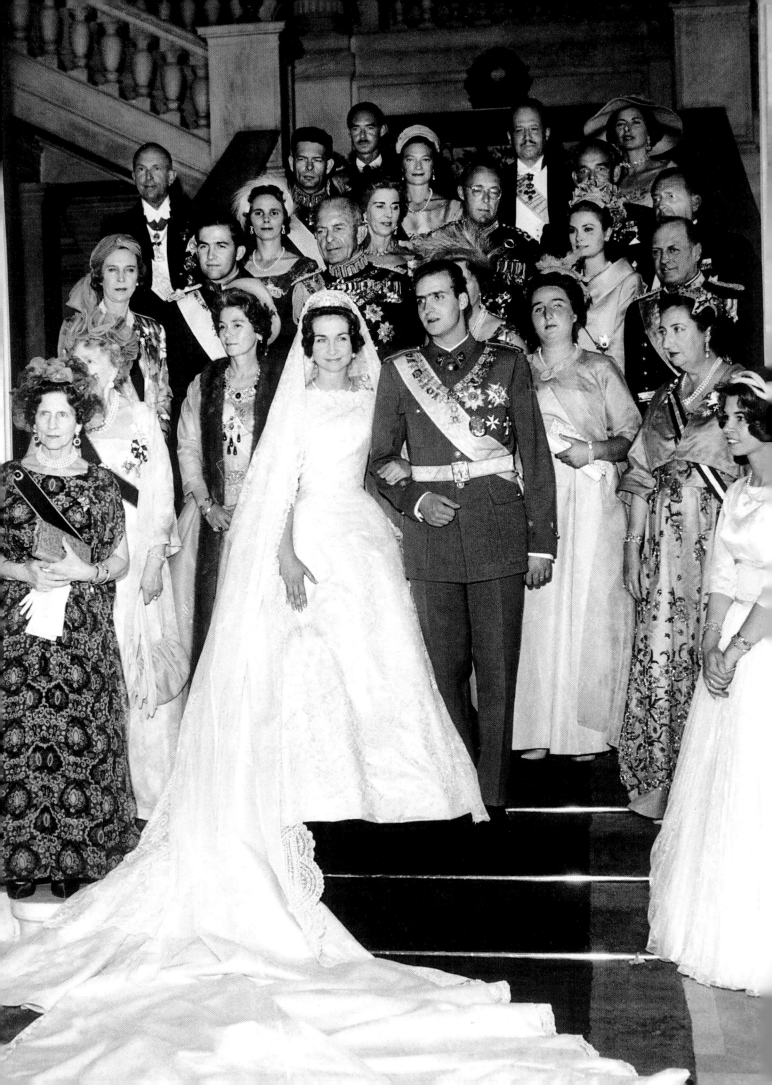

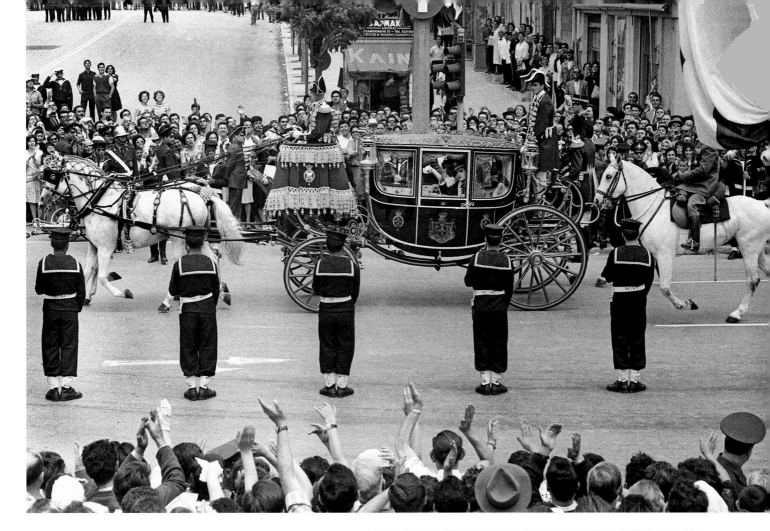

Königshäuser im Wandel. Während Juan Carlos 13 Jahre später nach dem Tod von Diktator Franco den spanischen Thron bestieg und die Bourbonen damit wieder ein regierendes Herrscherhaus wurden, musste die griechische Königsfamilie nach dem Militärputsch 1967 das Land verlassen. 1973 wurde die Monarchie in Griechenland vollends abgeschafft.

Royal vicissitudes. Whereas on the death of Franco 13 years later Juan Carlos acceded to the Spanish throne and the Bourbons became a reigning house again, the Greek royal family were forced to leave their country after a military coup in 1967. In 1973 the monarchy in Greece was finally abolished.

Flitternd um die Welt. An Bord einer Luxusjacht des Reeders Niarchos begannen für das Brautpaar am Tag nach der Hochzeit die Flitterwochen. Insgesamt fünf Monate reisten die beiden über fünf Kontinente und stellten sich der Welt vor, bevor sie sich in Madrid im Zarzuela-Palast niederließen.

Global honeymoon. On the day after the wedding the bridal couple set out on their honeymoon on board a luxury yacht owned by the shipping magnate Niarchos. For five months they travelled throughout all five continents before returning to Madrid to take up residence in the Zarzuela Palace.

157

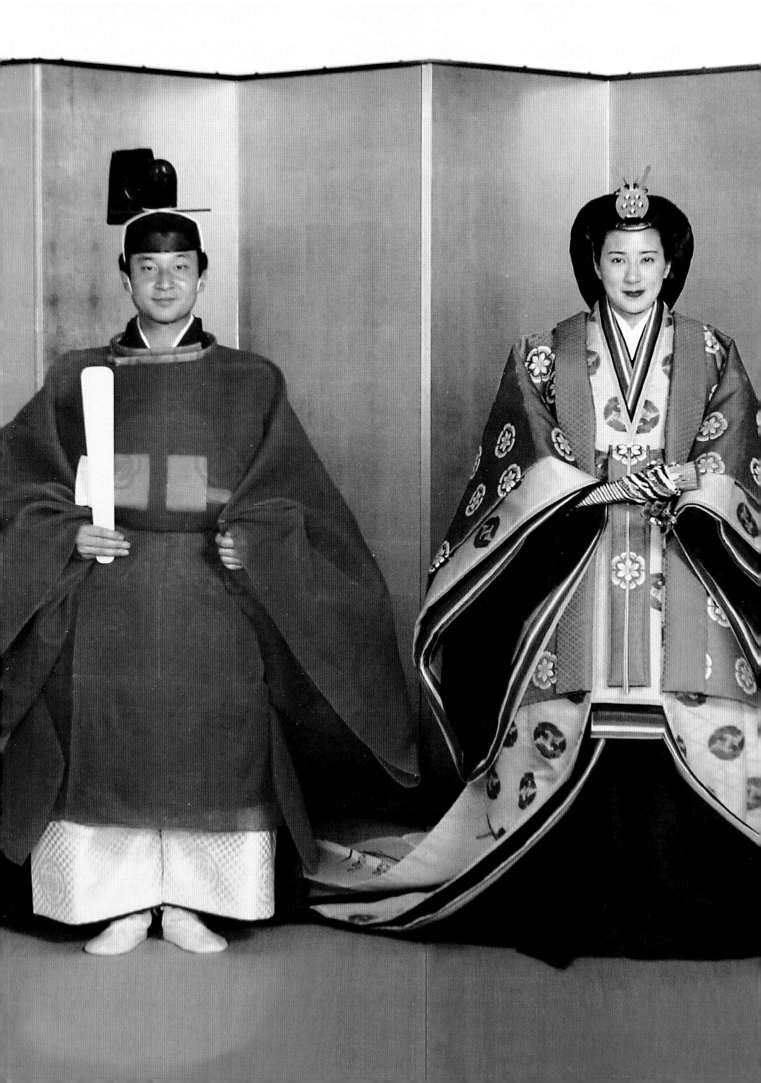

Naruhito & Masako

Die Hochzeit ohne Zeugen
Japan, 9. Juni 1993

The Wedding behind Closed Doors
Japan, 9 June 1993

Während bei Europas Königshäusern meist Millionen Menschen dem „Ja-Wort" von royalen Paaren lauschen, wissen im japanischen Kaiserhaus nur die Brautleute, die Priester und die Götter, wie die Eheschließung genau ablief. Die 812 geladenen Gäste mussten auf dem Vorplatz warten, als Kronprinz Naruhito und seine Braut Masako den Inneren Heiligen Raum des Schreins der Sonnengöttin Amaterasu auf dem Gelände des Kaiserpalastes von Tokyo betraten. Naruhito kniete auf einer Reisstrohmatte vor dem Altar, hinter ihm kauerte seine Braut. Nachdem beide der Göttin einen Zweig geopfert hatten, las der Kronprinz ein rituelles Heiratsgelöbnis vom Blatt ab. Masako schwieg. Danach krochen die beiden auf Knien in den Äußeren Heiligen Raum, tranken drei Schlucke Reiswein und verließen einzeln den Schrein.

Unter den weltweiten Heiratsgebräuchen gehören die des japanischen Kaiserhauses sicherlich zu den geheimnisvollsten. Denn seit Jahrhunderten hält diese sonst so moderne Nation an Ritualen fest, die für Außenstehende völlig fremdartig sind. Die Braut allerdings unterschied sich nur wenig von ihren Amtskolleginnen in Europa. Masako Owada war eine bürgerliche junge Frau, die mit beiden Beinen im Berufsleben stand. Nach einem hervorragenden Studienabschluss in Harvard hatte sie eine vielversprechende Karriere im japanischen

Whereas weddings in European royal houses are usually watched by millions, in the Japanese imperial family only the bridal couple, the priests and the gods are allowed to witness the actual ceremony. The 812 invited guests had to wait outside as Crown Prince Naruhito and his bride, Masako, entered the sacred inner sanctum of the Sun Goddess Amaterasu in the grounds of the imperial palace in Tokyo. Naruhito knelt on a rice-straw mat before the altar while his bride crouched behind him. After they had each sacrificed a branch to the goddess the crown prince read aloud a ritual marriage vow. Masako remained silent. Then they proceeded on their knees to the sacred outer sanctum, drank three sips of rice wine and separately left the shrine.

Of all the marriage customs throughout the world those of the Japanese imperial house are certainly among the most secretive. This otherwise so modern country still keeps centuries old rituals quite alien to outsiders. In this case however the bride was not unlike her sisters in Europe. Masako Owada was a commoner, a young woman well established in her profession. After an excellent degree from Harvard University she had embarked on a very promising career in the Japanese diplomatic service. But fate decided otherwise: for a long time the arch-conservative officials of

159

Außenministerium begonnen. Und doch kam alles ganz anders: Die erzkonservativen Beamten des Kaiserhofs waren bereits seit längerem auf der Suche nach einer Frau für den Thronerben und trotz ihrer westlichen Prägung passte Masako in das Raster, das der Hof für geeignet hielt. Doch wie die Auserwählte von einem Leben im Kaiserpalast überzeugen? Noch immer lebt die Familie des Tenno in einem engen Korsett aus althergebrachten Verpflichtungen, wie dem Spielen mittelalterlicher Instrumente. Spaß und Unterhaltung haben hier wenig zu suchen. Nur ganz selten wird Journalisten der Zugang zum Hof gewährt, und selbst wenn

the imperial court had been looking for a wife for the heir to the throne, and in spite of her western connections Masako Owada seemed to suit the court's requirements. How could life at the imperial palace be made to appeal to her? The emperor's family were still tightly bound by a web of ancient ritual where fun and entertainment had no part to play. Journalists were seldom allowed into the court and even when occasional television pictures were permitted they were nearly always without sound and showed the imperial family strolling in gardens or admiring the cherry blossom.

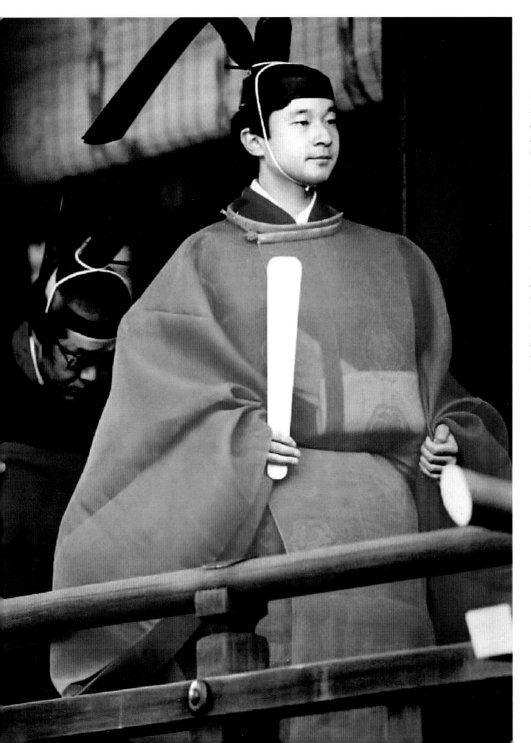

Ungewöhnlicher Aufzug. Der Bräutigam war an seinem großen Tag in einen Seidenkimono im Stil des japanischen Frühmittelalters gehüllt. Eine derartige Kopfbedeckung aus schwarz lackierter Gaze tragen normalerweise shintoistische Priester. Naruhitos Heiratsgelöbnis hätten seine Untertanen auch dann nicht verstehen können, wären Mikrofone im Schrein erlaubt gewesen. Es war im Japanisch des 8. Jahrhunderts formuliert und in chinesischen Schriftzeichen geschrieben.

Unusual attire. On his great day the bridegroom was dressed in a silk kimono in the style of the Japanese early middle ages, with a black lacquered headdress of the kind usually only worn by Shinto priests. His future subjects would not have understood his marriage vow even if a microphone had been allowed in the shrine, for it was couched in the Japanese of the 8th Century and written in Chinese characters.

Fernschaufnahmen gemacht werden dürfen, finden sie fast immer ohne Ton statt und zeigen die Mitglieder der Kaiserfamilie durch Gärten flanierend oder an Kirschblüten schnuppernd.

Masako lehnte daher zweimal ab, als ihr der Hof Naruhitos Interesse mitteilte. Wie es dem Kronprinzen schließlich gelang, ihr Herz zu gewinnen, hat er stets für sich behalten. Nur soviel wurde publik: Naruhito versprach ihr, bei dem schwierigen Wechsel von der modernen Welt in die Stille des Kaiserhofes stets stützend zur Seite zu stehen. Ein Versprechen, das er bis heute gehalten hat. Am 9. Juni war es auch ein Zugeständnis

Masako twice declined when informed by the court of Naruhito's interest in her. How the crown prince finally succeeded in winning her over he has never revealed. Only this much is known: he promised always to stand beside her in the painful change from the modern world to the silence of the imperial court; a promise he has kept to this day. As a concession to the bride the court agreed that the mysterious ceremony in the shrine on 9 June should be followed by a modern wedding procession in an open Rolls Royce. Masako, who had been under intense pressure the whole day, could relax at last and respond to the

Schwere Last. Bereits im Morgengrauen hatten Hofbeamte Masako in ihrem Elternhaus abgeholt, um sie in einer stundenlangen Prozedur mit der äußerst komplizierten traditionellen Brautkleidung auszustatten. Zunächst hatten Zofen ihr Haar mit Kamelienöl eingerieben und eine schwarze Perücke befestigt. Gesicht, Arme und Hände wurden weiß gepudert. Die größte Herausforderung aber war das Wickeln des zwölflagigen Kimonos. Das zehn Kilogramm schwere Gewand hatte einen Wert von geschätzten 30 000 US-Dollar. Für Masako war es eine große Herausforderung, sich in diesem Gewand zu bewegen.

Heavy burden. Court officials had fetched Masako from her parents' house at dawn in order to dress her in the extremely complicated traditional bridal robes, a process that took several hours. First her maids rubbed camelia oil into her hair and fitted her with a black wig. Her face, arms and hands were then covered in white powder, but the greatest challenge came with wrapping the twelve layers of the kimono. Estimated to be worth 30,000 US dollars it weighed 22 pounds and was extremely difficult for Masako to move in.

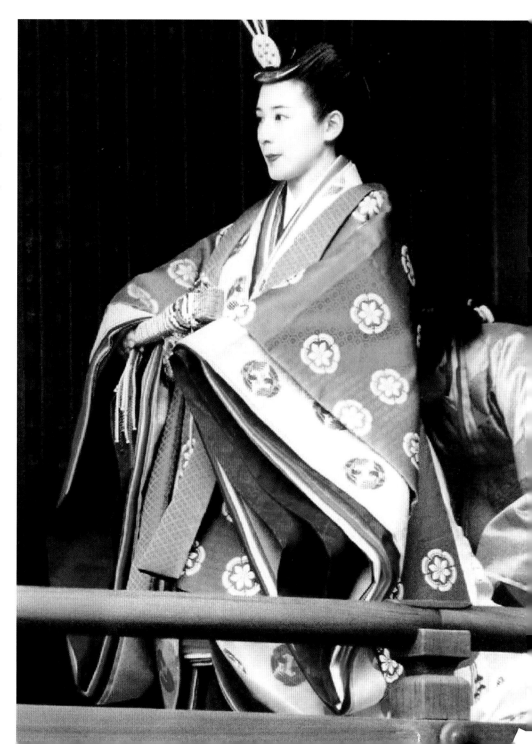

Tradition und Moderne. Die Hochzeit des Kronprinzen war das Medienereignis des Jahres in Japan. Ein Drittel der Fernsehzuschauer saß gebannt vor den Bildschirmen. Trotz des modernen Lebensstils verfolgen die Japaner das Geschehen in ihrem traditionsbewussten Kaiserhaus mit größtem Interesse.

Ancient and modern. The crown prince's wedding was the media event of the year in Japan. Two thirds of the population sat transfixed before their television screens. In spite of their modern lifestyle the Japanese follow the proceedings of the tradition-bound imperial family with great interest.

Vertrauter Anblick. Am Nachmittag des Hochzeitstages zog sich das Brautpaar um. Naruhito trug nun einen ordengeschmückten Frack, Masako ein elfenbeinfarbenes Seidenkleid. Ihr Kopfschmuck, eine mit 3 000 Diamanten besetzte Tiara, wird bereits seit Generationen in der Familie des Tenno weitergegeben. Um ihren einige Zentimeter kleineren Bräutigam nicht zu sehr zu überragen, trug Masako keine hohen Absätze.

Back to normal. In the afternoon the couple changed out of their ceremonial attire, Naruhito into a tailcoat with decorations and Masako into an ivory-coloured silk dress. Her tiara, set with 3,000 diamonds, had been passed from generation to generation in the family of the emperor. So as not to tower over her husband, slightly shorter than herself, Masako wore flat shoes.

des Hofes an die Braut, dass im Anschluss an das mysteriöse Gelöbnis im Schrein eine Hochzeitsparade nach modernen Gepflogenheiten im offenen Rolls Royce stattfand. Masako, für die der Tag bis dahin unter äußerster Anspannung verlaufen war, konnte etwas aufatmen und lächelte strahlend den 200 000 Menschen zu, die die Straßen vom Kaiserpalast bis zur Residenz des Kronprinzen säumten. Die Stadt hatte sich herausgeputzt: Überall wehten Wimpel und Fahnen mit der aufgehenden roten Sonne – der japanischen Nationalflagge. Ein kurzer Moment der Freude für das Brautpaar an diesem Tag der komplizierten Regeln und Verpflichtungen.

200,000 people lining the streets from the imperial palace to the residence of the crown prince with a radiant smile. The town showed itself at its best: from all the buildings fluttered banners bearing the blood-red rising sun, the national flag of Japan. It was a brief moment of happiness for the bridal couple on this day of complicated rules and obligations. There was another ceremony in the evening and even on their wedding night there was a further ritual to be performed. At 9 o'clock, guided by a priest, they had to don white kimonos, get into bed and sample 29 rice cakes. Only then were the doors closed and Naruhito and Masako

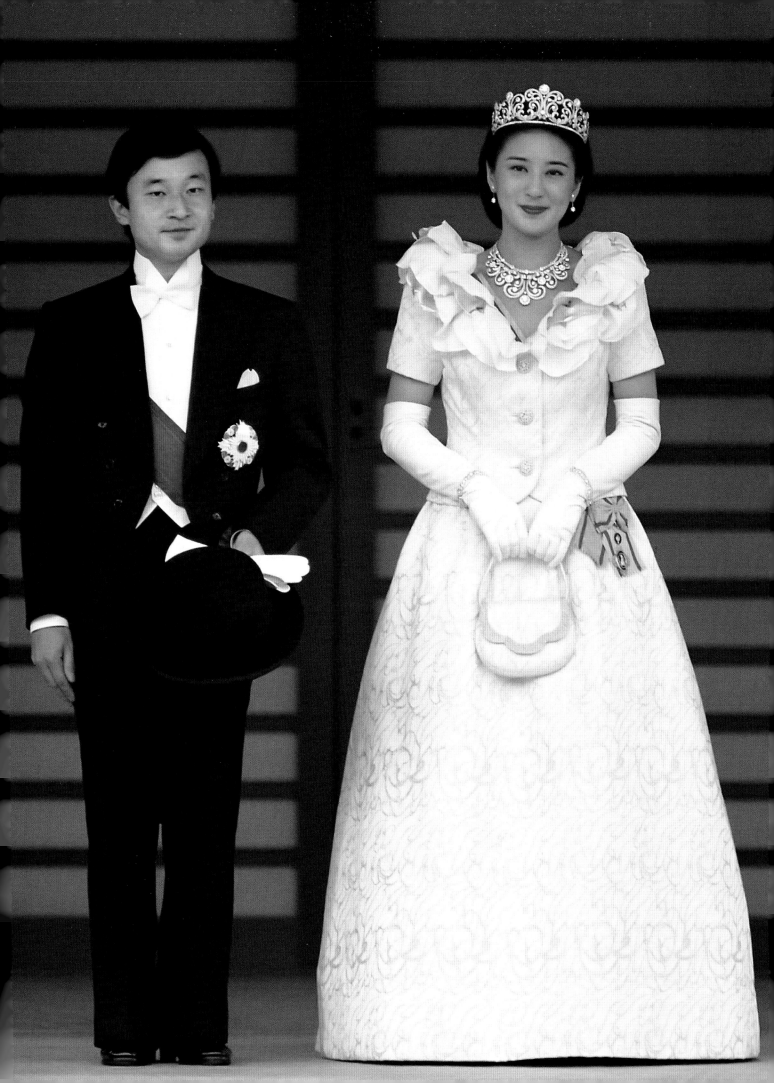

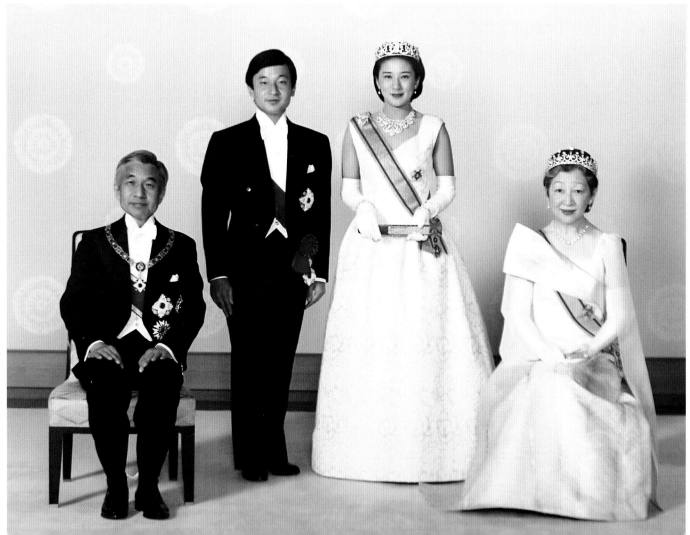

Am Abend folgte wieder ein Zeremoniell und nicht einmal in ihrer Hochzeitsnacht blieben Kronprinz und Kronprinzessin ungestört. Unter Aufsicht der Priester begaben sie sich um 21 Uhr in weißen Kimonos zu Bett und kosteten von 29 Klebreiskuchen. Danach erst schlossen sich die Türen und für Naruhito und Masako begann offiziell das Leben als japanisches Kronprinzenpaar. Ein Leben, um das sie, anders als europäische Prinzen und Prinzessinnen, nur von wenigen beneidet werden dürften.

could begin their official life as Japanese crown prince and princess, a life, unlike that of European princes and princesses, for which few would envy them.

Volle Tische, leere Mägen. Nach dem Gelöbnis fuhr das Brautpaar zum Kaiserpalast, um dem Tenno und seiner Frau die Eheschließung zu melden. Auf den Tischen befanden sich kulinarische Besonderheiten, die seit Jahrhunderten bei festlichen Anlässen verzehrt werden. Darunter Seeigel, Garnelen, Fischpastete, Fischbrühe und süßer Reiswein. Gegessen aber wurden die Köstlichkeiten nicht. Brautpaar und Kaiserpaar führten die Essstäbchen nur symbolisch zum Mund. Als Mitglied der Kaiserfamilie verlor Masako an ihrem Hochzeitstag auch ihren Nachnamen. Die Familie des Tenno ist die einzige in Japan, die nur Vornamen trägt.

Full tables, empty stomachs. After the wedding ceremony the bridal couple drove to the imperial palace to report their marriage to the emperor and his wife. Special delicacies which for centuries had been served on festive occasions, including sea urchins, shrimps, fish paté, fish bouillon and sweet rice wine, were spread on the tables; but they were not there to be eaten, the imperial family merely raised their chopsticks symbolically to their lips. On marrying into the imperial house Masako also lost her surname as the family of the emperor is unique in Japan in bearing only first names.

Jubel auf Japanisch. Viereinhalb Kilometer führte der Weg des Brautpaars vom Kaiserpalast zum Wohnsitz des Kronprinzen. 30 000 Polizisten sorgten für Disziplin unter den Fans am Straßenrand. Vielerorts intonierten Blaskapellen den für diesen Tag komponierten Marsch „Frühling der Friedensära".

Rejoicing in Japanese. A drive of some three miles took the bridal couple from the imperial palace to the residence of the crown prince. 30,000 police officers kept the spectators under control and brass bands played a march, "Spring in a Time of Peace" specially composed for the occasion.

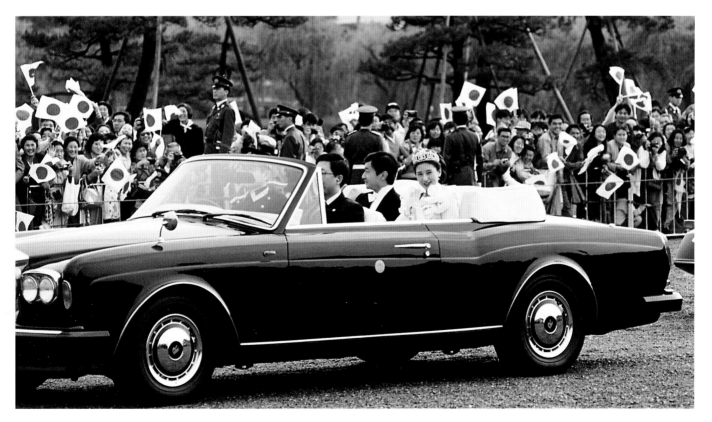

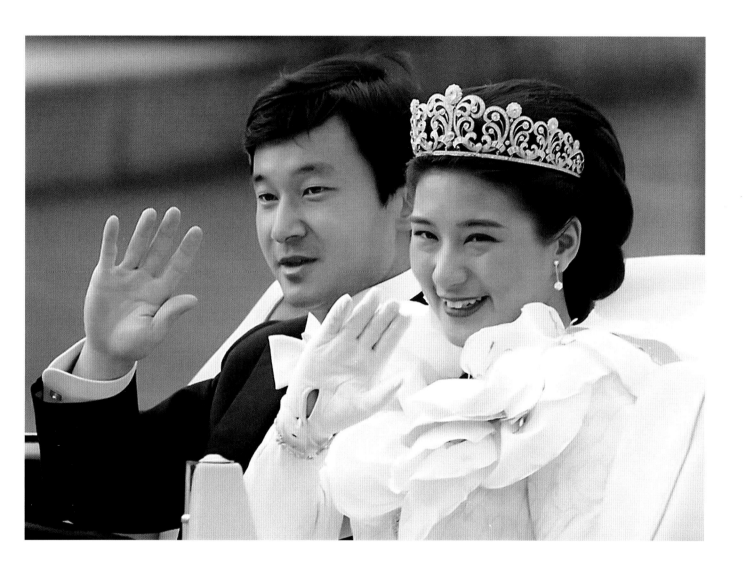

Goldener Käfig. Mit ihrem Hochzeitstag begann für Masako Owada das stille Leben hinter den dicken Palastmauern. Die Bürde, einen männlichen Thronfolger zur Welt bringen zu müssen, lastete schwer auf der jungen Frau. Töchterchen Keiko, die 2001 geboren wurde, wird wohl das einzige Kind des Kronprinzenpaars bleiben. Die Prinzessin hatte sich zeitweise völlig aus der Öffentlichkeit zurückgezogen, da sie sich den strengen Anforderungen des Hoflebens nicht mehr gewachsen sah. Ihr Mann Naruhito nahm viele Termine allein war und verteidigte seine Frau tapfer gegen alle Kritik von Seiten des Hofes und der Öffentlichkeit.

Golden cage. With her wedding day Masako Owada began her lonely life behind the massive walls of the palace. The burden of having to bear a male heir to the throne weighed heavily on the unfortunate young woman. Daughter Keiko, born in 2001, will be the only child of the crown prince and his wife. At times the princess withdrew entirely from public life, no longer able to live up to the rigid demands of court life. Her husband fulfilled many public engagements without his wife and bravely defended her against all criticism from the public or the court.

© 2011 teNeues Verlag GmbH + Co. KG, Kempen

Edited by Friederike Haedecke & Julia Melchior
Texts by Friederike Haedecke & Julia Melchior
Design by Eva Reuters
Editorial coordination by Pit Pauen, teNeues Verlag
Production by Tim Struwe, teNeues Verlag
Translation by Rosamund Huebener
Copy editing by David Rothery, Inga Wortmann

Color separation by MT-Vreden, Vreden

Published by teNeues Publishing Group

teNeues Verlag GmbH + Co. KG
Am Selder 37, 47906 Kempen, Germany
Phone: +49-(0)2152-916-0
Fax: +49-(0)2152-916-111
e-mail: books@teneues.de

Press department: Andrea Rehn
Phone: +49-(0)2152-916-202
e-mail: arehn@teneues.de

teNeues Digital Media GmbH
Kohlfurter Straße 41–43, 10999 Berlin, Germany
Phone: +49-(0)30-7007765-0

teNeues Publishing Company
7 West 18th Street, New York, NY 10011, USA
Phone: +1-212-627-9090
Fax: +1-212-627-9511

teNeues Publishing UK Ltd.
21 Marlowe Court, Lymer Avenue, London SE19 1LP, UK
Phone: +44-(0)20-8670-7522
Fax: +44-(0)20-8670-7523

teNeues France S.A.R.L.
39, rue des Billets, 18250 Henrichemont, France
Phone: +33-(0)2-4826-9348
Fax: +33-(0)1-7072-3482

www.teneues.com

ISBN: 978-3-8327-9455-2

Printed in Italy

Bibliographic information published by the Deutsche
Nationalbibliothek. The Deutsche Nationalbibliothek lists this
publication in the Deutsche Nationalbibliografie; detailed biblio-
graphic data are available in the Internet at http://dnb.d-nb.de.

Photos:

© getty images
14, 32, 40 (top left), 47 (right), 48, 50/51, 52 (1), 52 (2), 52 (3), 52
(4), 53 (1), 53 (3), 53 (4), 54 (left), 76, 78, 80/81, 82, 84, 85, 86/87,
88, 89, 90, 91, 92, 94, 95, 96/97 (right), 99, 100/101, 102 (top),
102/103 (right), 104, 106, 107, 108/109, 110/111, 112/113, 115,
119, 121, 126, 127, 129 (left), 130/131 (left), 134, 136, 142/143,
145, 146, 155 (bottom), 158, 160, 161, 162, 163, 164, 167, front
cover, back cover (bottom right)

© picture alliance
6, 8/9, 10, 12 (right), 14/15, 16/17, 18/19, 20/21, 22, 25, 26, 27,
28/29, 30 (bottom), 31, 34/35, 38, 39, 40 (top right), 41, 42, 43, 44,
46/47 (centre), 49, 53 (2), 54/55 (right), 56, 58, 59, 60/61 (right),
62, 63, 64/65, 66 (top), 67, 68, 70/71, 72/73, 74/75, 83, 96 (left),
98, 102 (bottom), 114, 116, 118, 120, 123, 124, 128, 131 (right),
132, 133, 139, 140 (left), 141, 144 (top), 147 (left), 147 (centre),
148, 150/151, 153, 154/155 (left), 155 (top), 156, 157 (top), 165,
166, back cover (top left, top right, bottom left)

© action press
46 (left), 60 (top), 129 (right), 135, 138, 142 (left), 147 (right), 152,
157 (bottom)

© Paul Hansen with the permission of Natur & Kultur Förlag
11, 12 (left), 13

© Sveriges Television AB
24

© Photo: Guri Dahl / tinagent.com
36

H.M. Queen Sonja of Norway
37 (right)

The Royal Court Norway
37 (left), 40 (bottom)

The Royal Collection, The Netherlands
60 (bottom), 66 (bottom), 77

Illustrations courtesy of The Royal Household of H.M. The King
of Spain
140 (right), 144 (bottom)

The Royal Court of Sweden with the permission of Ekerlids Förlag
30 (top)